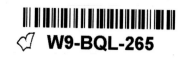

UNEMBEDDED

UNEMBEDDED

Four Independent Photojournalists on the War in Iraq

GHAITH ABDUL-AHAD · KAEL ALFORD · THORNE ANDERSON · RITA LEISTNER

Foreword by Philip Jones Griffiths · Introduction by Phillip Robertson

CHELSEA GREEN PUBLISHING COMPANY · WHITE RIVER JUNCTION, VERMONT

FOREWORD

Today photojournalism is under attack, but the courageous photographers who've produced this book are fighting back. With the mainstream media having given up, for the most part, on the task of truly informing the public, books are fast becoming the medium of choice for getting the truth out. *Unembedded* shows that there are still brave independent publishers out there prepared to swim against the tide of public misinformation.

We live in a world where the few control the many. American expansionism is on a rampage. Some have observed that if the United States were to invade Syria and Iran it would dominate all the lands from the Mediterranean to Pakistan. But less obvious is the government's current sway over countries such as India, which is embracing American consumer capitalism without a shot being fired. American hegemony appears unstoppable, perhaps even taken for granted. We are witnessing an expansion of empire analogous to the Roman Empire's reach two thousand years ago. Thankfully, this time there are cameras to record the machinations of a superpower, resource-hungry nation.

Photographers bearing irrefutable images pose difficulties for those in power who work on the principal that you can indeed fool most of the people most of the time. An eloquently captured view of the war in Iraq was feared by Washington insiders, who predicted that the truth could become a major problem. The entire Iraq misadventure, based on lies and deception, required a compliant media for support, and so a deal was struck.

Even loyal handmaidens can feel slighted, as did the major news media when they were prevented from covering Grenada, Panama, and the Gulf War in depth. The hollow excuse was that the press was to blame for the United States losing the Vietnam War. This lie eventually led to the currently accepted restrictions. So, for the American war on Iraq, a compromise was reached in which some seven hundred journalists would be "embedded" with military units. For most of the media, the chance to get close to the action overrode professional judgement and the truth: a provision of the contract that journalists had to sign gave the military control over the output of an embedded newsman. Then there came the rugged training: reporters and photographers climbed ropes, lifted weights, crawled on their bellies, and trekked for miles.

Once in Iraq, these "trained" reporters became cogs in the military machine. Soldiers were armed with plastic cards printed with a list of answers to be parroted out if the media questioned them. "We are a values-based, people-focused team that strives to uphold the dignity and respect of all" was one answer that must have confused the relatives of those people held in Abu Ghraib! Pentagon officials had already spelled out what "embedding for life" meant: "living, eating, moving in combat with the unit that you're attached to. If you decide to make the decision that you're no longer interested in the unit that you're with or you've covered them sufficiently, of course you can say, 'I want to try to retrograde back and leave the unit that I'm with.' But once you do

that, there are no guarantees that you'll get another opportunity with that unit or necessarily even with another unit. . . . That's what I am talking about when I say a newsman 'embeds for life.'"

A photojournalist assigned to a unit that had seen little action noticed a firefight nearby. He asked the officer in charge if he could wander over to take pictures. He was told, "When you leave us you can never come back." The photographer decided to stay.

Being embedded with a unit means that objectivity is easily abandoned. Ties and relationships are soon formed, and that is to be expected; bonding is an essentially human trait. The military calls it "unit cohesion." All of that living, eating, and—let us not forget—defecating does serve to bring people together. One female photographer, no doubt overcome with boredom, made a portrait of herself in the act, facing the camera while six or eight soldiers lined up on either side of her with their backs to the camera and mimicked urinating to produce what might well be the nadir of war photography.

The fearless photographers in this book chose to retain their independence and objectivity rather than drag the second oldest profession down to the level of the oldest one. This choice led to a problem for the authors: how to get their photographs published in magazines and newspapers that mainly run pictures reminiscent of Army recruiting posters. The one hundred thousand or so dead Iraqis are the invisible "others" whose corpses are never allowed to sully the pages of magazines dedicated to the trivial pursuit of gossip and celebrity chitchat.

Being fed anodyne images of the war is infantilizing the American public. Various excuses are used by the Pentagon to sanitize the war, with the line "out of respect for family members" being plausible in the case of dead GIs. But the extension of this restriction to cover even the photographing of unidentified caskets reveals a disdain for a people's right to know. The fear is that if the people appreciated the real cost, the administration would be subjected to further criticism. So the press is banned from any event that might reveal that American soldiers are being killed, and that ban includes soldiers' funerals at Arlington National Cemetery. This while President Bush claims to be spreading democracy through the world, repeatedly emphasizing that those new democracies must have a "free press."

This book is an antidote to the pap served to the American public, and it will increase in importance over time, because the hired revisionist historians will spread their lies for years to come.

Your grandchildren will appreciate this book, as will their grandchildren.

Philip Jones Griffiths
August 2005

Philip Jones Griffiths is a member and past president of Magnum Photos. His epic book *Vietnam Inc.*, first published in 1971, is recognized as a classic in photojournalism and war reporting.

This book is dedicated to the people of Iraq and to the memory of Marla Ruzicka, founder of the Campaign for Innocent Victims in Conflict (CIVIC), and her colleague, Faiz Ali Salim, who worked tirelessly on behalf of the victims of war.

To learn more about CIVIC visit www.civicworldwide.org.

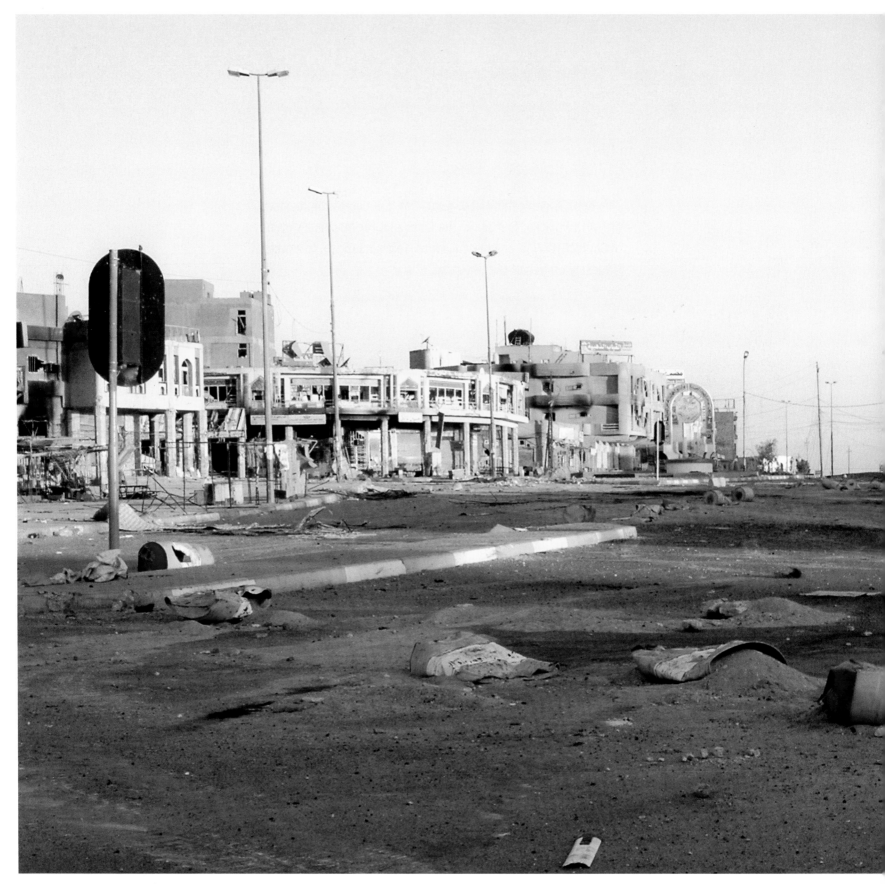

NAJAF, AUGUST 27, 2004 | RL

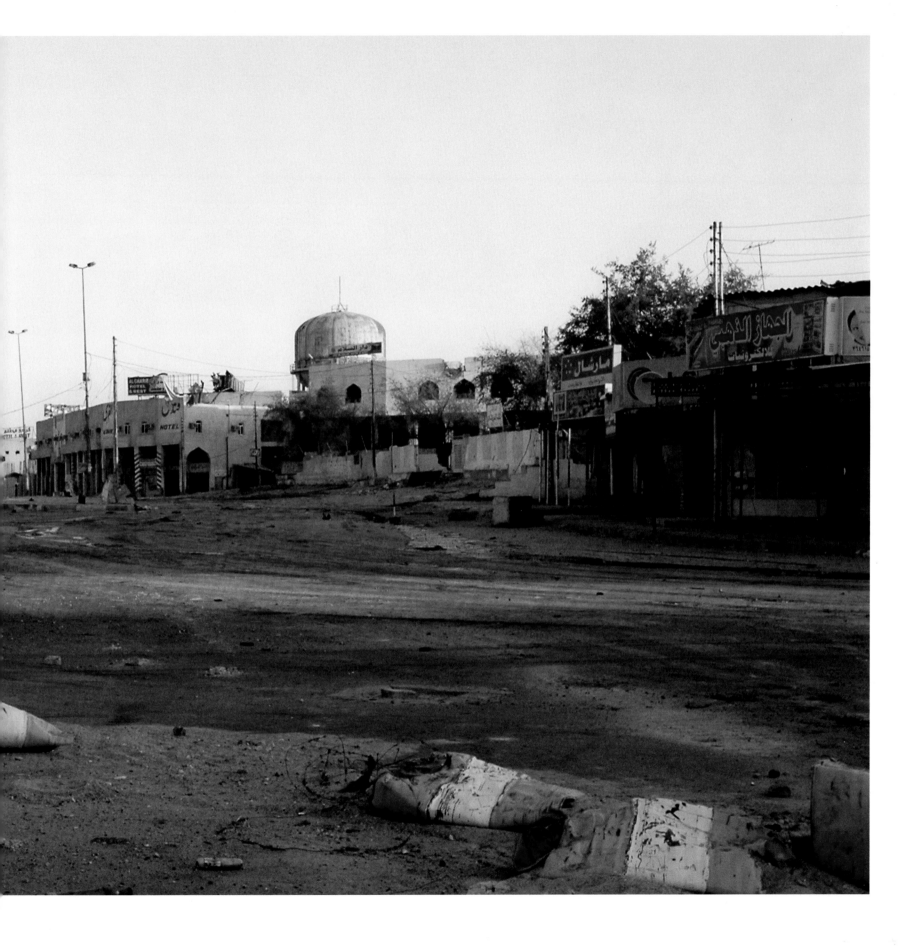

BAGHDAD, MARCH 26, 2003
A dust storm casts an eerie orange light over a house destroyed by U.S. cruise
missiles in one of the first attacks of the "shock and awe" bombing campaign. | KA

INTRODUCTION

If this book offers an explanation of what it means to work as a journalist outside the U.S. perimeter, it is also an involuntary exorcism of intense memories. There have been worse battles in Iraq since the late summer of 2004, but that doesn't matter. One death is still a death. It is the end of a universe. The photographs in this book, many of which were taken in Najaf during the siege that August, are the bright traces of the moments we witnessed there, and it is impossible for me to see them now without hearing the detonations, the entreaties, and the terrible silence of that time. During the siege of Najaf, a holy city to tens of millions of Shiite Muslims, the five of us—four photojournalists and I—were drawn together, pulled into a fierce orbit around the gold tomb where the saint Imam Ali lies buried.

On August 17, 2004, close to the height of the U.S.-led siege of Najaf, Thorne Anderson, Yassir Jarallah, and I crossed the U.S. cordon and the Mahdi Army lines on foot, thinking that if we could get to the old city, we would be able to understand what was happening at the center of the Mahdi movement. Very little information was coming from the old city inside the cordon because few reporters had made it through the blockade. Most had been turned back by gunfire or had been rousted from their hotel rooms by Iraqi police. For a period of a few days, journalists were threatened with arrest if they remained within Najaf city limits. We wanted to find our way through the cordon and break the news blockade.

On the day we crossed the cordon, Kael Alford was taking photo-graphs of a Najafi family trapped by the fighting near the desolate zone that characterized the front lines. Rita Leistner, who arrived in Najaf the following day, was in Baghdad tirelessly negotiating the release of our colleague Micah Garen, a Mahdi Army hostage in Nasriya. Ghaith Abdul-Ahad, whose columns for the *Guardian* are some of the best reporting to come out of the war, arrived in the shrine that evening and captured a doomed peace delegation as it met with Mahdi Army officials. I remember seeing his blue flak jacket as he followed the dignitary Hussein al-Sadr though a chanting mob of fighters.

As Thorne and I crossed the U.S. cordon with our hands in the air, we found ourselves in a landscape of burned buildings and smoldering cars. We continued over broken glass and melted plastic through a ruined market where we finally came across the first Mahdi Army position. We waved to a group of heavily armed men wearing black shirts, crouching in an alley, and when the fighters saw us, they did not arrest us. Instead, the commander sent an unarmed messenger to show us the path through the fighting to the old city. We walked to an open space where a wide street divided the old city from its newer sections. When we reached the middle of the street, where it was impossible to turn back, a sniper fired on us, and there was a cracking sound and dust in the air from the rounds hitting the concrete pillar above our heads. Thorne lay down in the road, finding shelter under a low concrete barrier. I ran behind a column. When the shooting was over, we walked slowly to the shrine in the old city, past dozens of

fighters in black, leaning against the walls with their weapons. It was a moment of relief, of somber triumph. Other photographers and journalists who have risked everything to cover the war from the other side know this feeling well because they have made this crossing or one just like it many times. Fighters on the other side of the street took us in, and there was an innocent, human quality in this moment that I cannot describe even a year later. It would have been easy for them to kill two American journalists, accuse them of being spies, but they did not. Perhaps that is all that needs to be said.

In the old city where most of the fighting took place, the sound of the great machinery of killing focused on a small space came through the air in shattering waves. A few dozen yards away from the great shrine of Imam Ali, Hellfire missiles fell from Apache helicopters and buildings were smashed into their basements, rocket-propelled grenades flew down Prophet Street, machine guns chattered in bursts. We watched young men rushing through the gates of the shrine, down Prophet Street toward death. In this way we learned that all of the weapons have their own distinct voices. Soon it was easy to imagine the machinery of war as demons, and the siege of Najaf as a war between heaven and hell. This was how the Mahdi fighters saw it. For them, it was a war of faith.

We entered the southern gates of the shrine and saw the tomb of Ali in the center of an expanse of polished white marble. The reflection of the sun off the gold minarets made them look like vessels being fired in a kiln. Wounded fighters were being carried through the gates to a makeshift infirmary in a small alcove, as the Mahdi lines collapsed around the shrine. Older men who tended the mosque wiped up the trails of blood from the wounded. The young men in black T-shirts and green headbands ran down Prophet Street toward the American lines and came back on wheeled carts, their bodies torn apart. After they died, comrades of the dead fighters wrapped them in white and carried them in a final circuit around Ali's gold tomb, shouting, "There is no god but God." While I filed reports for the radio and gave interviews over the satellite phone, Thorne took hundreds of pictures of the fighters in the shrine and near the front lines, documenting what I was unable to describe in words. He showed them eating meals, praying and fighting, the whole extent of their lives under fire. In his photographs you can see the connection he had made with the young Mahdi volunteers and the trust he had gained.

A few blocks to the north of where we slept, hundreds of Mahdi Army soldiers were hiding in a vast graveyard, a necropolis far larger than Najaf itself, with more than a million people buried in the sacred earth. Fighters huddled down in the dust of the tombs, firing at U.S. positions. We heard the sound of the missiles that destroyed them. The other men who took their place picked up the weapons of the killed and fought until they also died. The war and the routine that surrounded it functioned with mechanical regularity. And because machines are predictable, you always knew what would happen before it happened.

Three days later, on August 19, after learning that we couldn't safely leave the old city the way we had come in, Kael Alford and Rita Leistner brokered a ceasefire between the U.S. military and the Mahdi Army. It was the first step in a plan to evacuate us from the shrine. Riding in the first car of a convoy of journalists, Kael and Rita made their way into the old city, past the nervous fighters who fired warning shots to stop them. While some of the journalists in the convoy decided to turn back, Kael and Rita continued through the ruined city.

At four o'clock, dozens of journalists entered the shrine to bring us out, get quick interviews, take photographs of the Mahdi volunteers who were shouting and chanting Muqtada al-Sadr's name. I had first heard that they were coming when a young fighter ran up to me and said, "The journalists are coming."

"Which journalists?"

"All of them!" the boy said. An hour later, when Rita and Kael arrived, it seemed like a species of miracle. After we returned to Baghdad, we were shocked by some of the reactions people had to our work during the siege.

One U.S. officer who was angry that we covered the other side of the conflict in Najaf accused us in a *New York Times* editorial of putting American soldiers at risk. I am not sure what he meant, and it is certainly not true. Another man, in an Internet posting, threatened Thorne's life because of the photographs he took behind the Mahdi lines. This is a short catalog of incidents, but all of us have been escorted out of places, threatened with the loss of press credentials or with arrest. There are always consequences when stories run, but I was surprised by the bitterness and vehemence of the accusations, the absurd insinuations of treason.

We crossed the lines because we believe it is more important to humanize a conflict than it is to trade in rhetorical truths, or to reinforce easy notions of enemy and friend, which are mere propaganda.

Instead, we wanted to document honestly what we witnessed in the war because this is the sole duty of journalists, regardless of their nationality and religion. We were able to do this precisely because we did not carry weapons or claim allegiance to one of the warring parties. If our journeys behind the lines were acts of faith, then they were also proof that often when one man is confronted with the humanity of another, he will not raise his rifle and pull the trigger. This is not disloyalty to one's country. It is the thing that brings an end to war.

Now, here are your witnesses.

Phillip Robertson
Baghdad
June 1, 2005

Phillip Robertson is the Iraq war correspondent for the American news and culture Web magazine Salon.com.

UNEMBEDDED

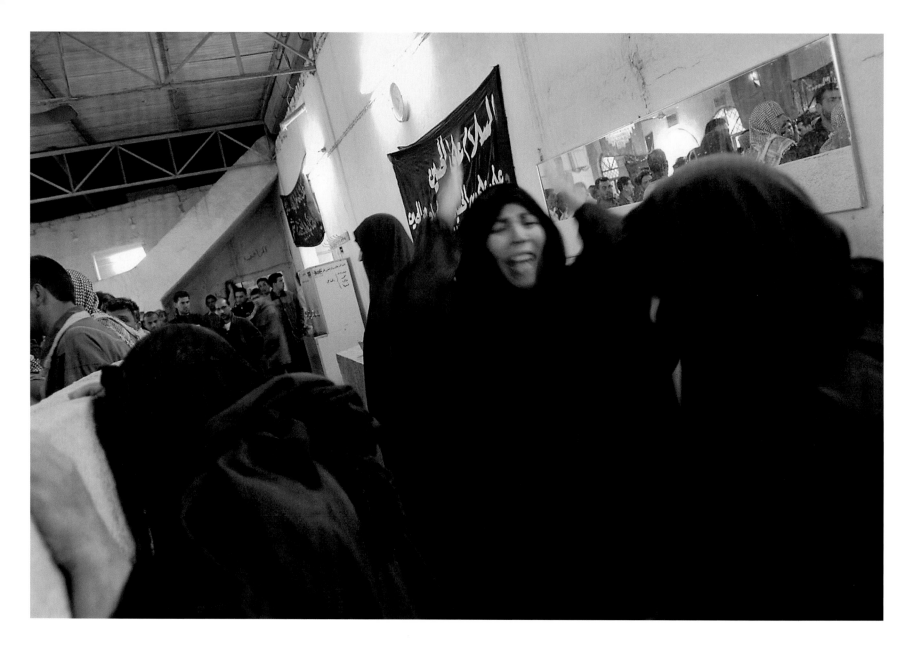

SHOALA, MARCH 29, 2003

Family members mourn in a mosque in a Shiite neighborhood north of Baghdad.
A U.S. bomb explosion there killed at least fifty people, including fifteen chil-
dren, and wounded many more. | KA

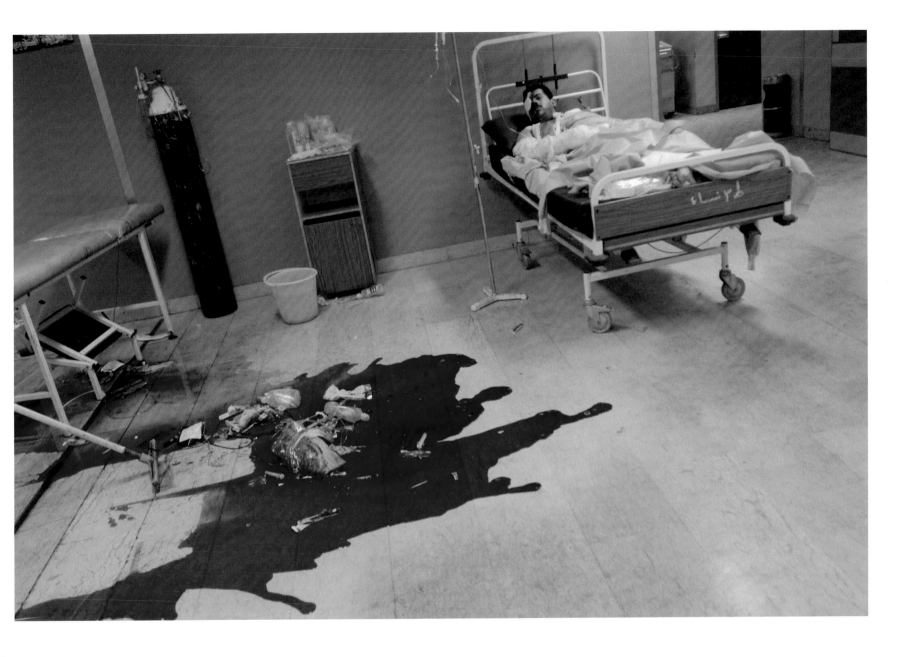

BAGHDAD, APRIL 9, 2003
The makeshift operating room at Medical City Hospital. The hospital was
overwhelmed with military and civilian casualties and suffered from water
and staff shortages during the U.S. bombing campaign. | KA

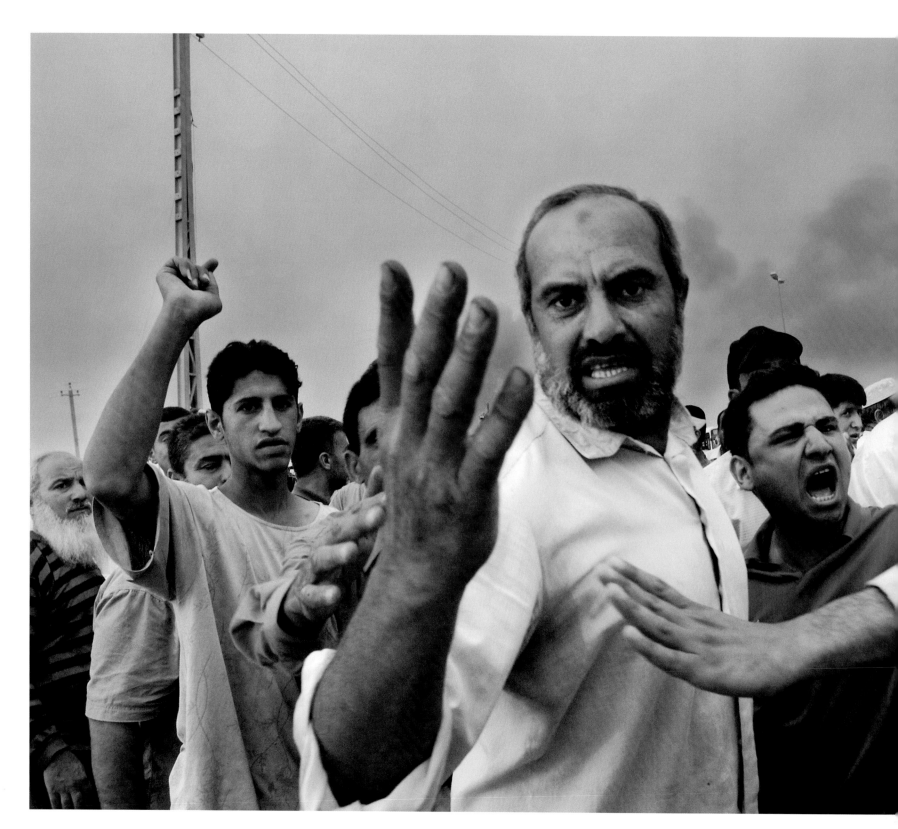

ZAFRANIA, APRIL 26, 2003
Angry residents of Zafrania confront U.S. soldiers guarding
an ammunition stockpile after an accident launched a
missile that killed people in nearby houses. | KA

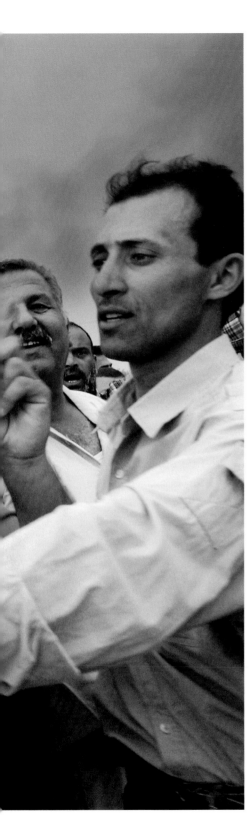

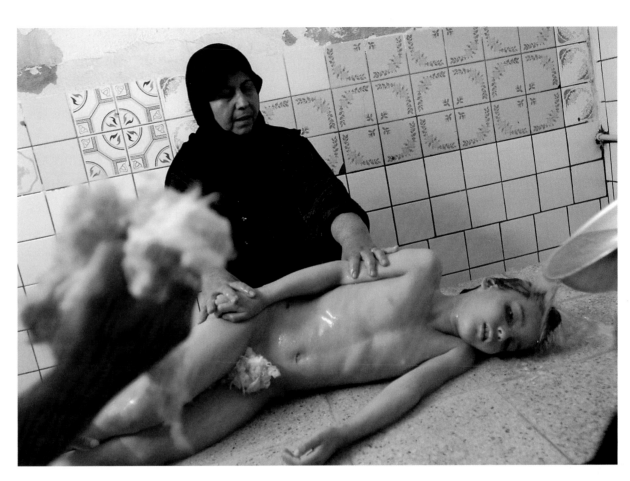

SHOALA, MARCH 28, 2003
An eight-year-old girl, killed in a U.S. bombing raid, is washed for burial. | KA

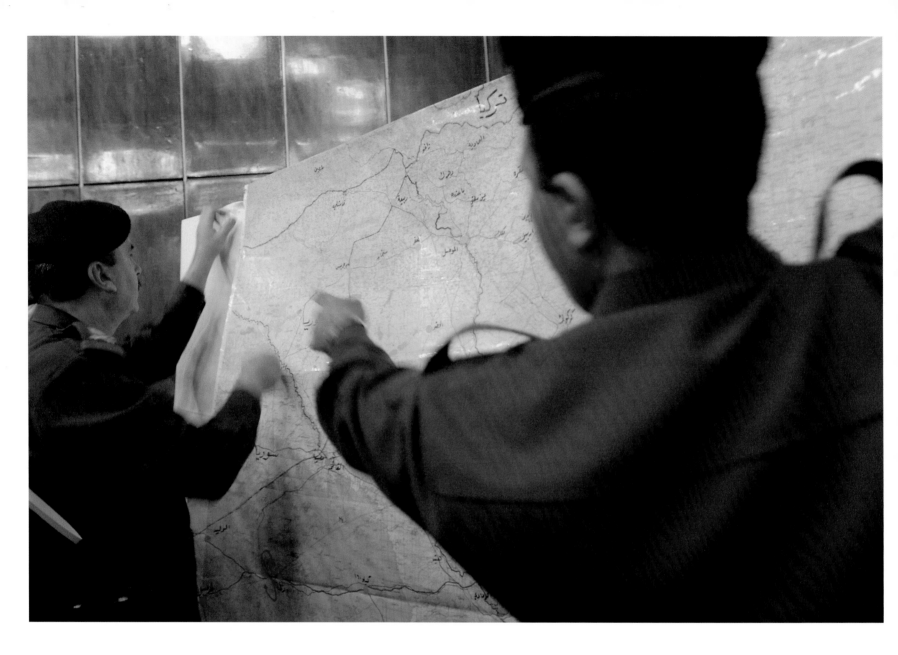

BAGHDAD, MARCH 24, 2003
The Iraqi Ministry of Information holds a press conference for foreign journalists. | KA

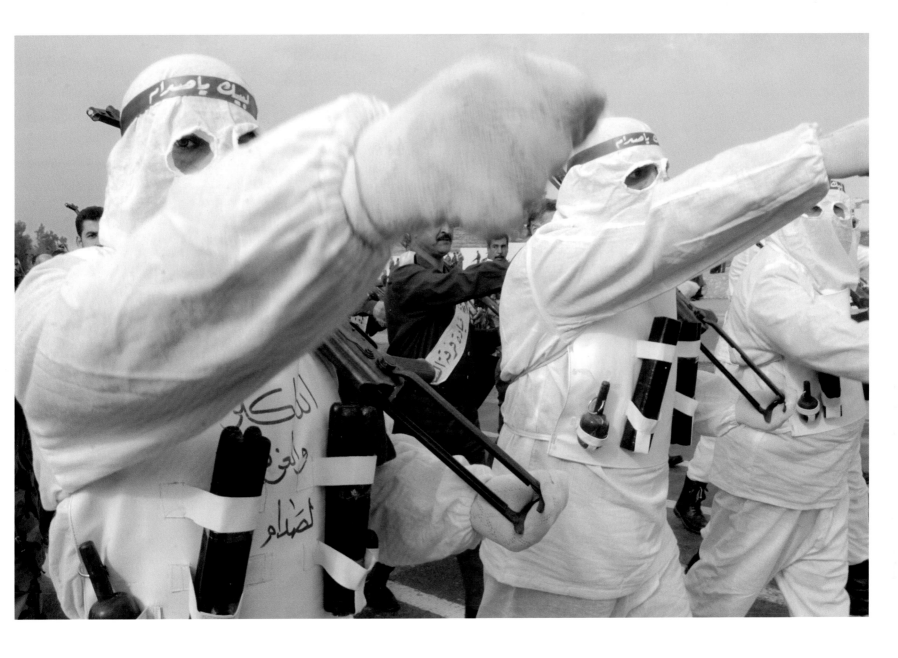

MOSUL, FEBRUARY 4, 2003
Members of the "Jerusalem Army" costumed as suicide bombers march in
a parade of some forty thousand members of the civil militia. The Jerusalem
Army had an estimated one million members throughout Iraq who were
pledged to defend their country against an American invasion. | TA

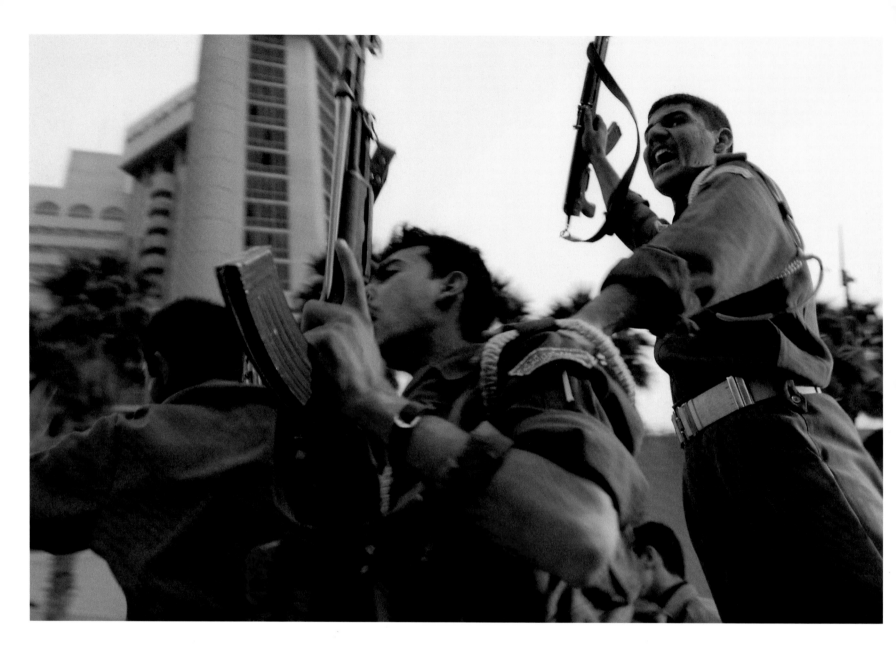

BAGHDAD, APRIL 5, 2003
Iraqi Republican Guardsmen parade past the Palestine Hotel where most
of the foreign press corps stay. American tanks and armored vehicles had
arrived on the outskirts of Baghdad early that morning. | KA

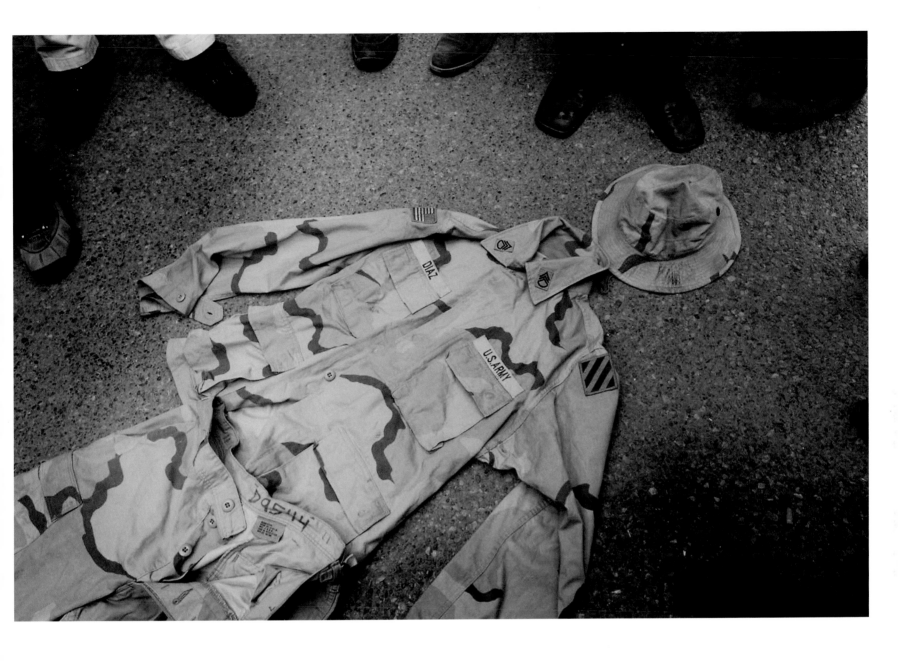

BAGHDAD, APRIL 5, 2003
The uniform of an American soldier is displayed outside the Palestine Hotel
by an Iraqi soldier, who claims to have killed the American in combat near the
Baghdad airport. | KA

MOSUL, APRIL 16, 2003
One of Saddam's bombed palaces draws crowds of curious Iraqi citizens in the days following the fall of Mosul. | RL

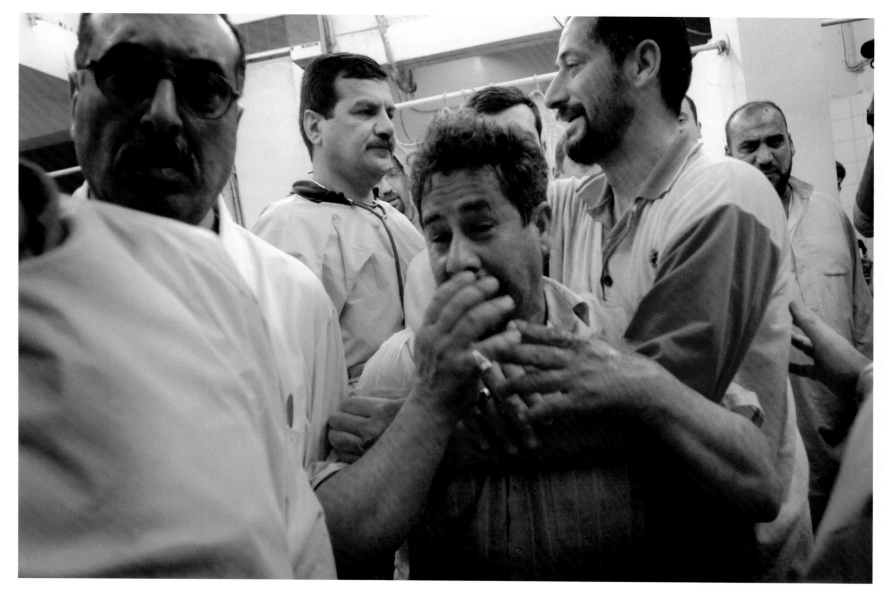

BAGHDAD, APRIL 8, 2003
A man who lost two children and his wife when a missile landed on their
house is restrained by a friend at the Kindi Hospital emergency ward. | KA

At Yarmouk Hospital, the director briefed journalists and foreign peace activists on the growing problems he faces in helping the wounded. Civilian telephone lines are disrupted citywide by coalition bombing, so residents can't phone for help. The night before last, he said, a man came screaming to the front door of the hospital that an ambulance was needed in a southern suburb of Baghdad. It took the man an hour to reach the hospital. "I am a medical professional," the doctor said. "I know what an hour means."

The doctor himself traveled to the site where an extended family was trapped beneath the rubble of their flimsy home, which had collapsed from a blast during an air raid in the early hours of the morning. Most severely wounded civilians come from poor neighborhoods in the

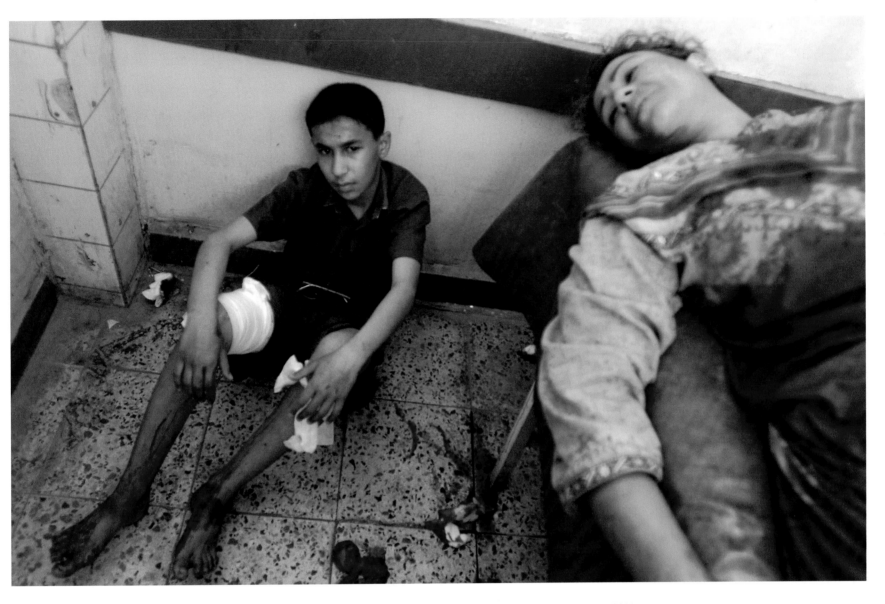

BAGHDAD, APRIL 8, 2003
A boy watches his dying mother on the emergency room floor of Kindi Hospital after his brother and sister were killed when a missile landed on their house in the eastern part of Baghdad. Doctors who believed they could do nothing to save the woman moved on to patients who could be helped. Iraqi civilian casualties at hospitals in the capital reached a peak as U.S. forces slowly gained control of the city on the ground. | KA

sprawling suburbs of Baghdad. He found twelve members of the family buried beneath the rubble. By the time he arrived, the only victim alive was a thirteen-year-old boy whose two badly burned arms had to be amputated to save him. "War wounds are always multiple wounds," the doctor explained. "It's not as simple as a bullet."

| Kael Alford, Baghdad, April 2003

The smell of torn flesh permeated Baghdad's emergency wards in the days before Baghdad fell. Battered cars and taxis screeched up to hospital doors, spilling wounded civilians slung in blood-soaked bedding. Outside the hospital corridors, shrouds of black smoke rose from heaps of rubble. At night, the walls of flimsy buildings trembled and glass rattled with the force of black tons of metal and fire falling from the sky. In the daytime between bombing raids, people came out of hiding to assess the damage and bury the dead. This had been the routine for three weeks. The Marines were closing in on Baghdad.

In the suburbs, U.S. missiles went wrong or landed close to brittle cinder block housing that collapsed on whole families in their sleep. By the third week of bombing, the communications and telephone exchanges had been destroyed, so no one could call for help. In Saddam City Medical Center, casualties filled the rooms and lined every hallway. I photographed doctors setting bones, sewing stitches, and treating burns on patients without anesthesia. The ambulances were broken down, and drivers said they didn't know where to find the injured anyway. These stories multiplied as the air raids grew to a crescendo before the Americans' final push for Baghdad, until one editor asked, "Please, don't send any more wounded civilian pictures."

I arrived in Iraq on a three-week visa, twenty-three days before the first U.S. bombs fell. I wanted to be in Baghdad during the war itself to experience being in the crosshairs of the largest war machine on earth. I wanted to know how that experience could change someone's view of the world. Can architects of war predict such things?

There is a familiar refrain hurled at foreign reporters in Iraq that I first heard in an emergency room in Baghdad. "Is this freedom and democracy?" a grieving mother shouted at a group of journalists. It is now a line so common in the tragedies of Iraq that it has almost lost any meaning.

Sometimes our Iraqi government minders grudgingly took us in small groups outside the circuit of organized press trips to a market, to the home of a family or the site of a bombing on a civilian target. Reporting from Baghdad was journalistically stifling, but it was astonishing that we were allowed to stay and work at all. I wondered if the U.S. government would allow Iraqi journalists to remain in the U.S. under similar circumstances.

I usually worked with a minder assigned by the Ministry of Foreign Affairs called Ali, who had worked as a foreign press attaché. He was a mild, middle-aged bureaucrat who seemed to regard the regime with pragmatic distance and considered himself a professional journalist. He was single and lived with his mother. He liked to tell stories of the beautiful foreign women he had dated while stationed at embassies in Africa. Ali could be surprisingly frank. In the first week of the bombing we asked him what he thought the Iraqi war strategy would be. He lowered his voice and said, "Some say that the plan is to allow the Americans to enter the country, and then there will be a guerrilla war in the cities."

On April 9, Baghdad had been pummeled into submission from the air and sat largely undefended. When the first Marine convoys appeared near the journalists' hotel in the center of town, Baghdadis crept from their homes like survivors of a massive earthquake or violent storm.

A few young men who seemed to have little to surrender stood on the side of the road waving bits of dirty white rags at the Americans. There was no celebration but an air of cautious relief as the American Marine convoy snaked down the road then stalled and considered. The tanks' turrets swiveled like the necks of steel dinosaurs, took a long look at the scattered assembly, and rumbled along. A large armored vehicle stopped on the side of the road and spilled soldiers onto the street. The soldiers moved quickly, fell into formation, and began a foot patrol securing the side roads. I photographed a grinning neighborhood son and father with a poodle who wanted their picture made in front of the gaping steel vehicle.

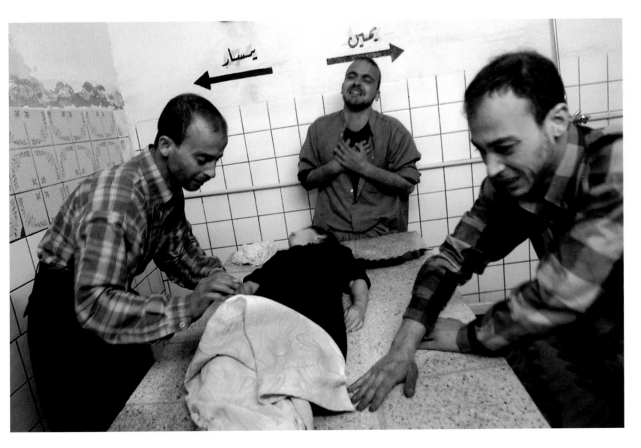

SHOALA, MARCH 28, 2003
A father and his brothers mourn an eight-year-old girl killed when a U.S. missile landed in a busy market in a Shiite neighborhood north of Baghdad. The U.S. bombing lasted twenty-one days, making way for the U.S.-led coalition invasion. | KA

Further up the road on Firdos Square a plan was devised to drag down the now infamous statue of Saddam Hussein. I heard a Marine radio in a request to pull the statue down with a tank.

When the tank arrived I climbed on top. There was a confused debate among the soldiers and the crowd about first an American and then an Iraqi flag draped over the head of the statue. The American flag looked too garish. The Iraqis gathered there, most of whom seemed to have arrived with the Americans, didn't want the Iraqi national symbol dragged to the ground. A young Marine pointed to his buddy in the gunner position sitting above an uncertain crowd of fewer than two hundred people and said, "He's from New York. Now that's poetic justice." Nearby a photographer who had just arrived in Baghdad with the troops said, "It's just like the Berlin Wall." It was a day of simultaneous mythmaking.

I photographed this event knowing it was a moment contrived by military planners for television. These soon-to-be iconic images would be more widely viewed than anything else I had photographed in a month. They didn't represent what I had experienced of the war in Baghdad. In the sweltering heat, ghosts of the bombing tickled the hairs on my neck and arms. I felt I'd failed them somehow.

Events moved forward quickly and Baghdad descended into chaos. I left the charade on the square to photograph the Americans securing their positions while looters sacked the city and the Iraqis collected their dead. |

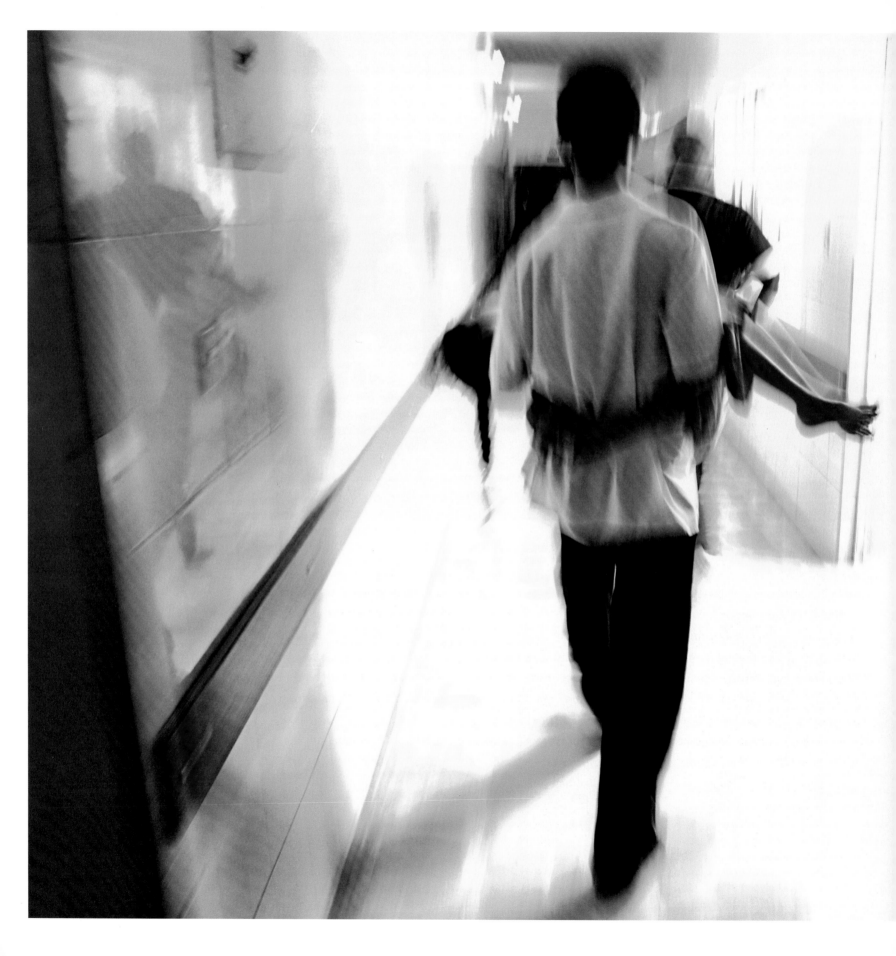

BAGHDAD, MAY 16, 2003
An man rushes his daughter to the emergency room at the Yarmouk Hospital. The girl was injured when a children's neighborhood scuffle over a ball turned into a gunfight among adults. The collapse of security following the U.S. invasion has continued to overwhelm emergency rooms. | TA

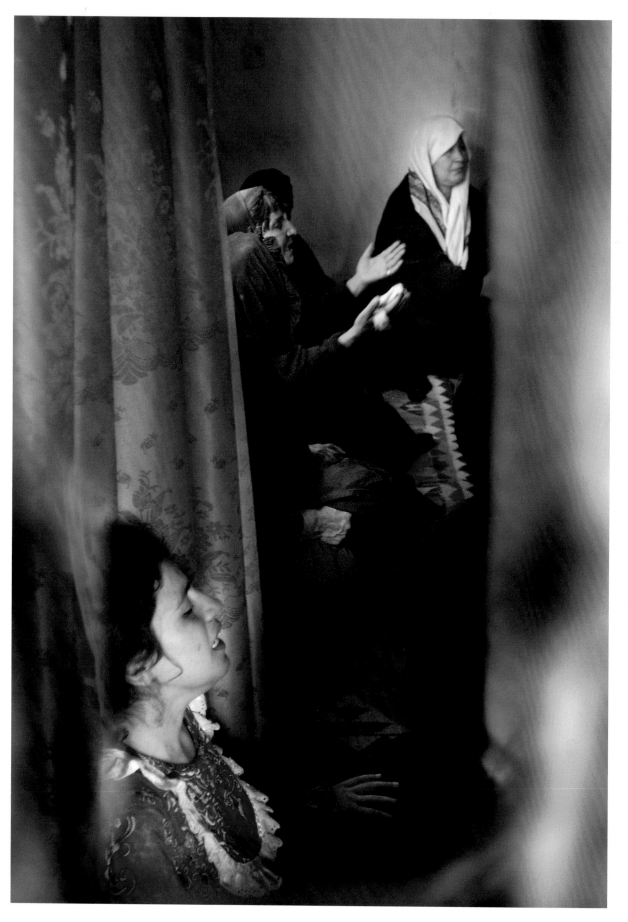

ZAFRANIA, APRIL 26, 2003
Women mourn family members killed when a missile landed on their home. The missile was launched accidentally from an ammunition collection point under U.S. military control. | KA

SHAOLA, MARCH 28, 2003
A casket is carried through the streets after
a U.S. missile landed on a marketplace. | KA

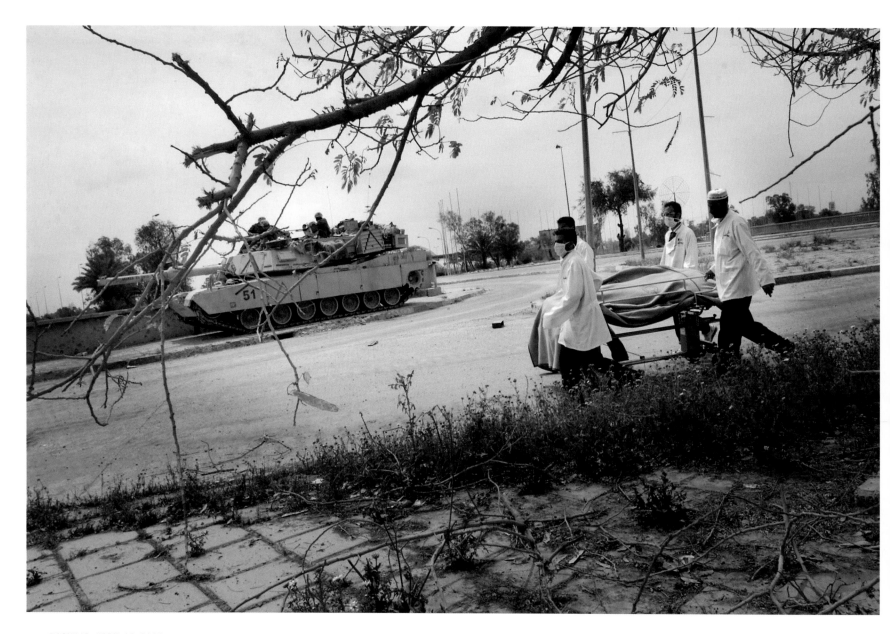

BAGHDAD, APRIL 12, 2003
Medical volunteers collect the bodies of slain Iraqi
fighters under the watch of U.S. Marines. | KA

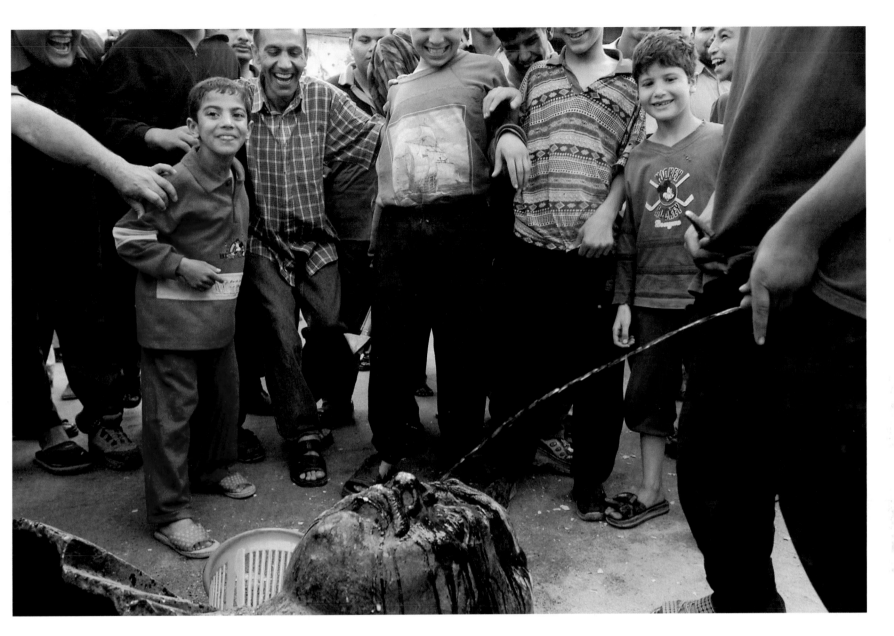

BAGHDAD, APRIL 14, 2003
A boy urinates on the head of a toppled
Saddam Hussein statue on Rashid Street. | TA

Today I followed a group of men with a crane going from Saddam statue to Saddam statue and tearing them down. There were cheers and rambunctious kicking and spitting on the heads as they were torn apart. (These are the scenes you will probably see on TV.) But at some point during each of these stops there were also chants of "Down, down, America!" (These are the scenes you probably won't see.) There is a lot of complexity to people's emotions here.

| Thorne Anderson, Baghdad, April 2003

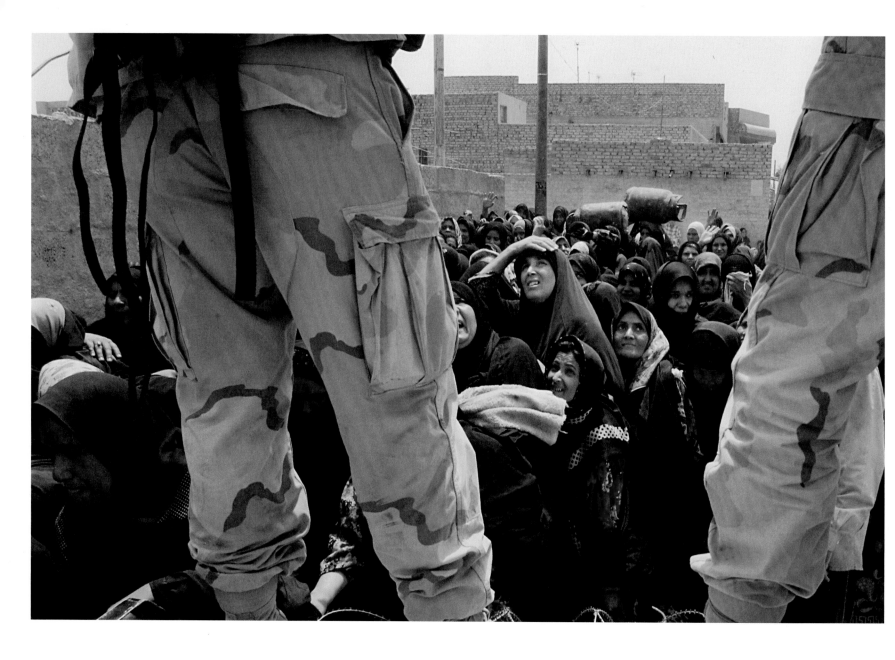

BAGHDAD, MAY 27, 2003
Under the watch of American soldiers, women struggle to form a line at a gas distribution center in the Shiite neighborhood formerly known as Saddam City. The U.S. Army, in cooperation with the former Iraqi government's distribution ministry, set up the center on an ad-hoc basis, hoping to ease the desperate shortage of fuel brought on by the disruption of Iraq's rationing system during the bombing. | TA

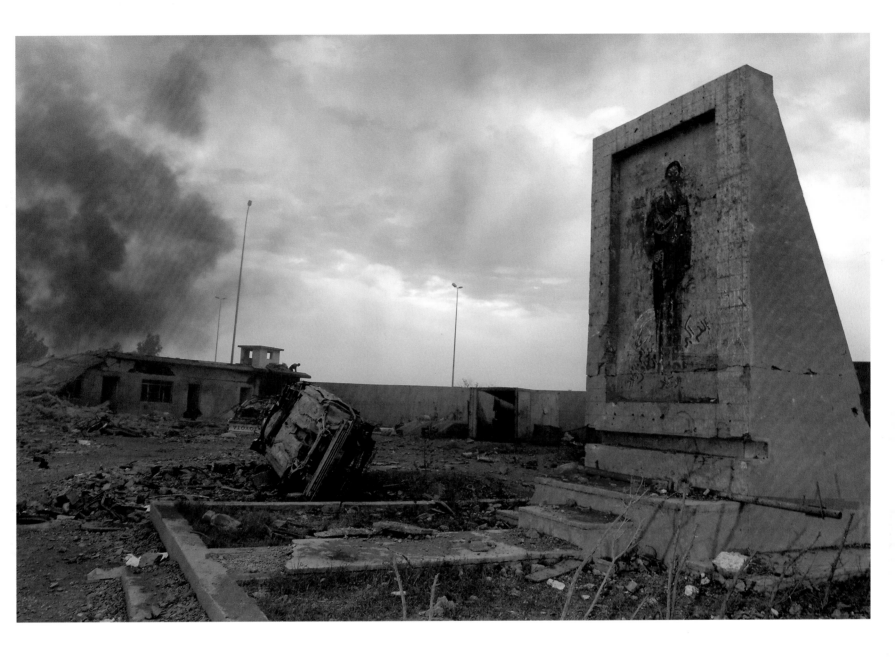

KIRKUK, APRIL 15, 2003
One of many defaced portraits of Saddam Hussein stands in the
smoldering debris of a building where prisoners were kept and tor-
tured under Saddam's regime. | RL

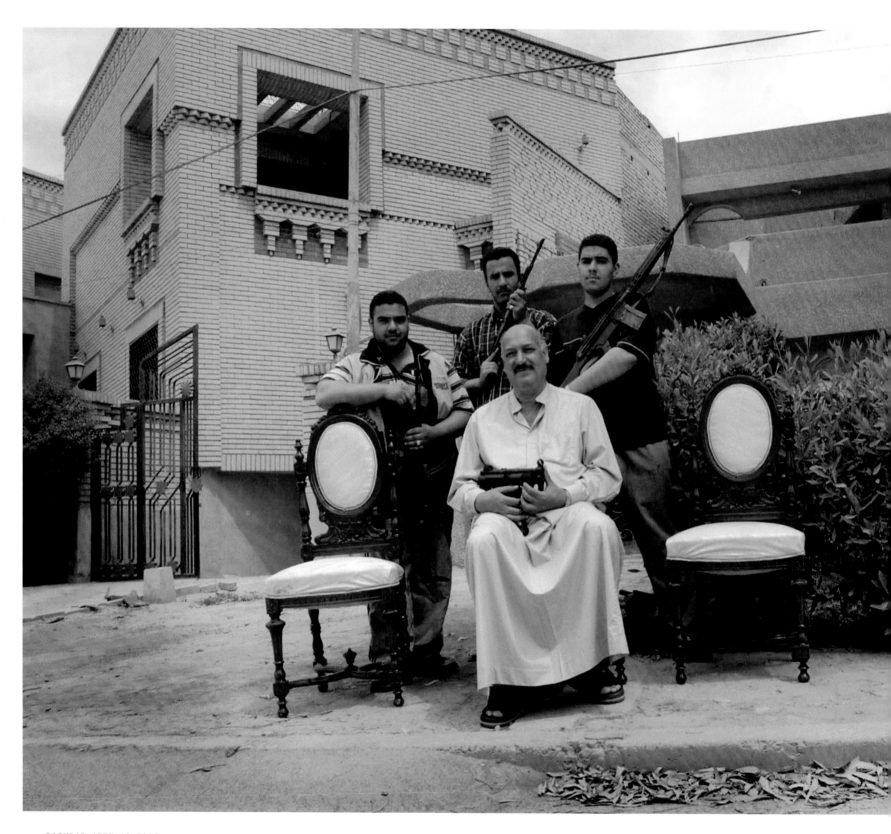

BAGHDAD, APRIL 12, 2003
A father and his sons guard their street from looters in the wealthy neighborhood of Kadhamiya. The neighborhood organized armed civilians who patrol twenty-four hours a day to keep thieves at bay. Looters ransacked the homes of government employees and Saddam family palaces just down the road. | KA

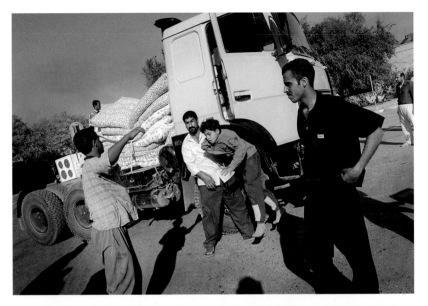

It took no time for people to figure out that they could steal without consequence. How long will it take for them to figure out that they can kill without consequence? | Thorne Anderson, Baghdad, April 2003

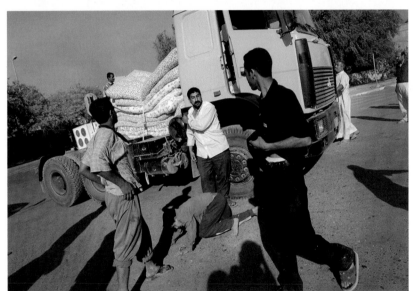

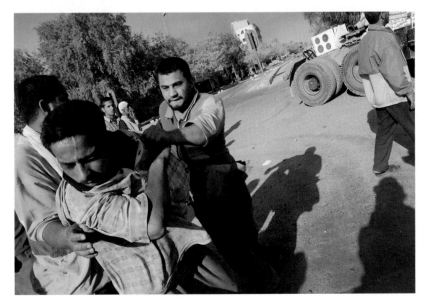

BAGHDAD, APRIL 11, 2003
Neighborhood vigilantes pull looters out of the cab of a stolen government car full of mattresses. The looters were beaten and chased out of the Shiite neighborhood and the truck was returned. As the capital descended into looting and chaos after the arrival of U.S. forces, many Baghdadis took the law into their own hands. | KA

AL-HINDIA, APRIL 21, 2003
Just two weeks after the fall of Saddam Hussein's regime, millions of Shiite Muslims made their first fully free pilgrimage to the holy city of Karbala in twenty years, many of them traveling on foot for several days and nights. The massive march immediately came to symbolize the emergence of Shiite religious power from decades of repression. The pilgrimage honors the fortieth day after the traditional anniversary of the death of Imam Hussein, who was killed in the battle of Karbala in 622, the event that marks the split between Shiite and Sunni Muslims. | TA

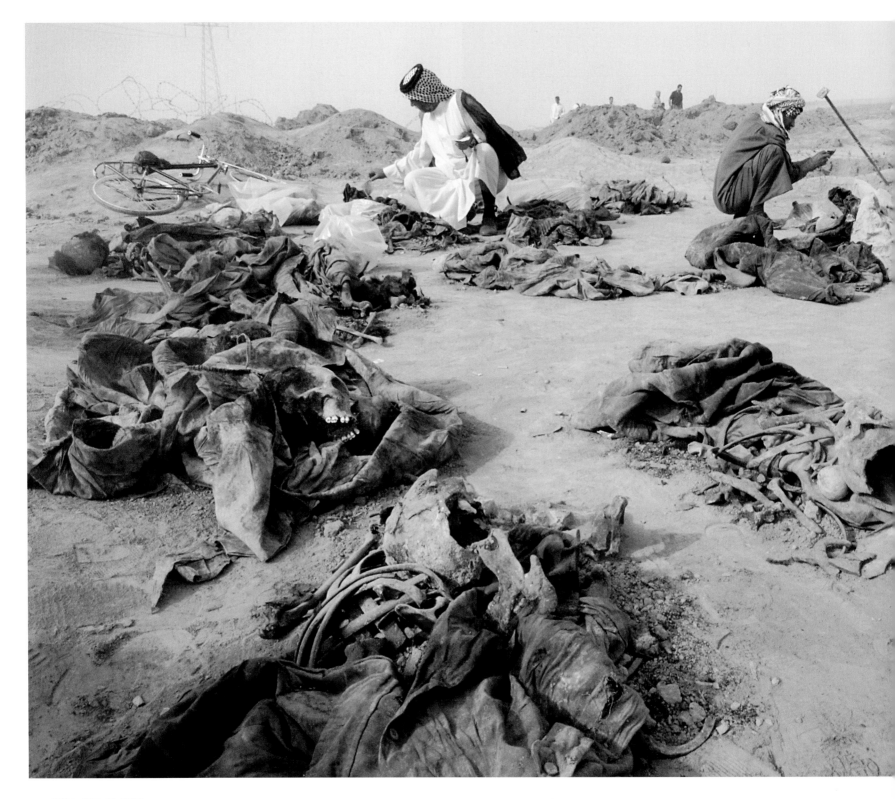

HILLA, MAY 15, 2003
Searching for friends and relatives, Iraqis sift through the remains of bodies exhumed from a newly unearthed, unmarked mass grave in Hilla, south of Baghdad. Nearly one thousand bodies were immediately identified. The men, women, and children had been secretly buried there when the regime of Saddam Hussein crushed Shiite uprisings in central and southern Iraq in 1991. Unlike the mass graves exhumed in the former Yugoslavia, which were carefully protected by NATO forces for meticulous examination, these sites were left uncontrolled, allowing important war crimes evidence to be destroyed. | TA

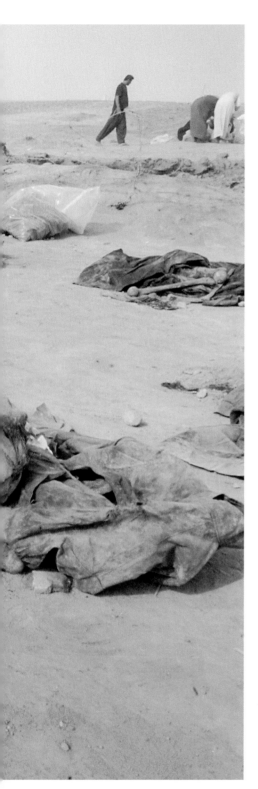

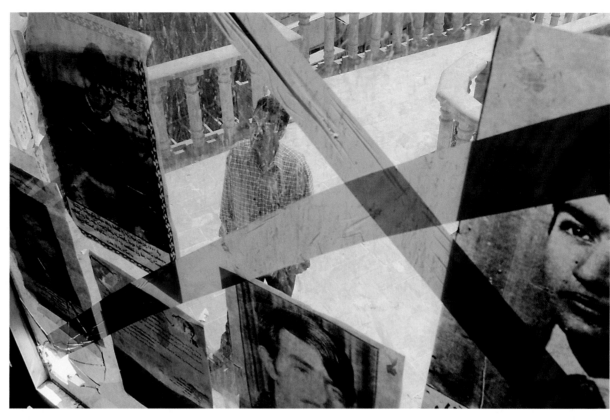

BAGHDAD, MAY 29, 2003
A man surveys posters of missing Iraqis taped to the window of the former home of Maher Mustafa Ali, a principle bodyguard for Saddam Hussein. The home was commandeered by a group called the Committee to Free the Prisoners, which collected secret records from the abandoned intelligence offices of the fallen regime to help the families of the missing obtain information from prison and death certificates. | TA

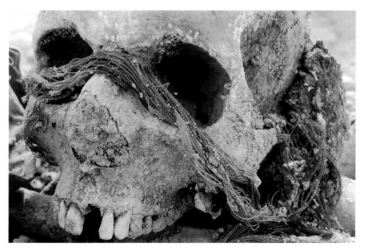

HILLA, MAY 15, 2003
A human skull, still bound in the executioner's blindfold, lies among the remains of bodies exhumed from an unmarked mass grave in Hilla, south of Baghdad. | TA

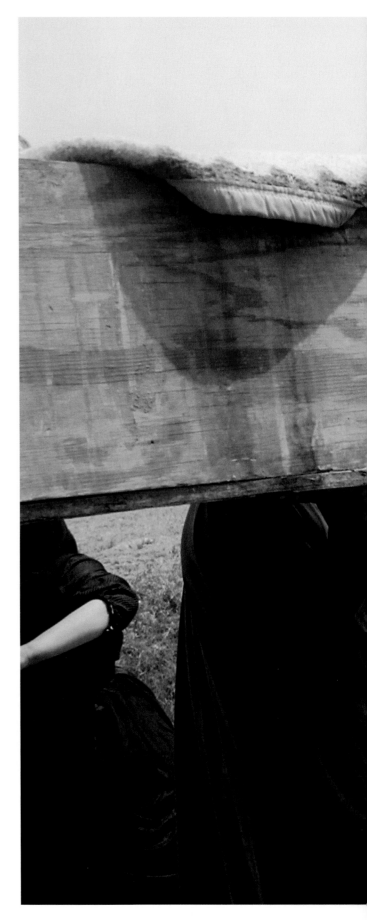

HILLA, MAY 15, 2003
Female family members wail and beat themselves in Shiite tradition as a coffin containing the remains of brothers, Naim and Fasal, is brought home for mourning. The two were killed when Saddam Hussein's regime crushed Shiite uprisings in central and southern Iraq in 1991. The men's mother, cousins, and widows searched newly uncovered mass graves for more than a week before locating the brothers' identity cards in clothing tangled in their bones. | TA

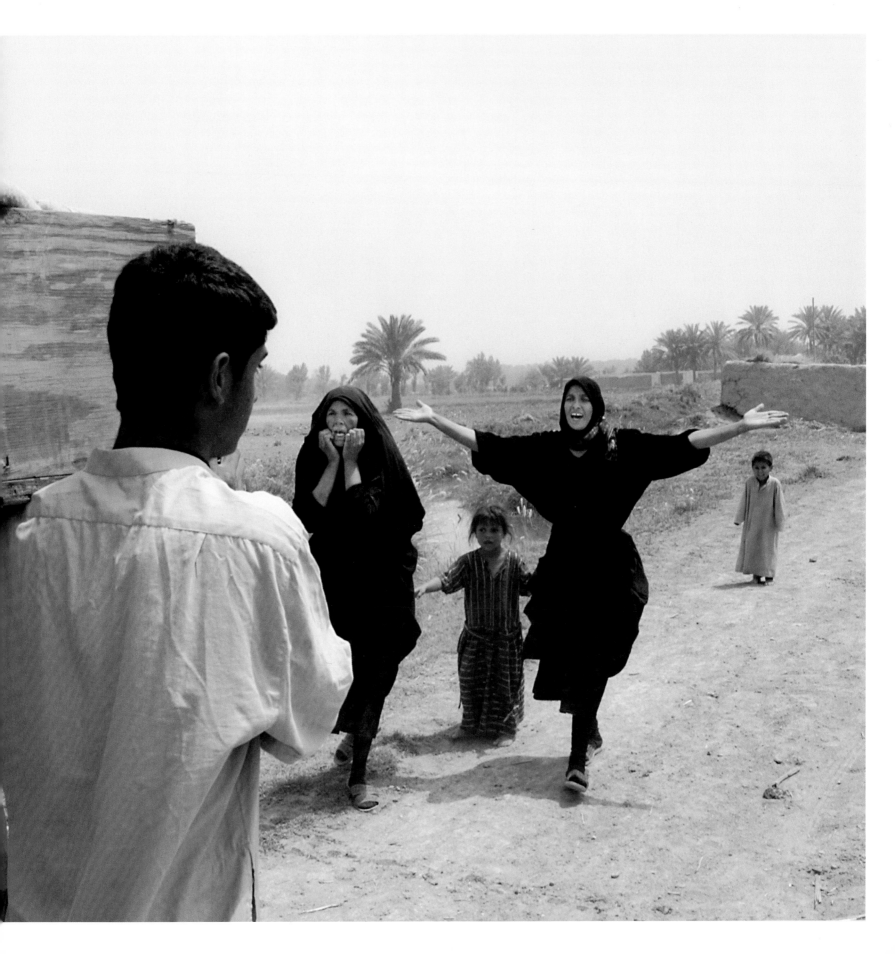

"We thought our country would be better with their help."

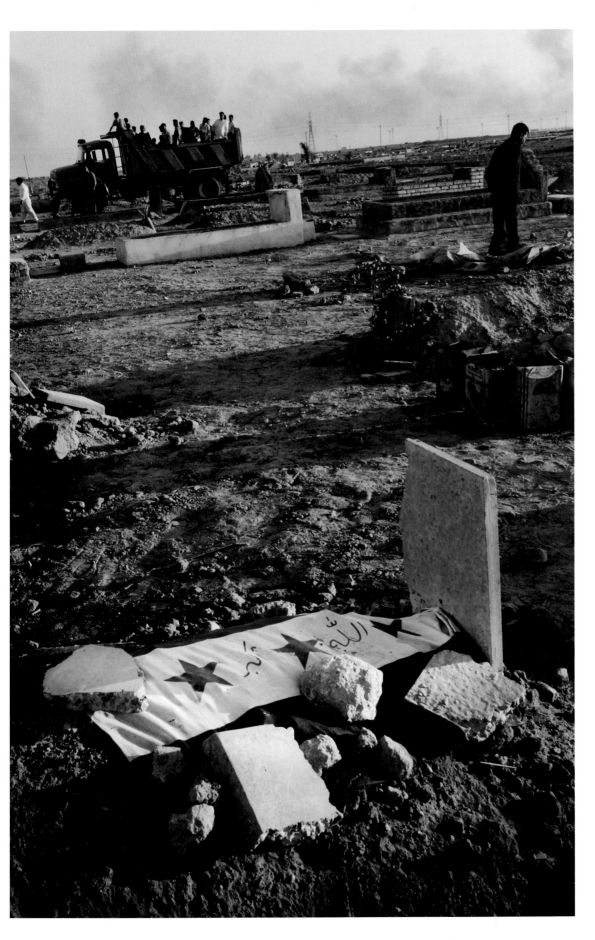

FALLUJA, APRIL 31, 2003
Mourners leave a funeral for a demonstrator killed when U.S. forces occupying a school opened fire on a crowd protesting the military use of the school building. At least fifteen people were killed and dozens more were injured. In the weeks after the incident, attacks against U.S. forces in Falluja escalated sharply, and the city became a center of resistance to the U.S. occupation. | KA

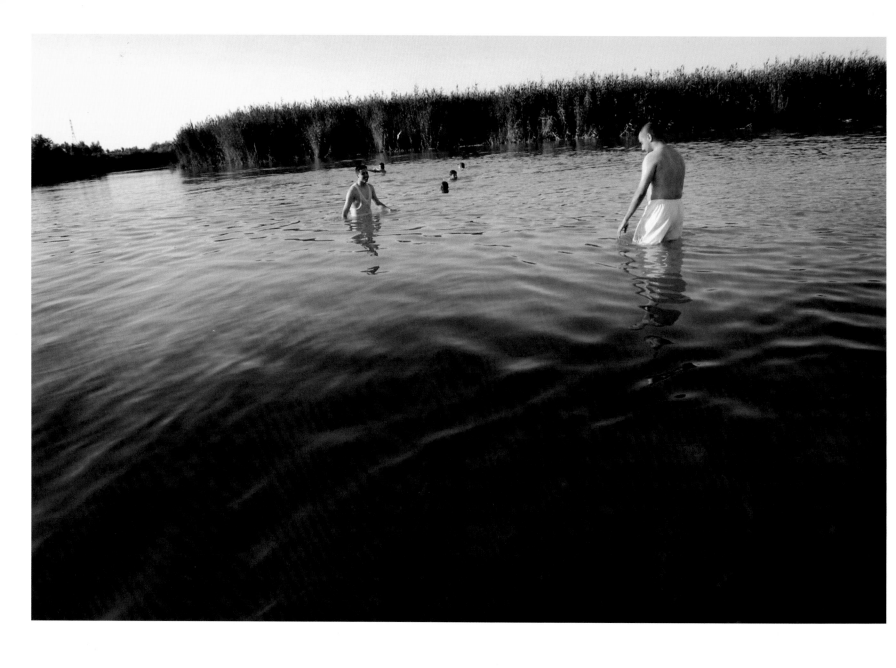

RAMADI DISTRICT, MAY 3, 2003
Boys swim in the Euphrates River. This region, which the U.S. military
calls the Sunni Triangle, is home to traditional Sunni tribes and known
for its Islamic piety. It is the epicenter of the Sunni resistance move-
ment against the U.S. occupation. | KA

RAMADI DISTRICT, MAY 3, 2003
A woman carries a tray outside for washing in a protected courtyard. Household privacy is deeply honored in traditional tribal culture, and men and women are often strictly separated, even within extended families. When U.S. troops began searching homes in this area, residents were angered by the soldiers' breech of tribal code, fanning the flames of resistance. | KA

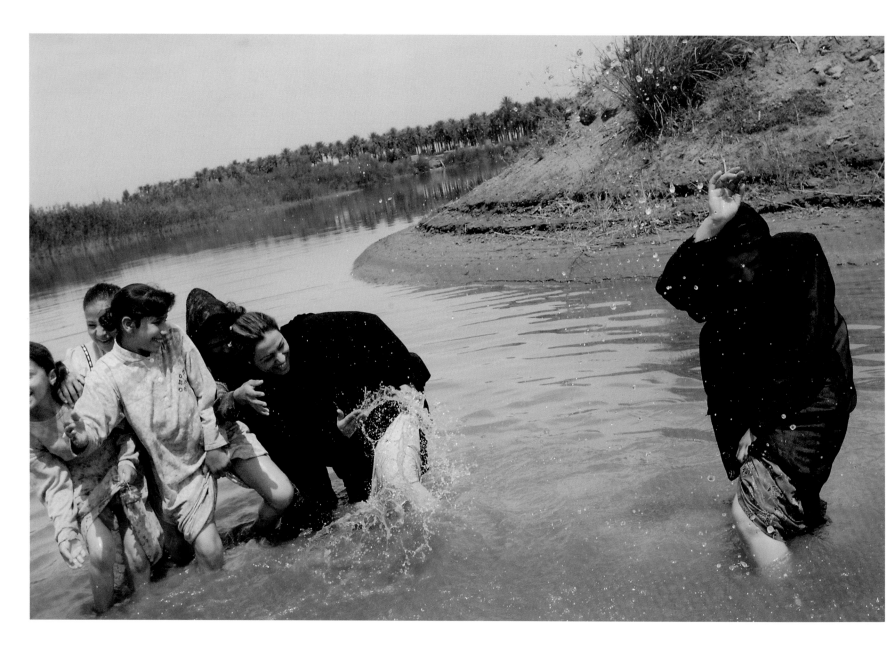

RAMADI DISTRICT, APRIL 18, 2003
Cousins outside the watchful gaze of male relatives play in the Euphrates River. | KA

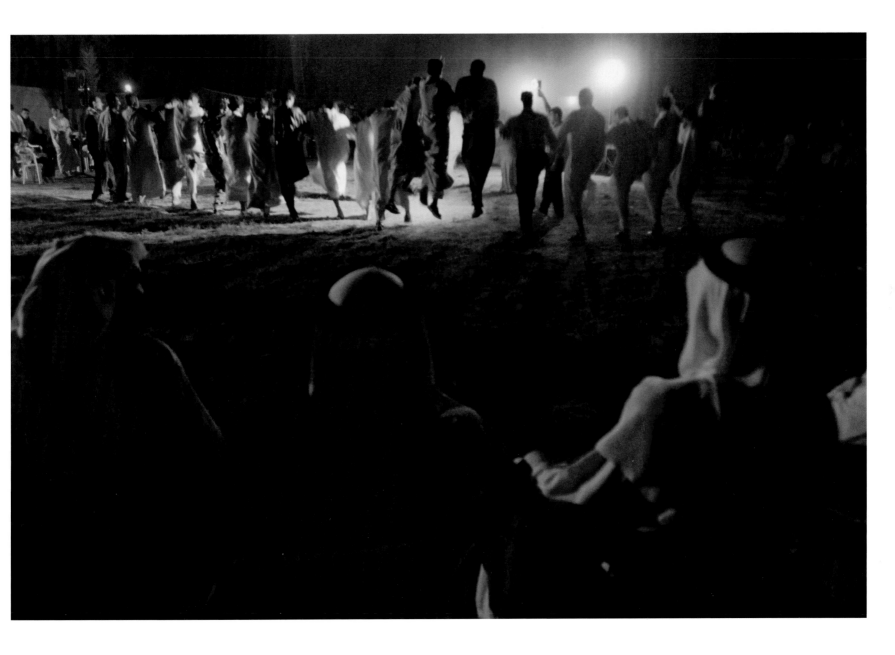

RAMADI DISTRICT, SEPTEMBER 25, 2003
Younger men leap during a wedding dance while older men watch from the
wings at a nighttime wedding celebration in the Sunni village of Deshah. | TA

FALLUJA, SEPTEMBER 26, 2003
Conversation ceases when American soldiers approach a gathering of Iraqi men
taking shelter from the heat in the shade outside their homes alongside the
Falluja-Baghdad highway. The highway has been the scene of numerous guerrilla
attacks on American soldiers. With tensions running high in this Sunni Triangle
town, locals attempt to maintain a cautious distance from American troops. | TA

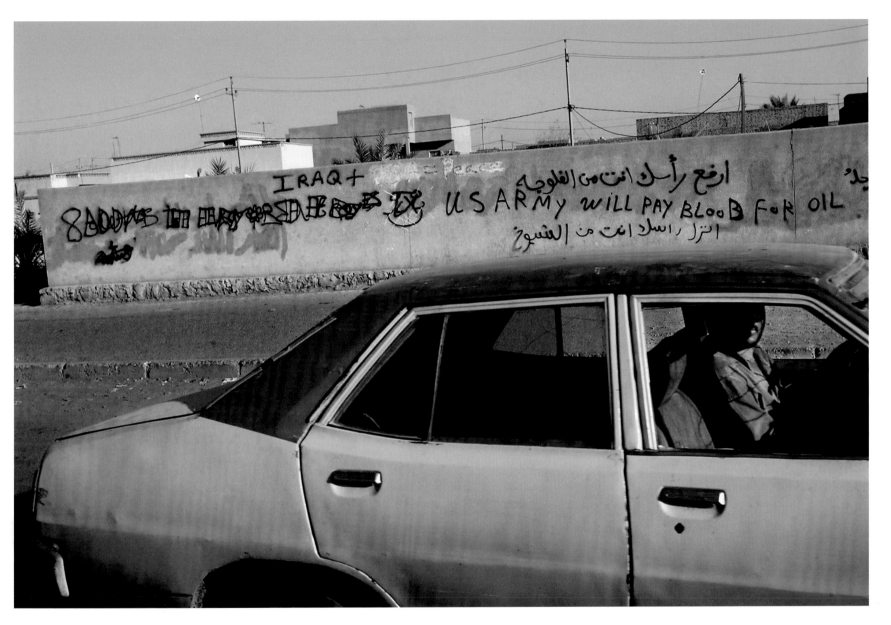

FALLUJA, SEPTEMBER 18, 2003
A wall of graffiti on the outskirts of Falluja reflects
growing anger toward U.S. occupation. | KA

You know we were all very happy when the Americans came; we
thought our country would be better with their help, but Allah the
Mighty wasn't pleased," said the mayor of Falluja. "The Americans
started making mistakes. . . ."

| Ghaith Abdul-Ahad, Falluja, June 2004

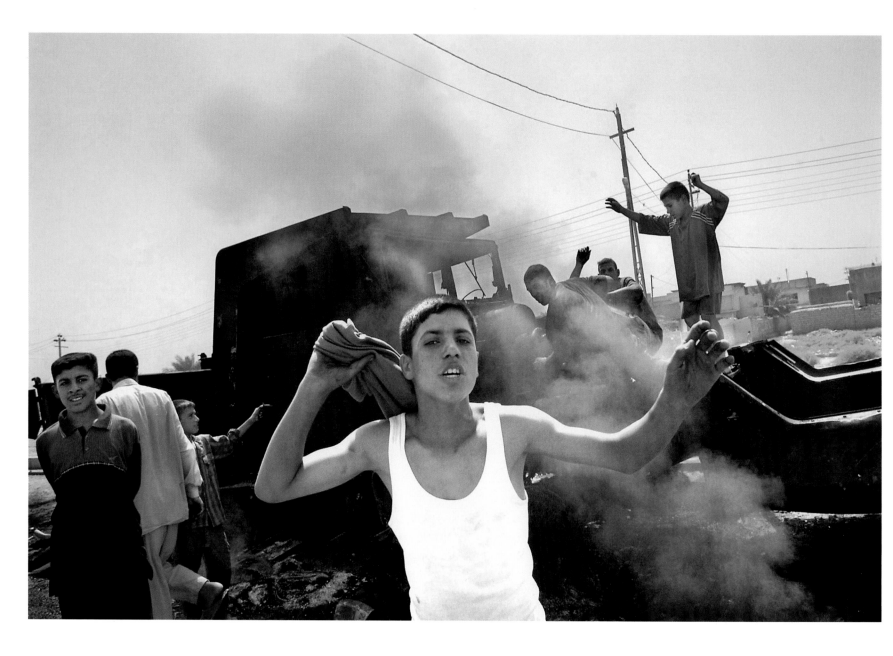

ROAD FROM BAGHDAD TO FALLUJA, SEPTEMBER 12, 2003
Boys and young men celebrate at the site of an attack by insurgents against
a U.S. military convoy. | KA

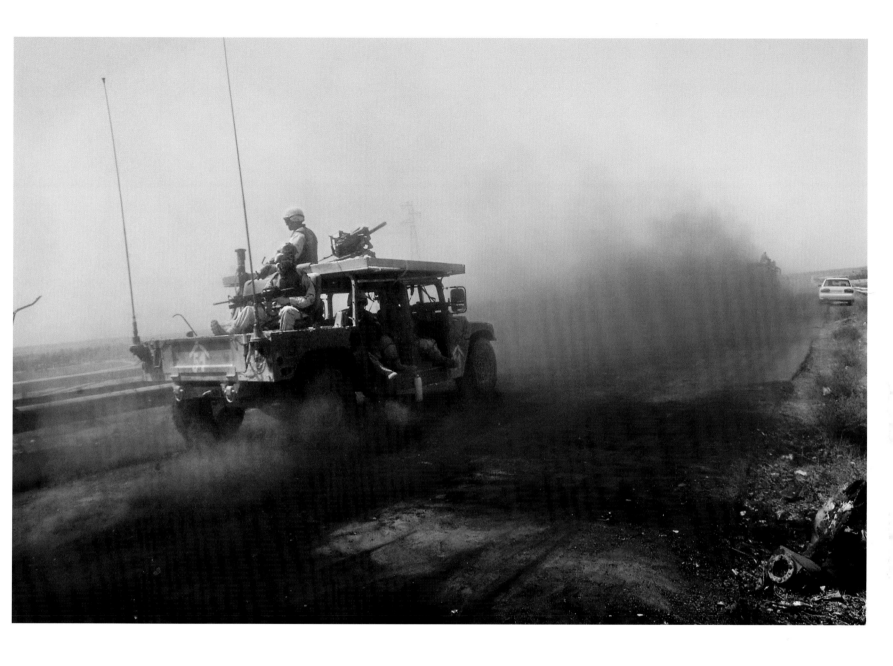

ROAD FROM BAGHDAD TO FALLUJA, SEPTEMBER 12, 2003
A U.S. jeep drives past the site of an earlier attack by Iraqi resistance fighters
on a U.S. convoy. This road became known as the highway of death because of
the frequency of insurgent attacks. | KA

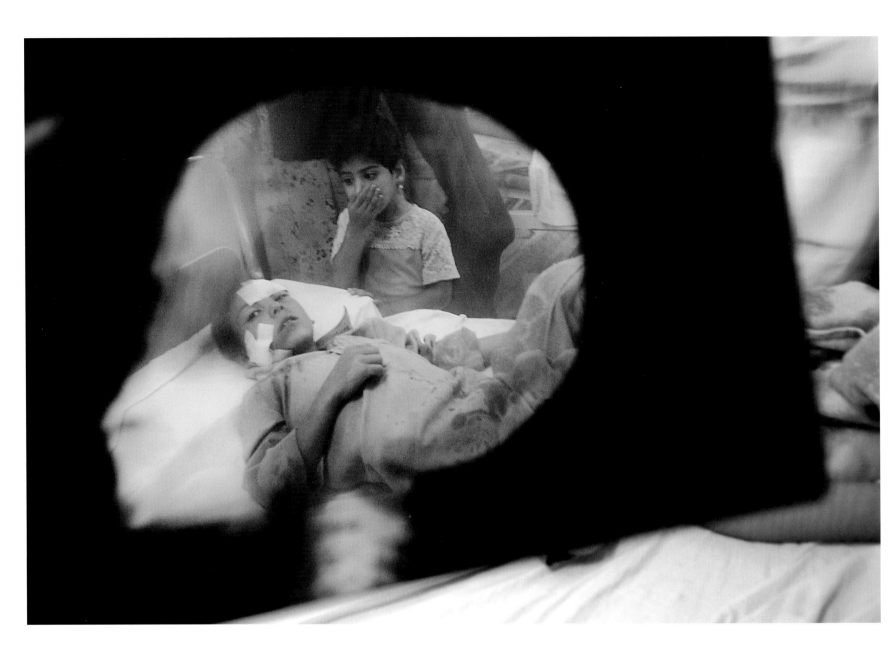

FALLUJA, SEPTEMBER 23, 2003

A doctor in the Falluja Hospital raises an X ray to point out head injuries to nine-year-old Hussein, whose home in the village of Sheker was attacked with American air strikes. His twelve-year-old brother was also seriously injured in the attack and three other members of his family were killed. A U.S. Army spokesperson did not acknowledge any mistakes and said that one "enemy fighter" was killed in the air strike. | TA

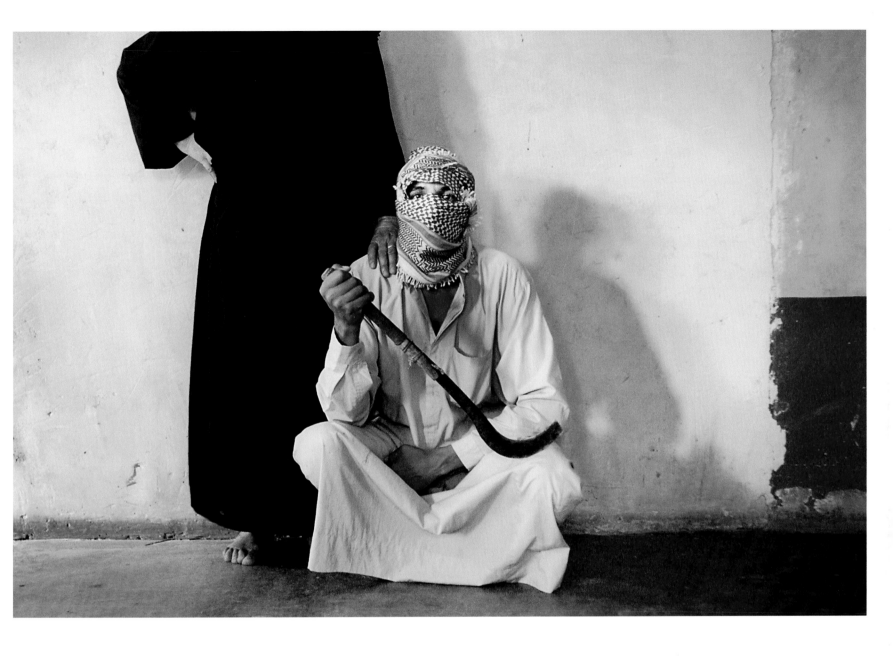

BALAD, OCTOBER 17, 2003

A Sunni guerrilla fighter using the name Jaber Said poses with his mother and a scythe used by date farmers. For two months he had been staging hit-and-run attacks on foreign occupation forces in the Balad area. "Our mothers are not afraid for us," he said. "When we join the resistance they encourage us in our attacks." | TA

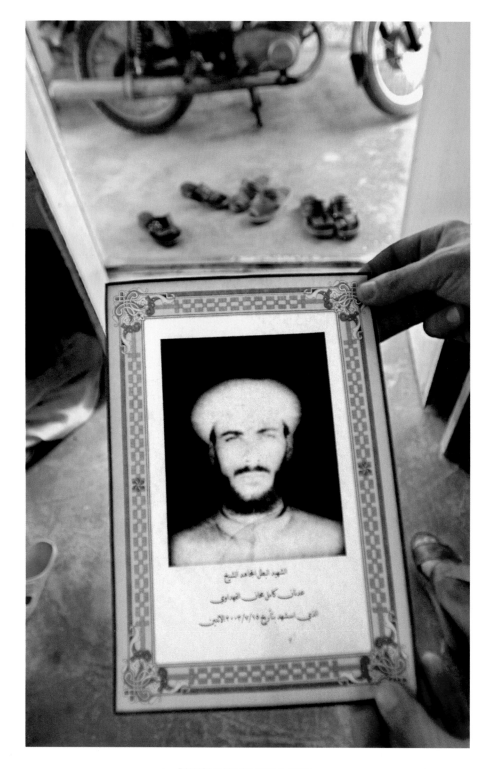

RAMADI DISTRICT, MAY 9, 2003

A resistance fighter displays the death announcement of a man who died during an attack on a U.S. military base outside of Ramadi. The man left a message behind asking his family not to mourn his death at the hands of the Americans but to celebrate his martyrdom and heavenly reward. He was among the first Iraqi resistance fighters to be killed in the area. | KA

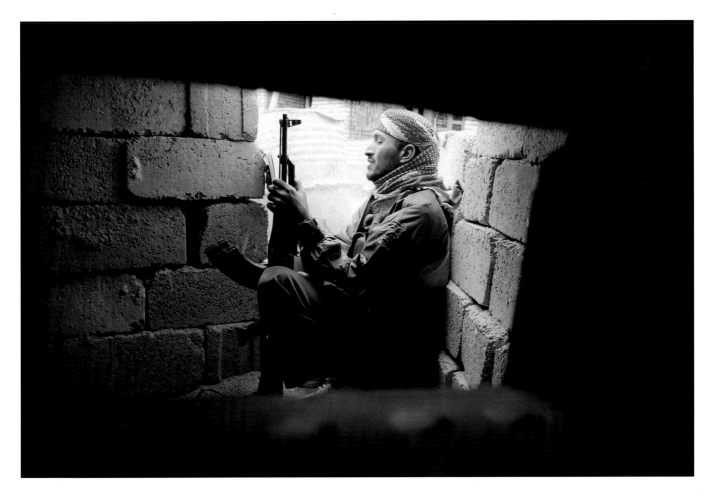

FALLUJA, NOVEMBER 7, 2004
An Arab foreign fighter sits in his bunker and reads the Koran as U.S. planes bomb Falluja.
The mujahideen, or holy warriors, battled for control of the city in fighting that left Falluja
in ruins and displaced more than 200,000 residents. | GA

With Kalashnikovs in their laps and copies of the Koran in their hands, they stared at us suspiciously.

The silence was punctuated by the sound of mortar shelling. With each explosion, the fighters would cry, "Allahu Akbar."

Eventually, the mujahideen started talking: "Who are you?" "What do you do?"

But mostly they were interested in converting us to Islam. They were still describing the pains I would go through in hell when another fighter, a short, thin teenager, appeared. He was still dressed in his white pajamas and he rubbed his eyes as he listened to the conversation.

"What are you doing?" he asked one of the fighters.

"We are preaching to them about Islam," said the fighter.

"Why? They are not Muslims?"

"No."

The young man looked with puzzlement at the other fighter and said, "But then, why don't we kill them?"

"We can't do that now. They are in a state of truce with us," the fighter said.

| Ghaith Abdul-Ahad, Falluja, November 2004

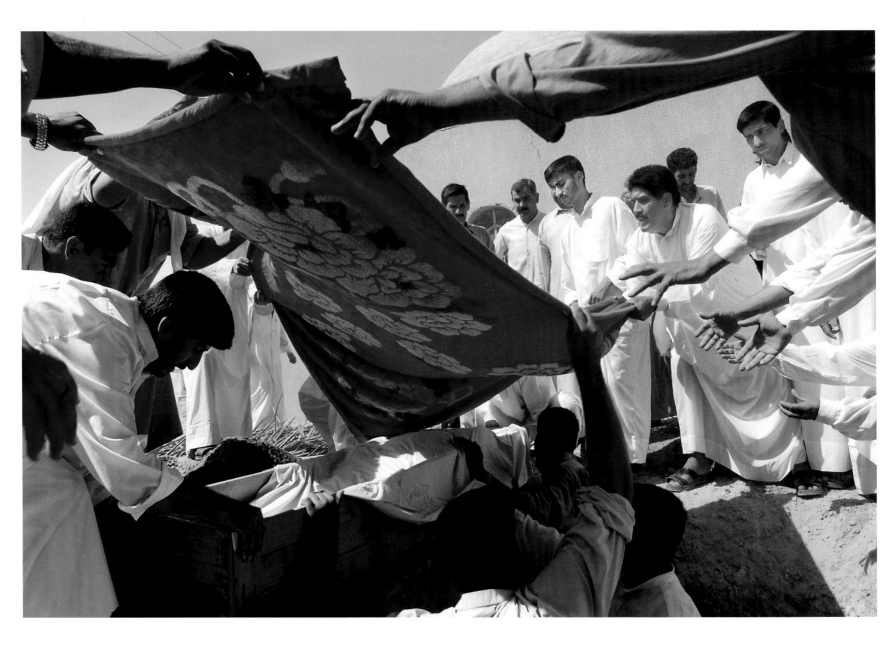

FALLUJA, SEPTEMBER 27, 2003
Mourners prepare to lower the body of Sheikha Beijiya into her grave. The elderly
woman was killed—along with her daughter, son-in-law, and one-year-old grandson—
by American soldiers who say they opened fire on the family's car when it failed to
stop at a temporary checkpoint on the road from Falluja to Baghdad. | TA

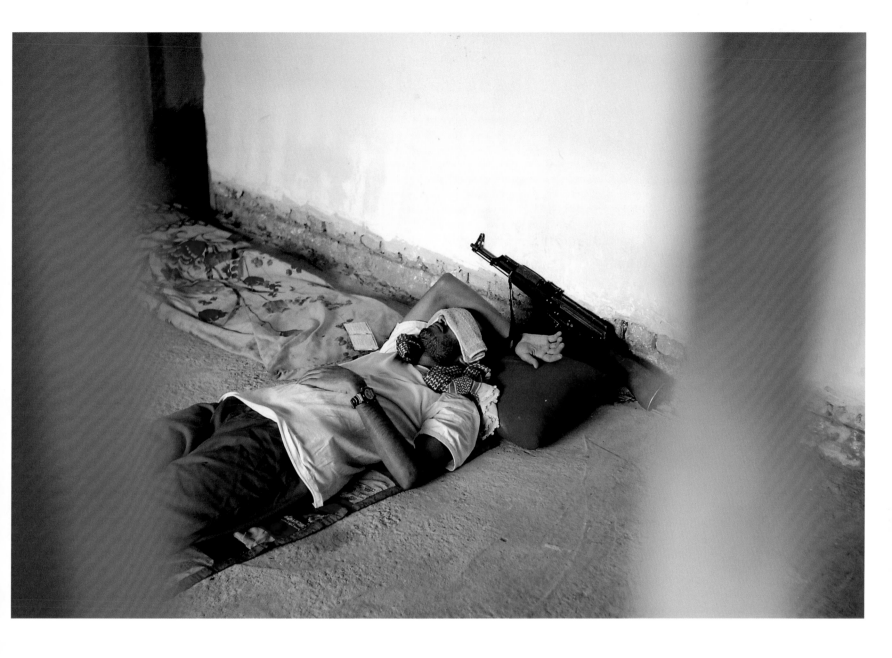

FALLUJA, NOVEMBER 7, 2004
An Arab foreign fighter rests after a night of heavy bombing by U.S. forces. | GA

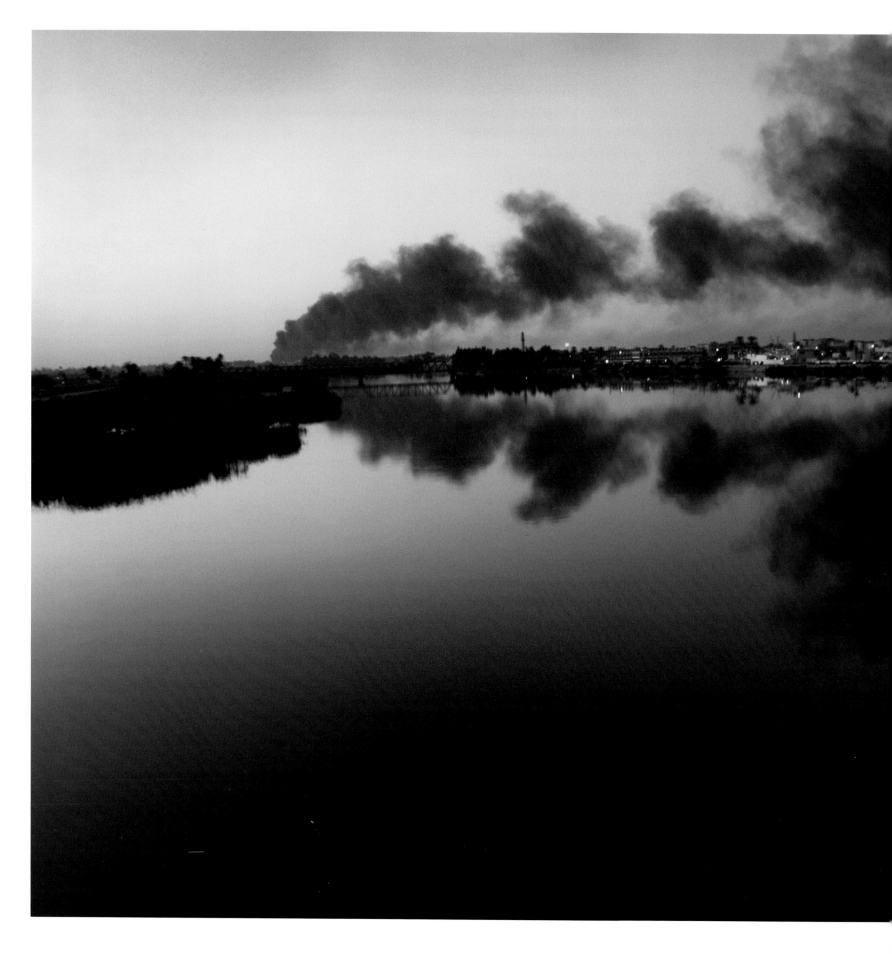

FALLUJA, APRIL 30, 2003
Smoke from burning oil trenches drifts over the Euphrates River. Shortly after the U.S.-led invasion, oil pipelines and infrastructure became targets of sabotage by Iraqi resistance fighters. Iraqi oil production continues to flow at rates lower than those prior to the invasion. | KA

In thinking about my life in Iraq over the past three years, two days stand out for me.

Almost two and half years ago I stood in a big square in central Baghdad with dozens of other Iraqis as thick black smoke covered the horizon. We watched with bemusement those muddy strangers with tired faces and big guns, emerging from their massive armored vehicles, as they tied a chain around the gigantic neck of a bronze Saddam statue. Surrounded by scores of photographers, cameramen, and reporters, watching history being made in front of my eyes, I remember trying very hard to record every single detail by heart, as I had no film in the camera I had borrowed that morning.

All my film and cameras had been confiscated a few days earlier by a bunch of republican guards who believed I was a spy. They would have shot me if not for a good-hearted officer who wanted my cameras for himself and in exchange gave me my life.

I was thrilled the day the Americans arrived in the square. I had spent the previous six years dodging military service, spending much of my time walking in the alleyways of Baghdad taking quick snapshots of streets and buildings. I didn't want to sit and be one of the people in the news; I wanted to record history.

The next day I lied my way through American checkpoints—claiming that I was a British journalist who had lost his credentials—and walked for two hours to go Saddam's palace where I took my first "freedom" pictures.

One thin Sunday morning in Baghdad last September my phone rang: "Big pile of smoke over Haifa Street." Still half asleep, I put on my jeans, cursing those insurgents who do their stuff in the early morning. *What if I just go back to bed?* I thought, knowing that by the time I got there it would probably be over. Indeed, on the way to Haifa Street I was half praying that everything would be over or that the Americans would seal off the area. I hadn't recovered from Najaf yet.

When I arrived there I saw hundreds of kids and young men heading toward the smoke. "Run fast, it's been burning for a long time!" someone shouted as I clutched my cameras and started to run. Then there were two big explosions and people started running toward me in waves. Seconds later, I heard people screaming and shouting and I headed toward the sounds, still crouching behind a wall. Two newswire photographers were running in the opposite direction and we exchanged eye contact.

About seventy-five feet ahead of me, I could see the American Bradley Fighting Vehicle, a huge monster with fire rising from within. It stood alone, its doors open, burning. I stopped, took a couple of photos, and crossed the street toward a bunch of people. Some were lying in the street, others stood around them. American helicopters were out of sight, buzzing some distance away.

I felt uneasy and exposed in the middle of the street, but lots of civilians were around me. A dozen men formed a circle around five injured people, all of whom were screaming and wailing. One guy looked at one of the injured men and beat his head and chest: "Is that you, my brother? Is that you?" He didn't try to reach for him—he just stood there looking at the bloodied face of his brother.

A man sat alone covered with blood and looked around, amazed at the scene. His T-shirt was torn and blood ran from his back.

I had been standing there taking pictures for two or three minutes when we heard the helicopters coming back. Everyone started running, and I didn't look back to see what was happening to the injured men. We were all rushing towards the same place: a fence, a block of buildings, and a prefab concrete cube used as a cigarette stall.

I had just reached the corner of the cube when I heard two explosions. I felt hot air blast my face and something burning on my head. I crawled behind the cigarette stall. Six of us were squeezed into a space less than seven feet wide. Blood started dripping on my camera and all that I could think about was how to keep the lens clean. A man in his forties next to me was crying. He wasn't injured, he was just crying. I was so scared I just wanted to squeeze myself against the wall. The helicopters wheeled overhead, and I realized that they were firing directly at us. I wanted to be invisible, I wanted to hide under the others.

Nearby I noticed a young man, maybe in his early twenties, who was wearing a pair of leather boots and a tracksuit. He was sitting on the ground, his legs stretched in front of him but with his knee joint bent outward unnaturally. Blood ran onto the dirt beneath him as he peered around the corner. I started taking pictures of him. He looked at me and turned his head back toward the street as if he were looking for something. His eyes were wide open and kept looking.

There in the street, the injured were all left alone: a young man with

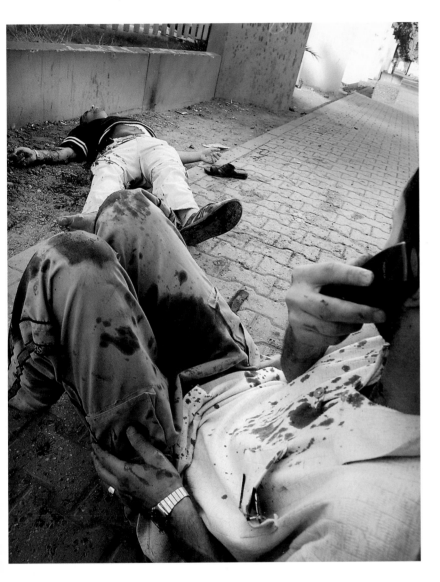

BAGHDAD, SEPTEMBER 12, 2004
An injured Iraqi civilian calls for an ambulance during fighting in Haifa Street. Twenty-two Iraqi civilians were killed and forty-eight injured when U.S. helicopters opened fire at crowds celebrating around a burning U.S. armored personnel carrier. | GA

One of the three men piled together raised his head and looked around the empty streets in astonishment. He then turned to the boy in front of him, then back to the horizon again. I watched as he lowered his head to the ground, rested his head on his arms, and stretched his hands toward something that he could see. It was the guy who had been beating his chest earlier, trying to help his brother. He was there dying in front of me. Time didn't exist. The streets were empty and silent and the men lay there dying together. He slid down to the ground, and after five minutes was flat on the street.

I moved, crouching, toward where they looked like sleeping men with their arms wrapped around each other in the middle of the empty street. I moved closer to photograph the boy with the *dishdasha. He's just sleeping*, I kept telling myself. I didn't want to wake him. The boy with a severed leg was there too, left there by the people who were pulling him earlier. The vehicle was still burning.

Someone shouted, "Helicopters!" and we ran. I turned and saw two small black helicopters in the sky. Frightened, I ran back to my shelter just as two more big explosions shattered the stillness. *They're firing at us*, I told myself.

The man with the bent knee was unconscious now, his face flat on the curb.

We left the kids behind to die there alone. I didn't even try to move any with me. I ran into the entrance of a building and someone grabbed my arm and took me inside. "There's an injured man. Take pictures. Show the world the American democracy," he said. A man was lying in the corridor in total darkness as someone bandaged him.

In time, an ambulance came. I ran to the street as others emerged from their hiding places, all trying to carry injured civilians to the ambulance.

"No, this one is dead," said the driver. "Get someone else."

All the people I had shared my shelter with were dead. Every time I look at these pictures I tell myself I have killed those people. I should have helped them instead of taking pictures. |

blood all over his face sat in the middle of the cloud of dust, then fell onto his face.

I was scared; I wanted to do something, but I couldn't. I tried to remember the first-aid training I had had in the past, but I just kept taking pictures, unthinking, automatically.

I turned back to the man with the twisted knee. His head was on the curb now, his eyes were open, and he kept making a faint sound. I started talking to him, saying, "Don't worry, you'll be OK, you'll be fine." From behind him I looked at the middle of the street, where five injured men were still lying. Three of them were piled almost on top of each other; a boy wearing a white *dishdasha* lay some feet away.

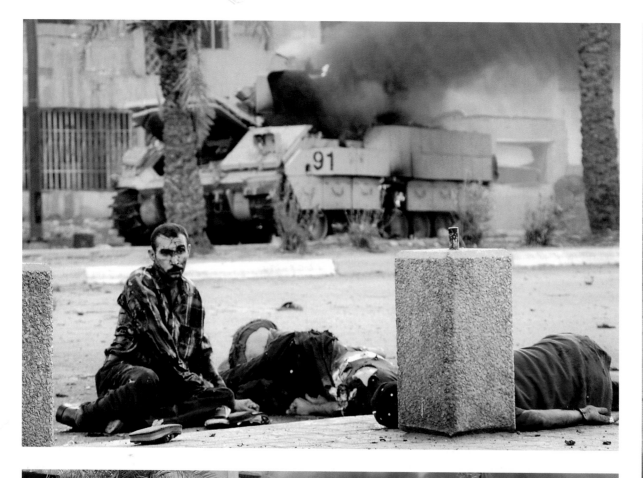

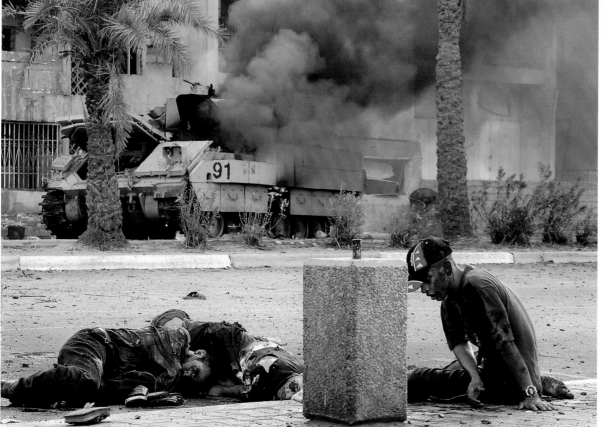

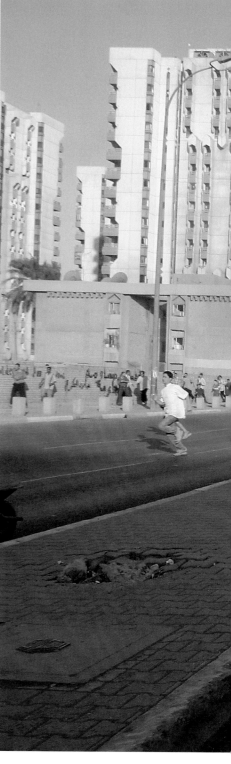

BAGHDAD, SEPTEMBER 12, 2004
Iraqi civilians are left injured and dying after U.S. helicopters opened fire on a crowd in Haifa Street. | GA

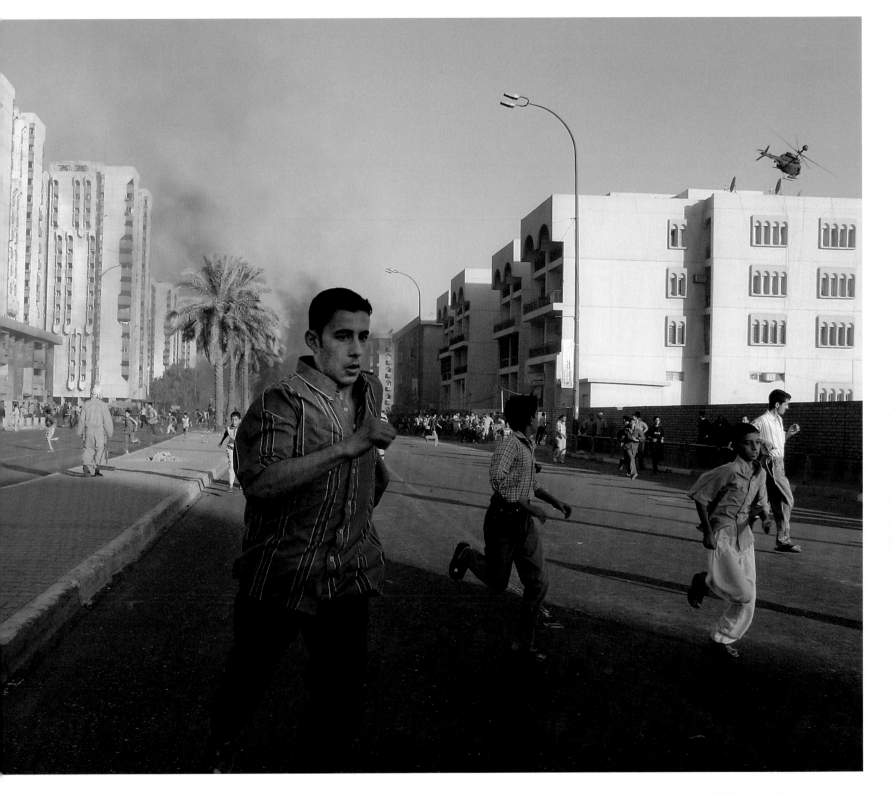

BAGHDAD, SEPTEMBER 12, 2004
Civilians flee as U.S. helicopters attack Haifa Street. | GA

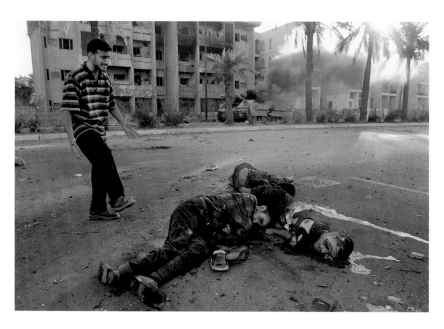

BAGHDAD, SEPTEMBER 12, 2004
A distraught man approaches civilians killed by U.S.
helicopters on Haifa Street. | GA

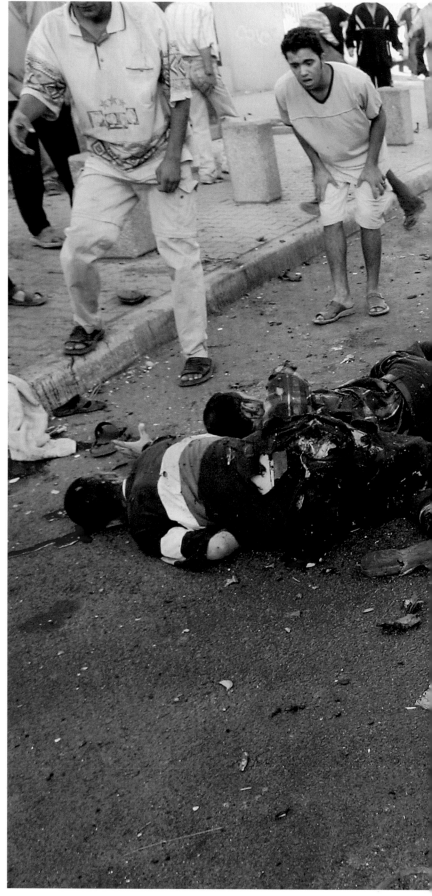

BAGHDAD, SEPTEMBER 12, 2004
Injured civilians are carried from Haifa
Street during attacks by U.S. helicopters. | GA

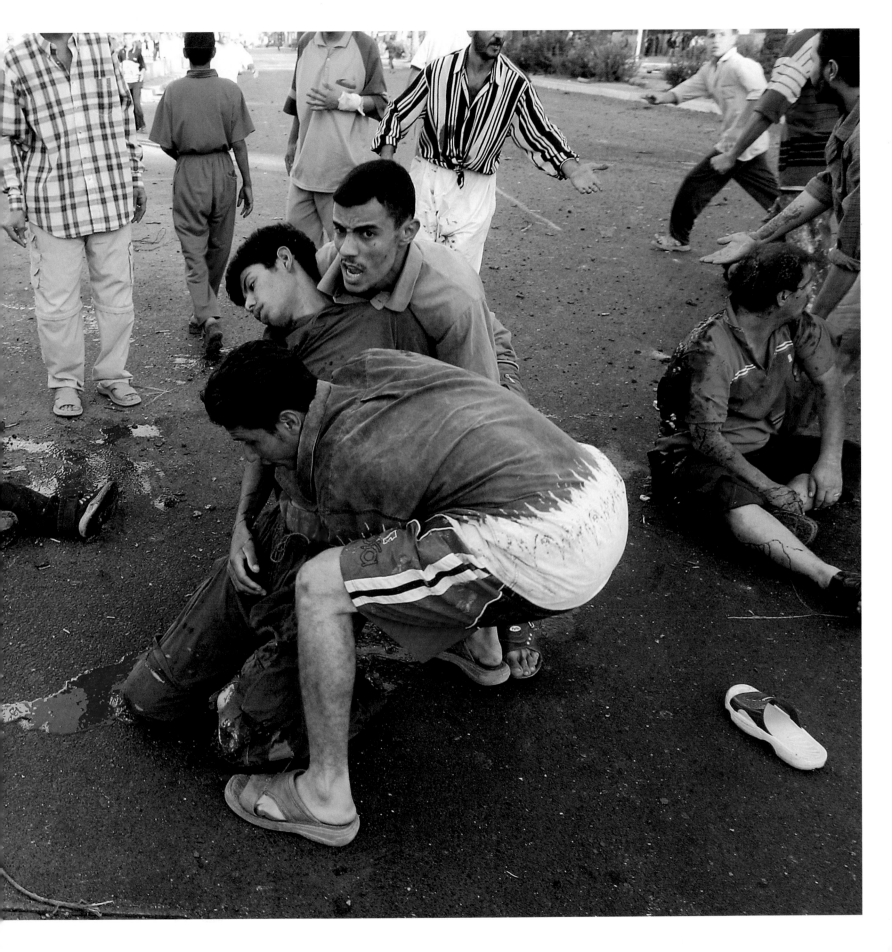

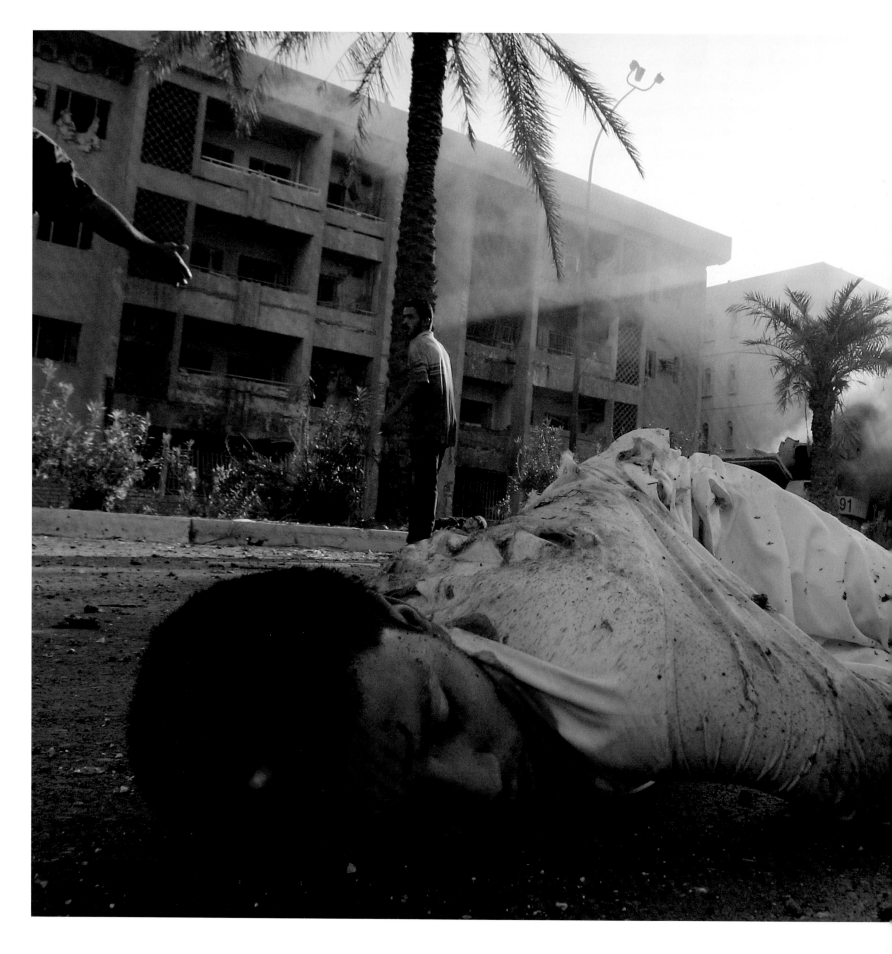

BAGHDAD, SEPTEMBER 12, 2004
A young Iraqi civilian lies dead in Haifa Street as a U.S. armored personnel carrier burns in the background. Twenty-two Iraqi civilians were killed and forty-eight injured when U.S. helicopters opened fire on crowds celebrating around the burning vehicle, which was disabled by an insurgent attack. No American soldiers were killed in the fighting. | GA

"Sometimes one finds strength,
 like a drowning person."

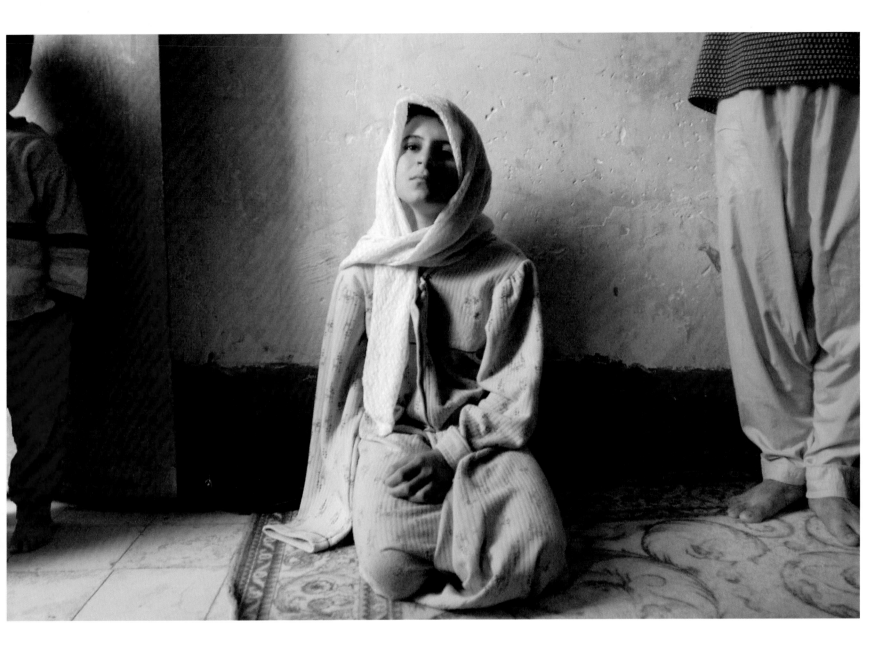

ABU FALOOS, FEBRUARY 2, 2003
Twelve-year-old Isra lost her right arm when her village, Abu Faloos, was hit with an American bomb during an attack in the "no-fly zone" in southern Iraq in 1999. Five other children were injured and four were killed. The United States bombed Iraq regularly over a twelve-year period, in part to "soften up" Iraqi air defenses in preparation for the 2003 invasion. | TA

Some days later I meet Leyla alone at the small house where she lives with her mother and brother. Her father was killed during the Iran-Iraq war. The tiny living room is plastered with pictures of Muqtada al-Sadr. Leyla, unlike most young women I have met, is ambivalent about marriage.

"I am a fighter and I will only marry if my husband agrees with that," she tells me. I ask her if she knows how to use a gun and she says yes, but not very well.

"So how will you fight?" I ask.

"I can strap explosives to myself and be a suicide bomber."

| Kael Alford, Baghdad, September 2004

BAGHDAD, SEPTEMBER 3, 2004
Leyla, twenty, adjusts her *abaya* in the mirror. Leyla is a supporter of Muqtada al-Sadr's Mahdi Army. She helped to feed fighters during the uprisings against the U.S. occupation. She lives in a two-room house with her mother and brother, supported by income from her younger brother's construction job. | KA

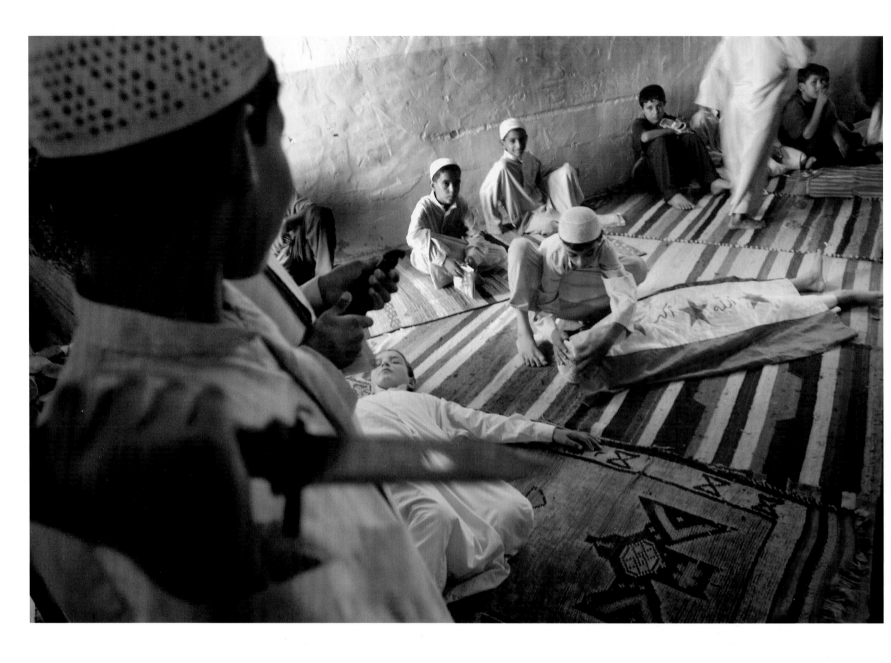

SADR CITY, BAGHDAD, JULY 30, 2004
Children at a *husseiniya*, a center for religious learning, perform a reenactment of
a battle between U.S. soldiers and the Mahdi Army. In this scene they carry away the
body of a fallen martyr, a young boy who was the first casualty of the fighting. | KA

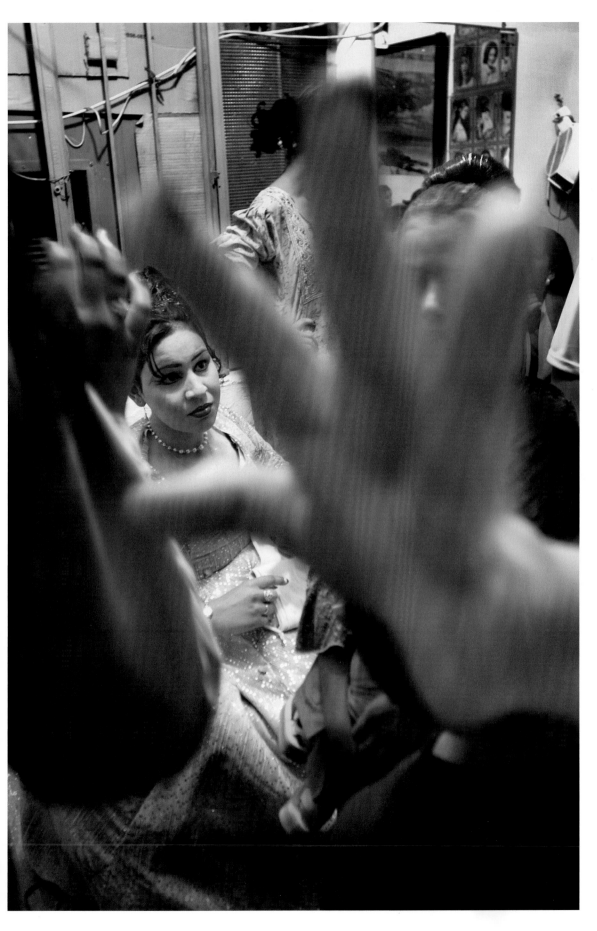

SADR CITY, BAGHDAD, JULY 22, 2004
A young woman protects the modesty of her friend, who is preparing for her wedding. Some women are afraid that appearing in photographs will anger their conservative families or bring them bad reputations. At a conservative wedding, the bride is seen only by her husband and close relatives, not by other guests. | KA

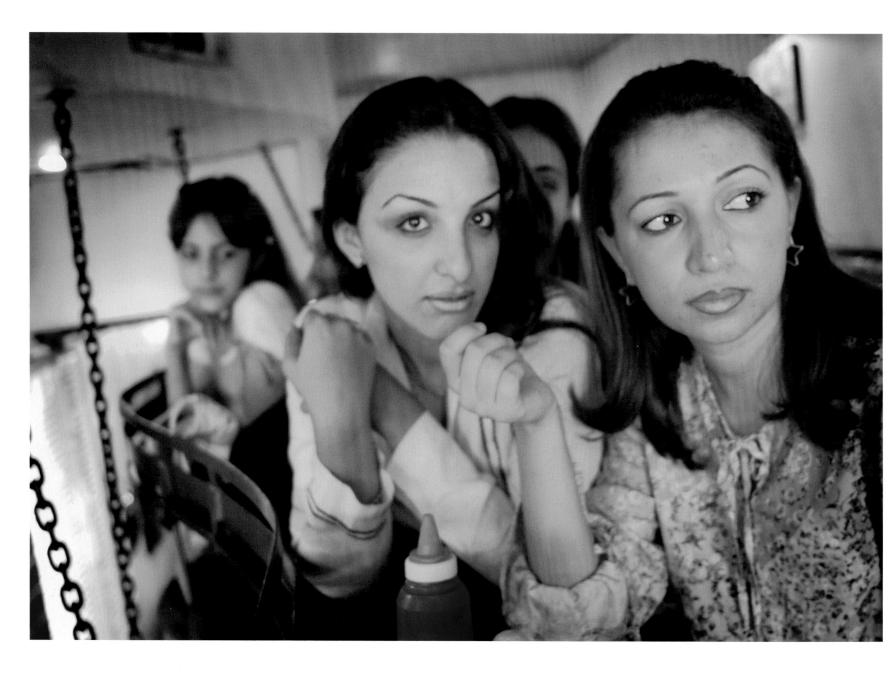

BAGHDAD, SEPTEMBER 5, 2004
University students gather at a restaurant popular among young, middle-class Baghdadis. Women are far less active and spend more time at home than they did before the war due to the deteriorated security situation in Baghdad. Kidnapping for ransom has been common since the invasion. | KA

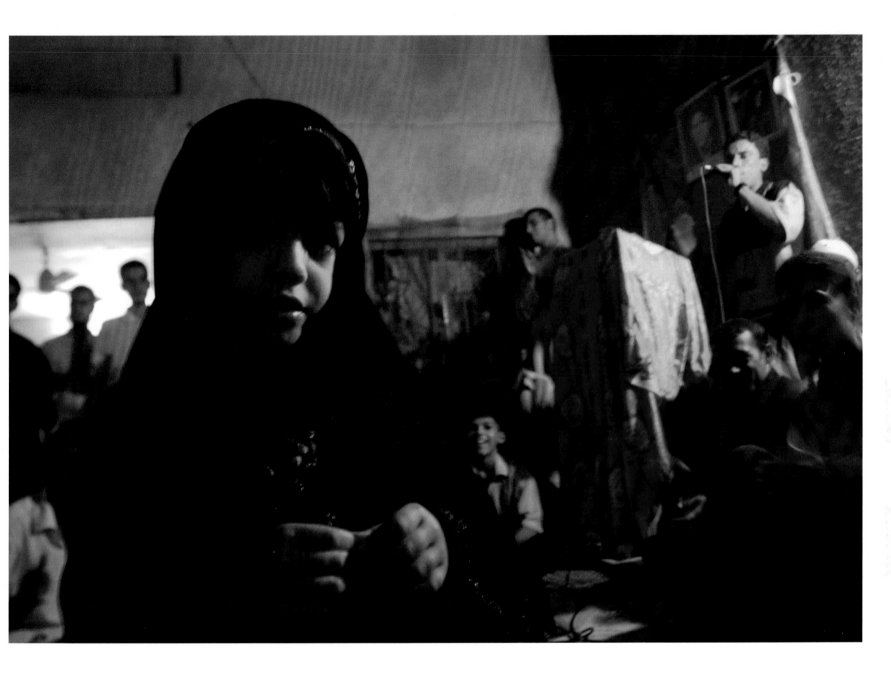

SADR CITY, BAGHDAD, JULY 23, 2004
The four-year-old daughter of a martyred Mahdi Army fighter is dressed conservatively in keeping with the style of Muqtada al-Sadr's followers. The group sings religious songs and battle cries at a rally against the U.S. occupation. | KA

The Rashad Psychiatric Hospital lies on the outskirts of Sadr City, a sprawling slum of two million in east Baghdad, frequently racked with fierce fighting. Inside Rashad, against this backdrop of ongoing conflict, live nine hundred patients, three hundred of them women. Most are diagnosed with schizophrenia. According to Dr. Sultan, Chief of the Ibn Omran Women's Ward, 80 percent of his patients, given reliable medication and outpatient support, could function in society. These criteria are unlikely to emerge anytime soon in war-torn Iraq. Moreover, there are cultural obstacles. "If mental illness is a stigma elsewhere in the world, in Iraq it is a hundred times worse, two hundred times worse," said Dr. Sultan, "and the mentally ill often become scapegoats of family disputes." There is a fear among many Iraqis, the doctor told me, that if one daughter has a mental disorder the family won't be able to marry off any of their other daughters. So they are sent to Rashad, cast away from society by their families, who will often provide false addresses so hospital staff can never find them again. Some mentally healthy women find refuge at the hospital from beatings and honor killings, a traditional code that has resurfaced in the instability of postwar Iraq. Most of the women have no choice but to live at the hospital for the remainder of their lives.

| Rita Leistner, Baghdad, September 2004

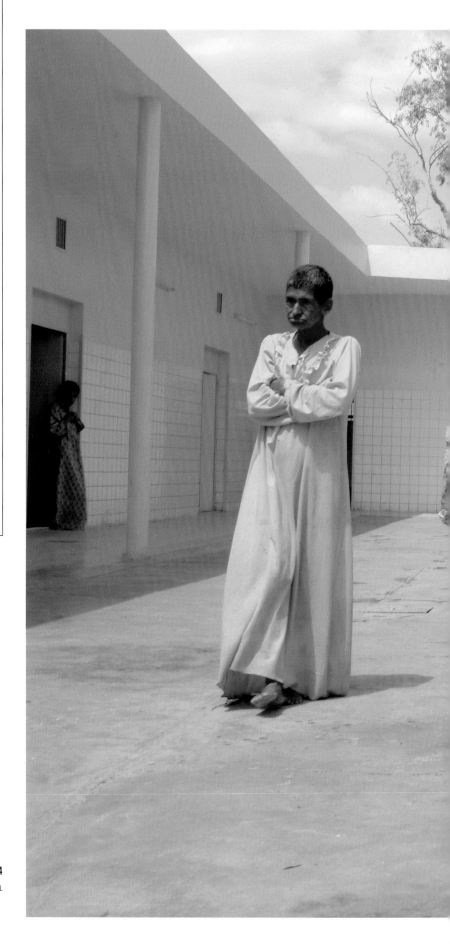

RASHAD PSYCHIATRIC HOSPITAL, BAGHDAD, APRIL 17, 2004
Female patients pace the courtyard in the Zenab Women's Ward. | RL

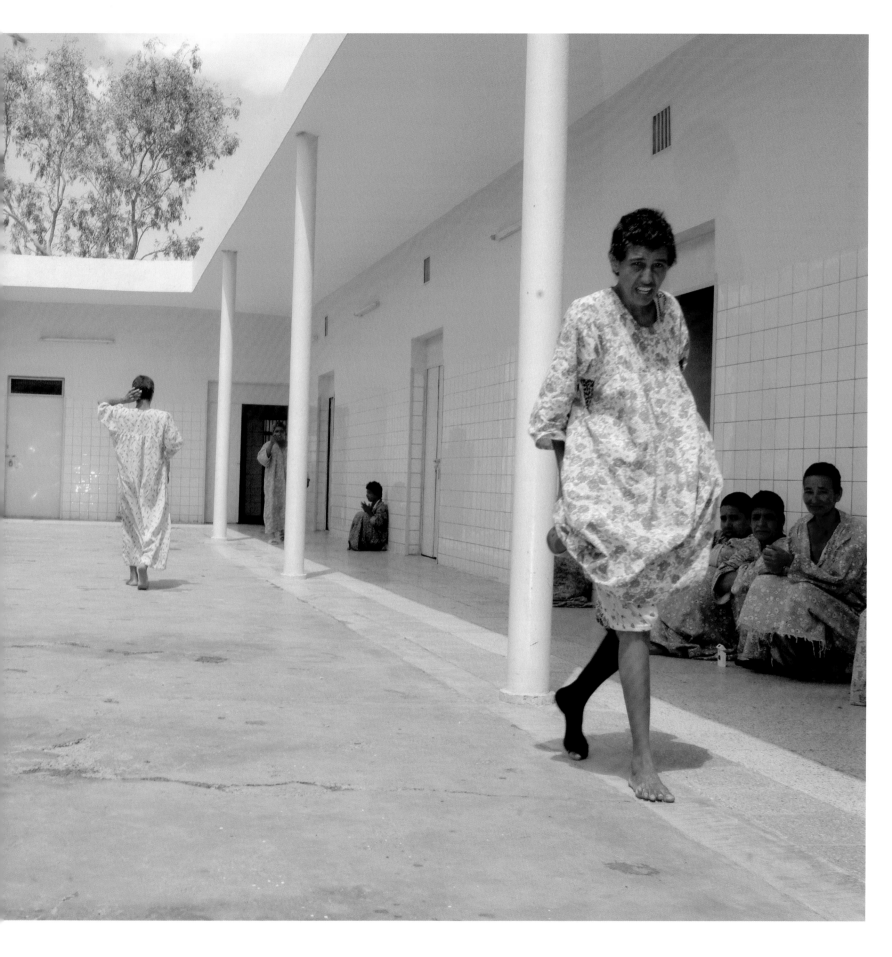

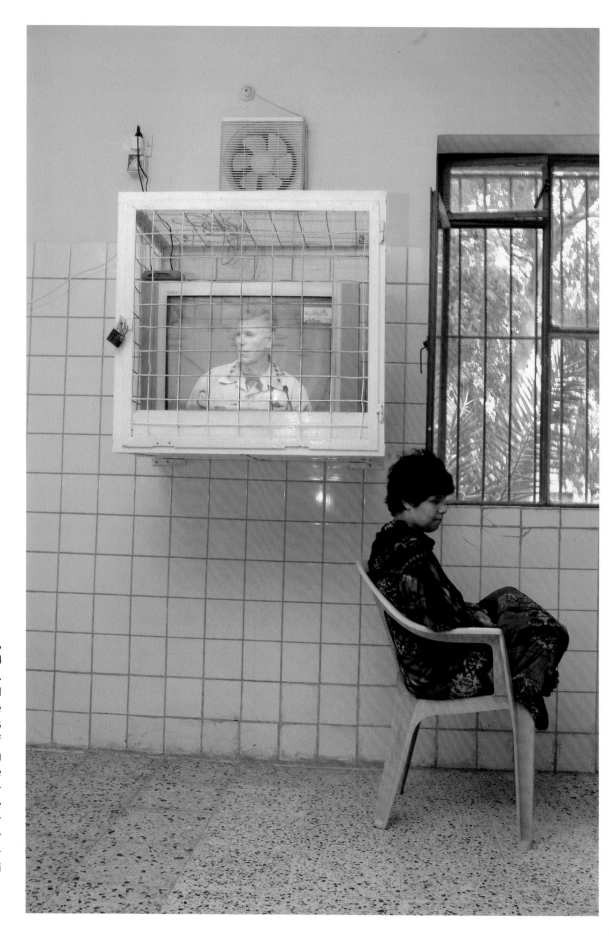

RASHAD PSYCHIATRIC HOSPITAL, BAGHDAD, APRIL 15, 2004

Patients had few activities to occupy them. One was watching television, which included the Coalition Provisional Authority's daily live broadcasts and updates to the press. On this day, General Richard Myers, the Chairman of the U.S. Joint Chiefs of Staff, was fielding questions on how he proposed to address the rising insurgency, especially Muqtada al-Sadr's Mahdi Army. Myers underplayed the threat of the insurgents. A few months later the hospital grounds would shake from nearby bombs, and mortars would land in its court-yard as coalition forces fought the Mahdi Army right outside the hospital gates. | RL

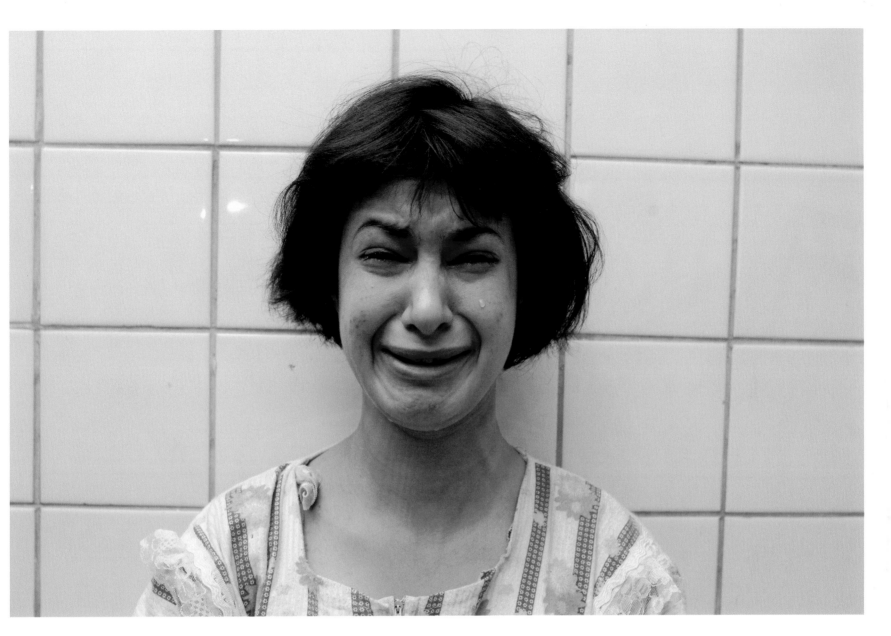

RASHAD PSYCHIATRIC HOSPITAL, BAGHDAD, APRIL 17, 2004
A young patient, newly arrived from the southern Shiite town of Karbala, pleads to go
home: "I don't belong here. Please don't make me spend the rest of my life here." | RL

Ranya, a devout, forty-seven-year old Shiite Muslim, has been at the Rashad Psychiatric Hospital for two and a half years. She has ten brothers and sisters. The doctors had tried to send her home after the war, but her brothers wouldn't take her in. "I am normal," she told me. "I don't even take any medication." I was told there were problems with family money and her brothers. It was something I heard a lot. "After my mother died, my brothers wanted control over the family property. They have been trying to get me to sign it over to them since. Every few months, they visit me and try to force me to sign papers, but up to now I have refused. Before she died, my mother had gone to the imam to ensure the family property would be left to her daughters, but my brothers cannot accept this."

| Rita Leistner, Baghdad, September 2004

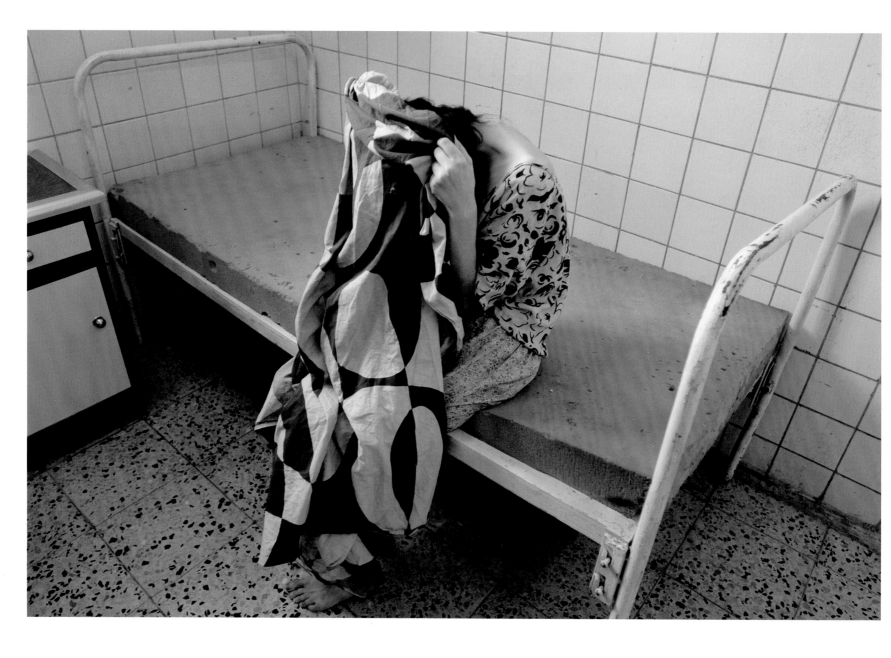

RASHAD PSYCHIATRIC HOSPITAL, BAGHDAD, JULY 28, 2004
A patient weeps inconsolably. The nurse said, "She is suffering
from a broken heart." | RL

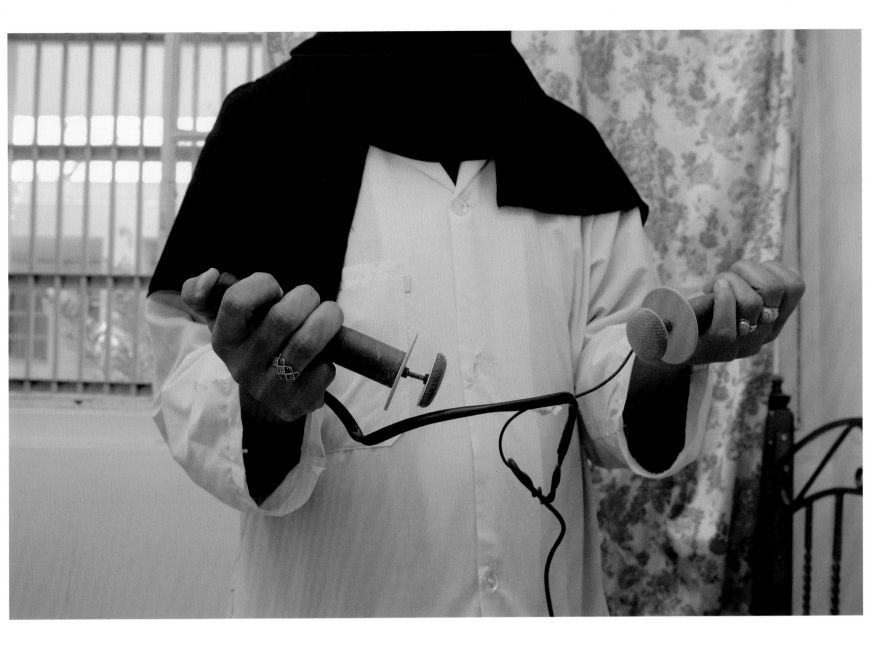

RASHAD PSYCHIATRIC HOSPITAL, BAGHDAD, APRIL 16, 2004
A nurse prepares anodes for applying electric shock treatment
to a female patient. | RL

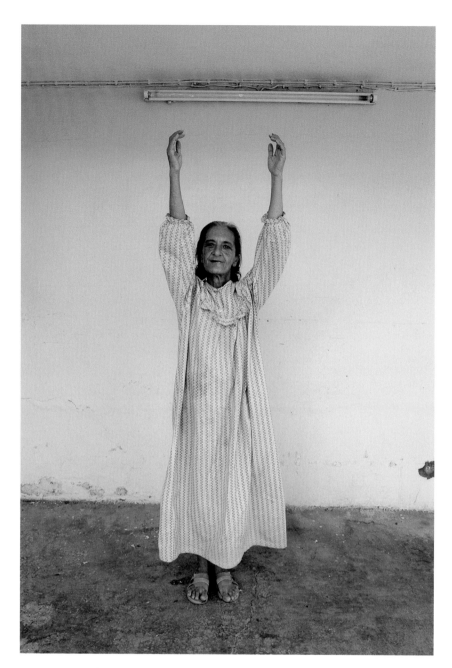 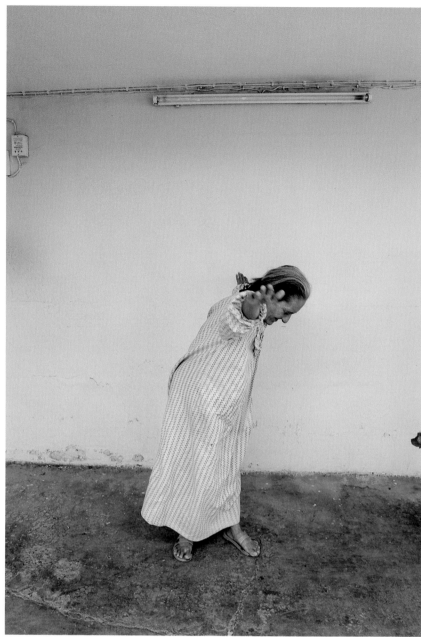

RASHAD PSYCHIATRIC HOSPITAL, BAGHDAD, SEPTEMBER 6, 2004 | RL

Mayada, fifty-four years old, pinched my bicep and smiled. "I like to keep fit. Would you like to see me do my exercises?" In the hundred-degree shade, Mayada stretched upward and downward, then side to side. When a nearby explosion shook the ground beneath the hospital she said, "Don't be afraid. I feel safer in here than out there. I don't want contact with the conflict in the outside world. I hate war, these many wars. But I do like life. Sometimes one finds strength, like a drowning person."

| Rita Leistner, Baghdad, September 2004

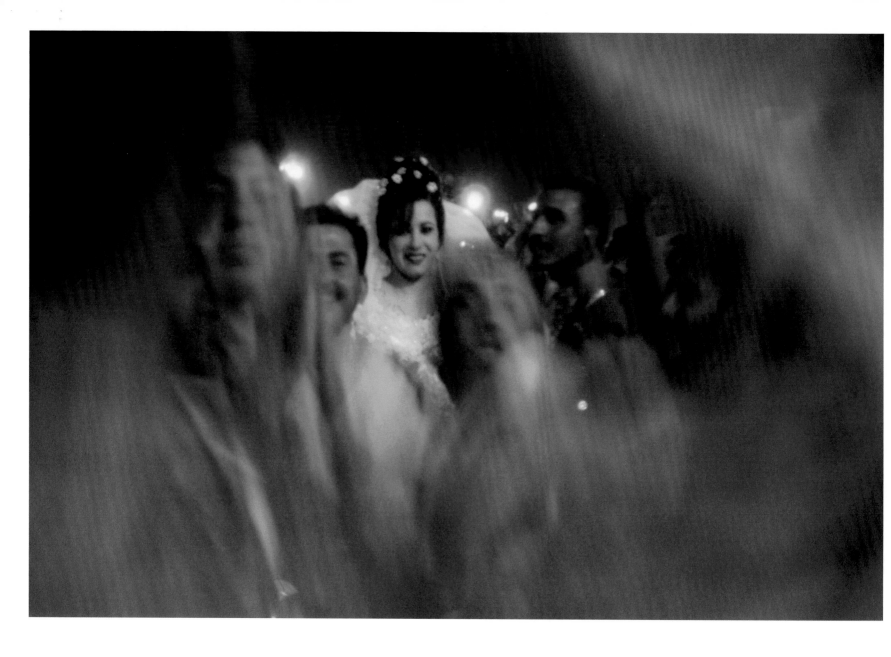

BAGHDAD, NOVEMBER 13, 2002
A bride is surrounded by dancing friends and relatives in
her procession into the Palestine Hotel. | TA

BAGHDAD, SEPTEMBER 4, 2004
A young boy begs money from passing drivers in an affluent shopping district. Many families left homeless and dispossessed after the war migrated to the capital. | KA

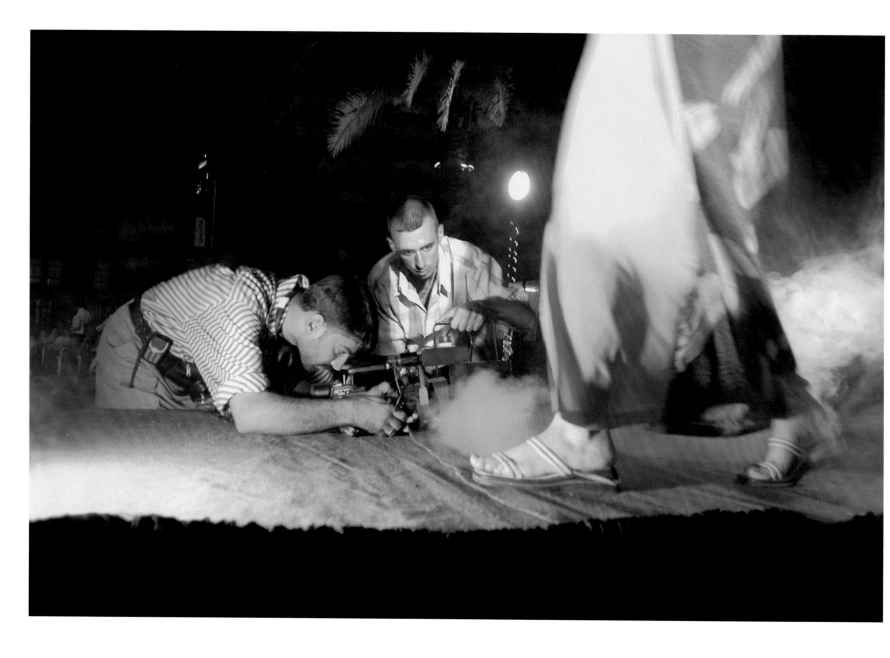

BAGHDAD, JULY 25, 2004
An Iraqi film crew, enhancing the scene with smoke machines,
documents a gala fashion show at the private Hunting Club.
Events like these are rare occurrences since the ousting of the
secular Baath regime. | RL

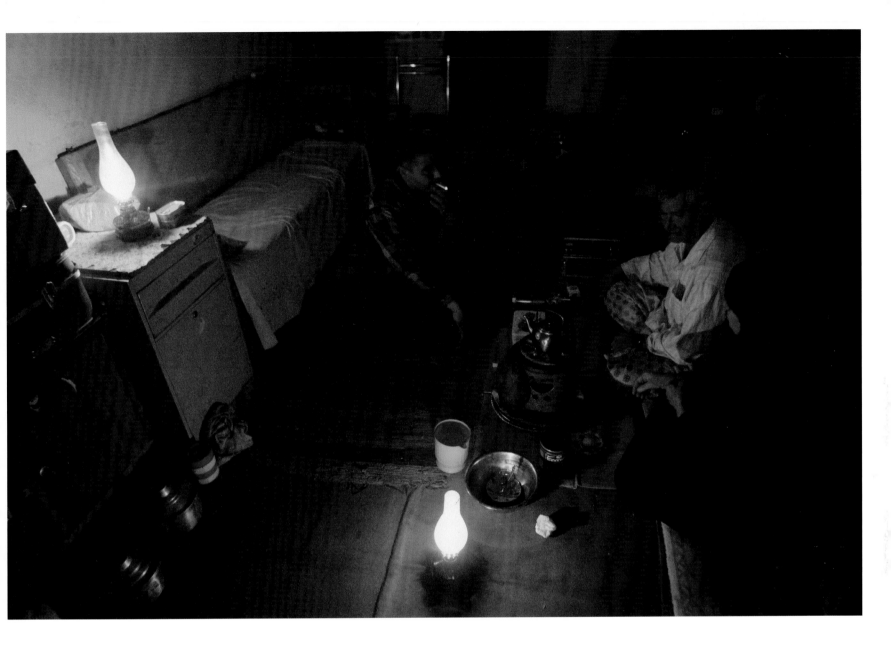

BAGHDAD, DECEMBER 10, 2004
An Iraqi family uses an oil lamp as they endure an electricity blackout. Baghdad continues to suffer from a chronic power shortage due to sabotage, mismanagement, and corruption in the reconstruction process. | GA

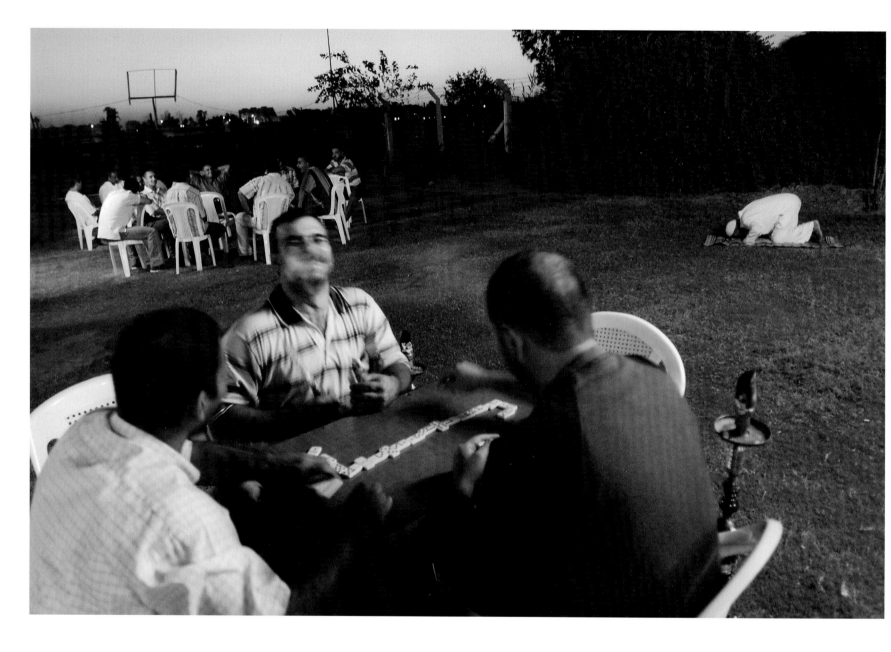

BAGHDAD, JULY 19, 2004
Iraqi men smoke water pipes and play dominoes as the day fades in
the garden of a tea house on the banks of the Tigris River. | TA

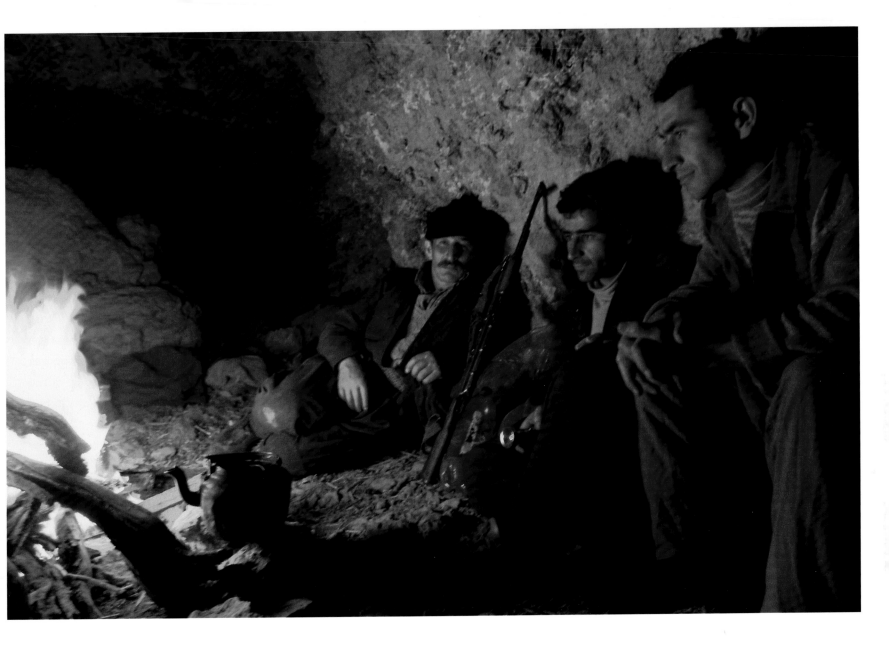

TURKEY-IRAQ BORDER, APRIL 12, 2003
In the mountains between Turkey and Iraq, Kurdish smugglers
settle down for the night in a hidden cave along the Tigris River. | RL

intended to enter Iraq in mid-March via the Turkish border, which seemed an obvious and relatively easy plan. As an independent freelancer, if I wanted to get in I had few other options. I didn't consider the possibility of not going. Like many people, I had seen images of war in the media, but I felt compelled to witness this one for myself and to record its effect on those on both sides of the conflict.

At the time it seemed Turkey would allow the American forces passage to Iraq. But as it happened, the border never opened, and I found myself stranded in Turkey as coalition forces advanced toward Baghdad from Kuwait. Some journalists who had been counting on Turkey returned home. Others got on planes to Jordan or Kuwait to try other means of access. To save money, I decided to walk to Iraq. Despite the threat of Turkish border guards who had shoot-to-kill orders, I paid smugglers to lead me on foot through what I'd been told would be a one-day hike. The trip turned into a harrowing three days. A full moon, which made it more difficult to move undetected at night, and a sudden unanticipated increase in border patrols meant we had to change the route through exceptionally steep and often treacherous mountains in Syria and Iran before reaching Iraq. Halfway, in the pitch dark as we scaled a cliff high above the Tigris, I slipped, narrowly escaping a deadly fall. I was lucky and only sprained my knee, but every step thereafter was agonizing. Stoned on painkillers, I scrambled up snow-covered pitches with the aid of a stick. Sometimes we could see the garlands of guard tower lights on the cliffs above in plain view. When we finally arrived in Iraq on April 13, it was just in time to watch the fall of Tikrit on television—an event being hailed as the end to the "high intensity phase" of the war. While embedded journalists were preparing to leave their troops and go home, I headed south to Baghdad to see what stories the war had left behind.

I'd given most of the money I had to the smugglers, so when I got to Baghdad I worked for newspapers for cash because there was no way of accessing funds from Iraq. The Turkish press corps put me up and fed me for free. Finally, by late April I had a story of my own. I'd befriended the soldiers of C Troop, 3-7 Cavalry, 3rd ID, whom I'd met on assignment as they guarded the entrance to Camp Victory (the big military base at Baghdad Airport). They invited me to come live with them, and so began my four-month embed—an unusually long stint. That summer the troop was sent to the Sunni Triangle. The soldiers, who had led the ground war into Iraq, had expected to be sent home, but instead they found themselves fighting a new kind of guerrilla war—something cavalry was not specifically trained to do. House raids meant leaving the armored security of tanks and Bradleys. Their task was complicated by the fact that they didn't know anything about the insurgents they were meant to find and capture. When the troop was sent home in August 2003, I returned to New York with some of the first photographs of detained Iraqis. The insurgency, which had seemed at first to be a sideshow of the war, would move to center stage by the spring of 2004, by which time I was back in Iraq, this time unembedded.

Without the protection of the military I knew I would be taking greater risks, but I wanted to get a more complete picture of the story in Iraq. As the momentum of the insurgency increased, I took frequent trips to the south in search of the Mahdi Army. At that time, the Mahdi Army was still feeling out its relationship with the media and did not seem to pose a deadly threat. However, many different insurgent groups were in play by then and some were not friendly to journalists, so when I was on my way back to Baghdad one day with my good friend Adnan Khan, a writer for Canada's *Maclean's* magazine, we proceeded cautiously. But not cautiously enough.

On April 11, 2004, we drove into the tail end of an ambush in the Sunni stronghold of Latifiya. I snapped some quick pictures out the window—two tankers on fire, bodies lying in the road. Then we made an error: we got out of the car to get more photographs. Moments later I found myself in the middle of a firefight. Some neighborhood

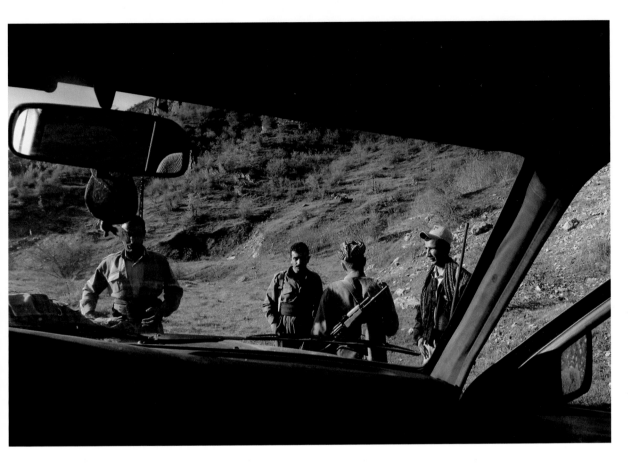

men and I huddled against a street corner, and it looked like there was no way out of open sight until a woman ushered us through a gate into a nearby house. I hid in the house and soon after, someone else led Adnan to me. We thought we (and my photographs) were safe, until five men crazed with anger and adrenaline burst through the gate, intent on killing "the Americans." We showed them our Canadian passports. A series of debates and screaming matches ensued between the men holding guns at our heads and the women of the house, who pleaded over and over again that they could not kill a Muslim (Adnan, who also had a Pakistani passport). Our driver, Ali, begged for our lives, swearing on a Koran that we were "good journal-

ists." They spared us our lives and took all of our camera equipment and digital media.

Back at the hotel, I felt acute anxiety over losing my images and being without a camera. I already had several stories in the works. One on the Mahdi Army, but also a story on the women patients of the Rashad Psychiatric Hospital. I had come back to Iraq to get up close, to make portraits of individual people, as I had with the Cavalry soldiers. The abduction only drew me closer to what was going on in Iraq, involving me more intimately than ever in the lives of those affected by the ongoing conflict. So I went back to New York to replace my gear and returned as soon as possible. My unembedded tour had just begun. |

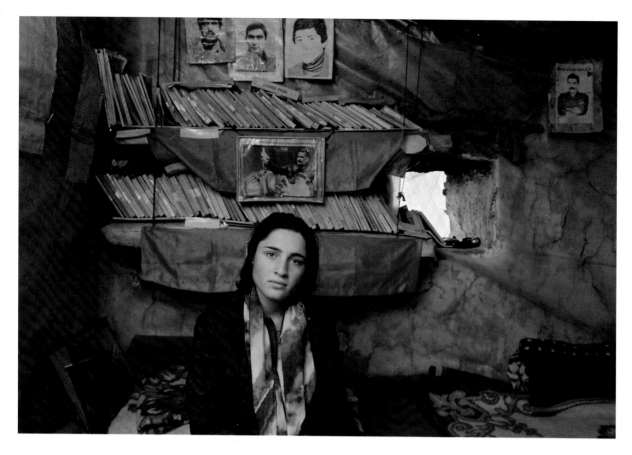

KURDISTAN, APRIL 3, 2004
The Iranian-Kurdish wife of Osman Ocalan, a leader of the PKK Kurdish separatist group, lives simply at a camp hidden in the mountains of northern Iraq. Outlawed in Turkey, the PKK advocates an independent Kurdish homeland. | RL

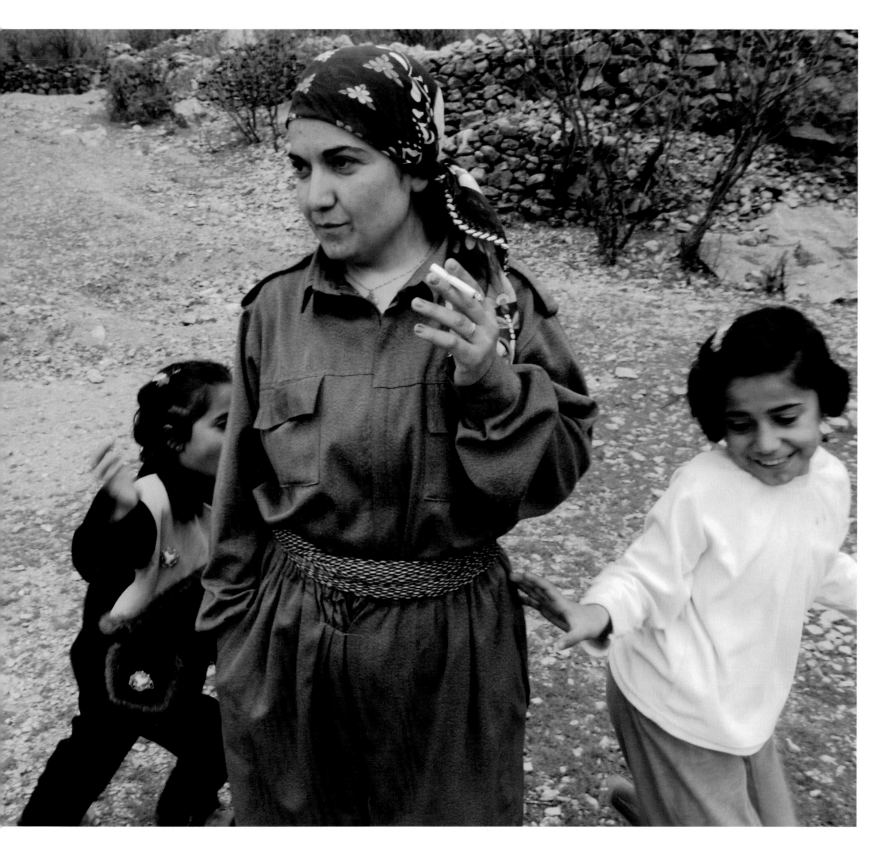

KURDISTAN, APRIL 3, 2003
A Kurdish separatist guerrilla of the outlawed PKK joins her children
outside at a secret camp in the mountains of northern Iraq. | RL

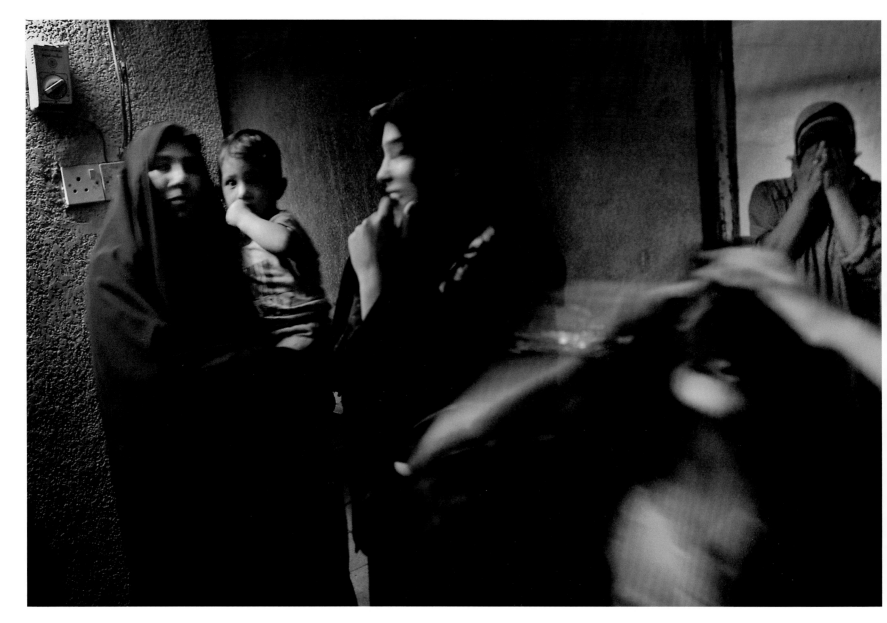

SADR CITY, BAGHDAD, JULY 23, 2004
Women friends gather at home while their husbands meet in Sadr City, a stronghold of the conservative Shiite leader Muqtada al-Sadr and his armed followers, the Mahdi Army. | KA

I ask them if they like to wear the *bushiya*, the veil that covers their faces. "We have always wanted to dress this way," says Leyla, a charming twenty-year-old girl with an oval face and almond-shaped eyes. I had met her before, and she had vouched for me so that I could meet the other women who sympathized with the resistance. "But under Saddam it wasn't possible, we would be followed and he would know that our men are against him." Not much has changed. Followers of conservative clerics might be revolutionaries.

| Kael Alford, Baghdad, September 2004

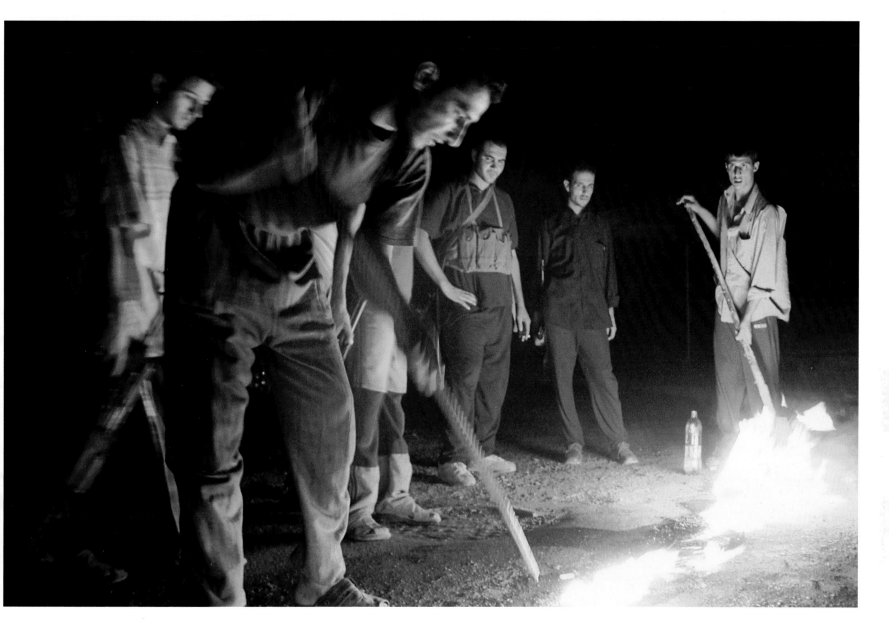

SADR CITY, BAGHDAD, AUGUST 7, 2004
Members of the Mahdi Army camouflage a remote-controlled explosive with a covering of asphalt in an intersection. The Mahdi Army buried the improvised explosive devices (IEDs) to defend against American incursions into Sadr City during a period of large-scale Shiite rebellion against the American occupation. | TA

BAGHDAD, JULY 18, 2004
Young men and women venture out for the evening in Zowra Park. Socializing after dark in Baghdad ceases during periods of heavy fighting or suicide bombings, but rebounds as soon as there is a perceived lull. Still, mixed-gendered public outings are increasingly discouraged by religious conservatives' censure. | TA

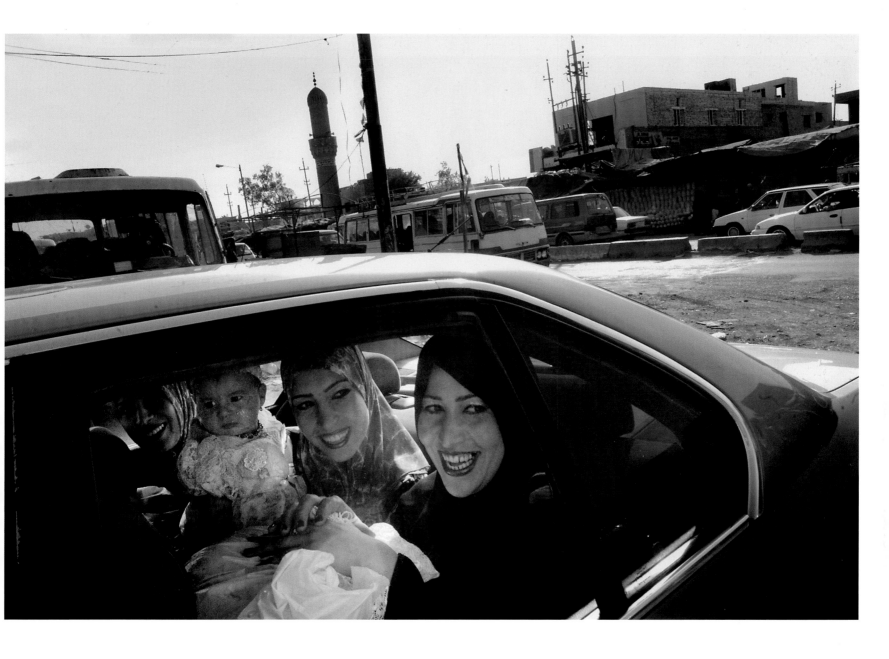

SADR CITY, BAGHDAD, JULY 15, 2004
Women squeeze into a car on their way to a henna party, the Iraqi equivalent
of a bridal shower, after they have had makeup applied in a salon. They ride
behind tinted windows to protect their modesty. | KA

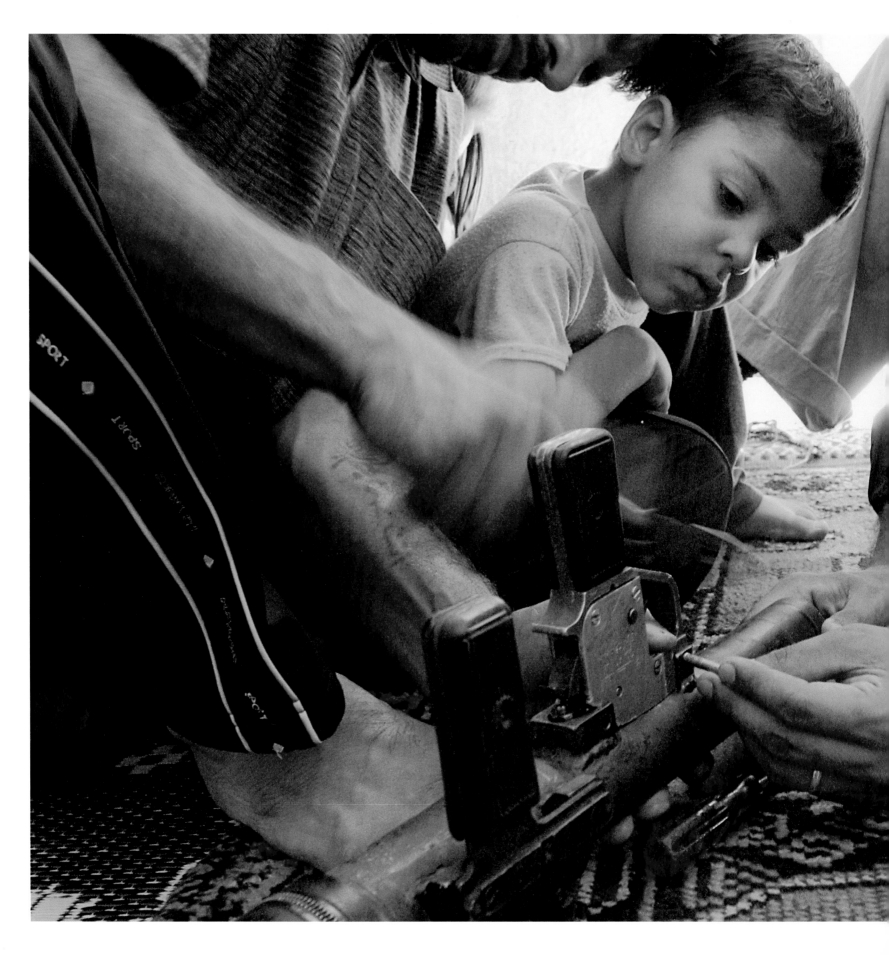

SADR CITY, BAGHDAD, AUGUST 7, 2004
A young boy watches his relatives repair a rocket-propelled grenade
launcher in the home of a Mahdi Army fighter. | TA

"To become a martyr
like my brother."

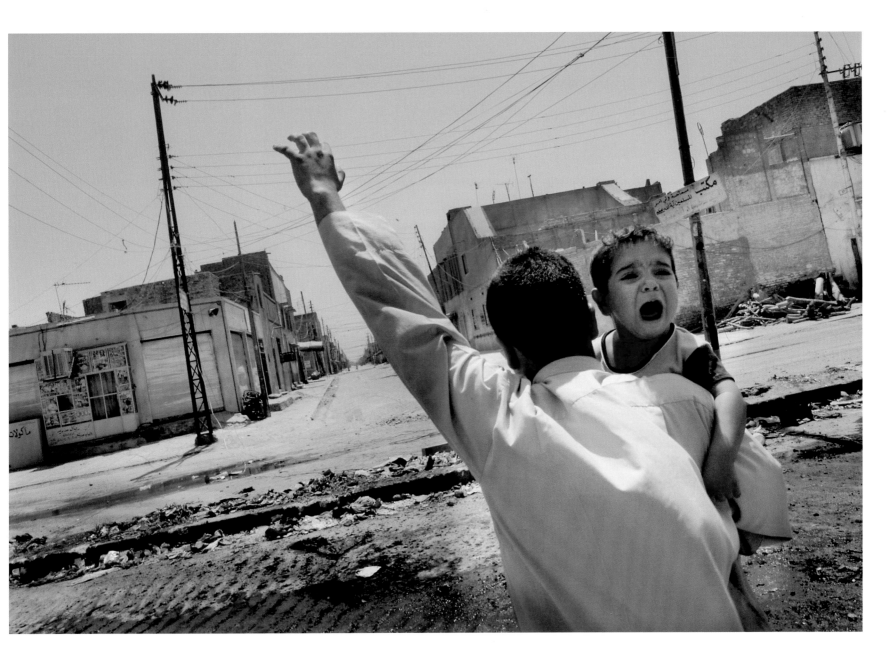

NAJAF, AUGUST 21, 2004
A father shows his hand to snipers as he carries his terrified child across the front line between U.S. forces and the Mahdi Army at the wrecked outskirts of the old city. | KA

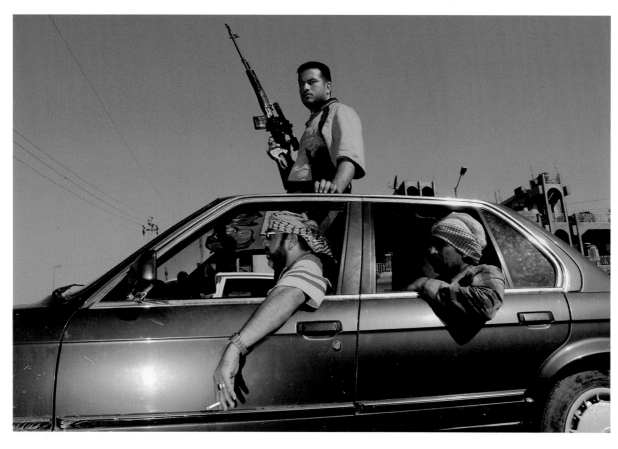

SADR CITY, BAGHDAD, AUGUST 7, 2004
Members of Muqtada al-Sadr's Mahdi Army take to the streets in rebellion
against the interim Iraqi government and American military occupation. | RL

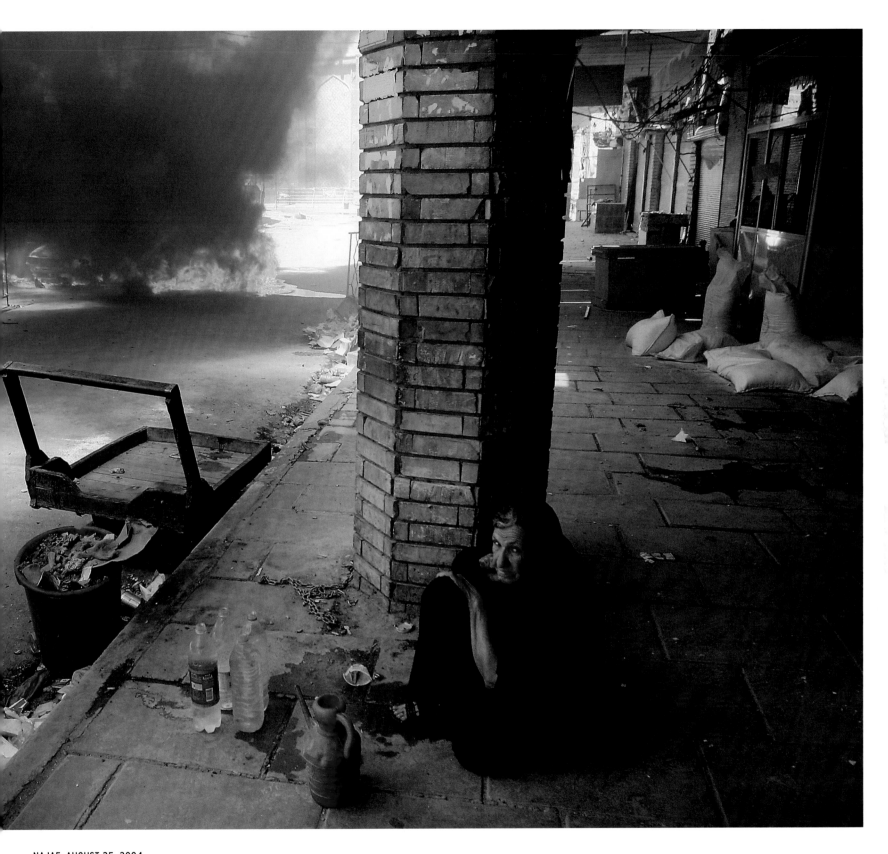

NAJAF, AUGUST 25, 2004
A woman sits in front of a burning car fifty yards away from the shrine of Imam Ali. The car was hit by U.S. fire on
Prophet Street, the main street leading to the shrine from the south, transformed into a sniper alley by U.S. forces. | GA

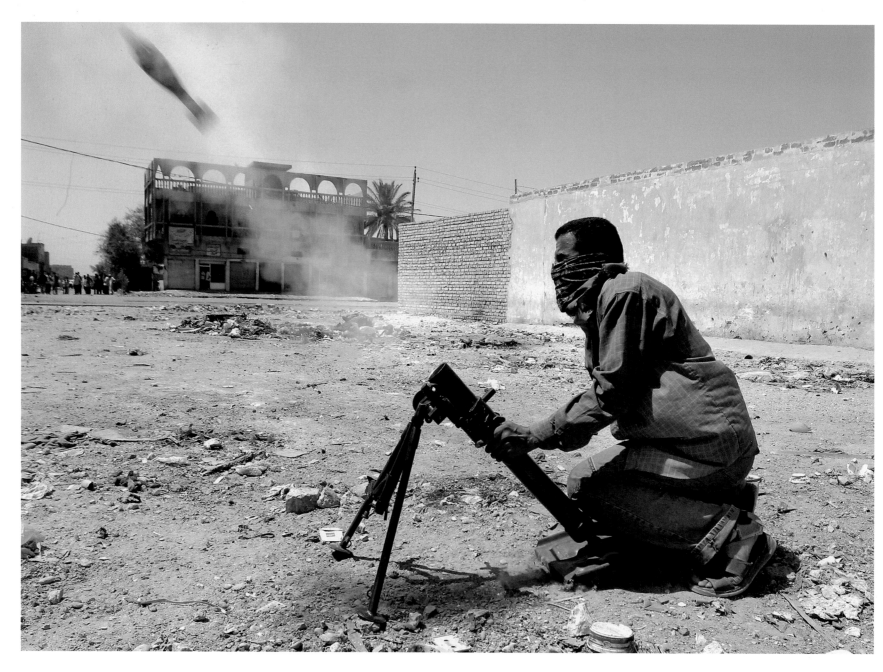

SADR CITY, BAGHDAD, JUNE 5, 2004
A fighter loyal to Muqtada al-Sadr fires a mortar round at a U.S. Army position. | GA

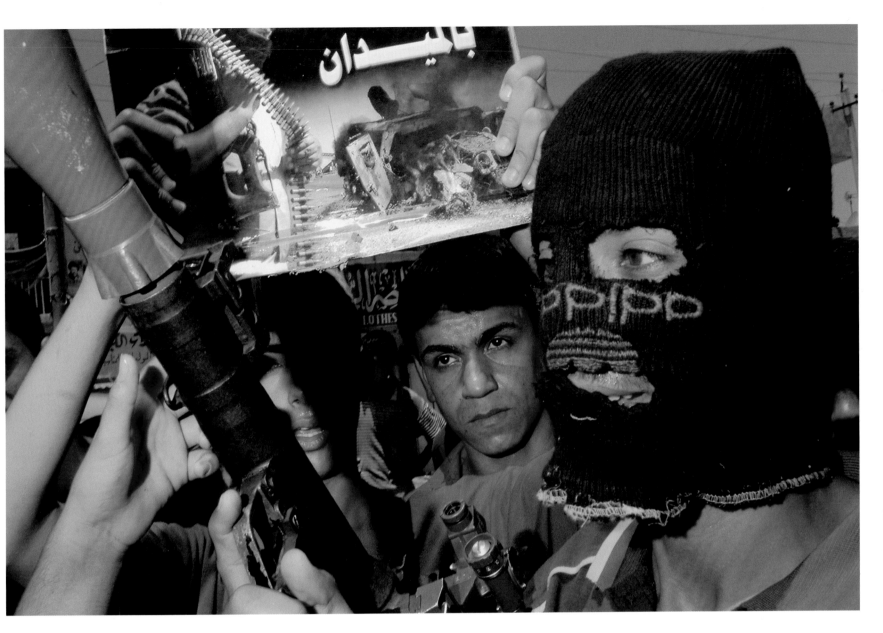

SADR CITY, BAGHDAD, AUGUST 6, 2004
Members of Muqtada al-Sadr's Mahdi Army rally in Sadr City. | RL

Follow me on foot to the shrine of Imam Ali," he said.
As we walked toward the city center, fighters standing in the doorways began chanting.

"This is a good song," an interpreter for *The Telegraph* said. "It's the song that signals to fighters up ahead not to shoot the journalists."

| Rita Leistner, Najaf, August 2004

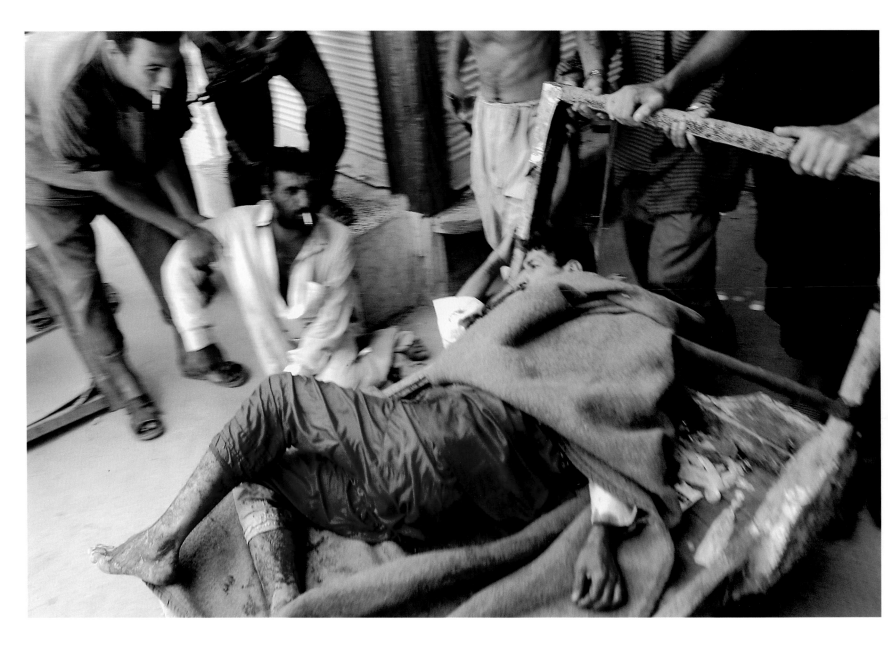

NAJAF, AUGUST 25, 2004
An injured fighter is wheeled toward a makeshift hospital in the shrine
of Imam Ali. | GA

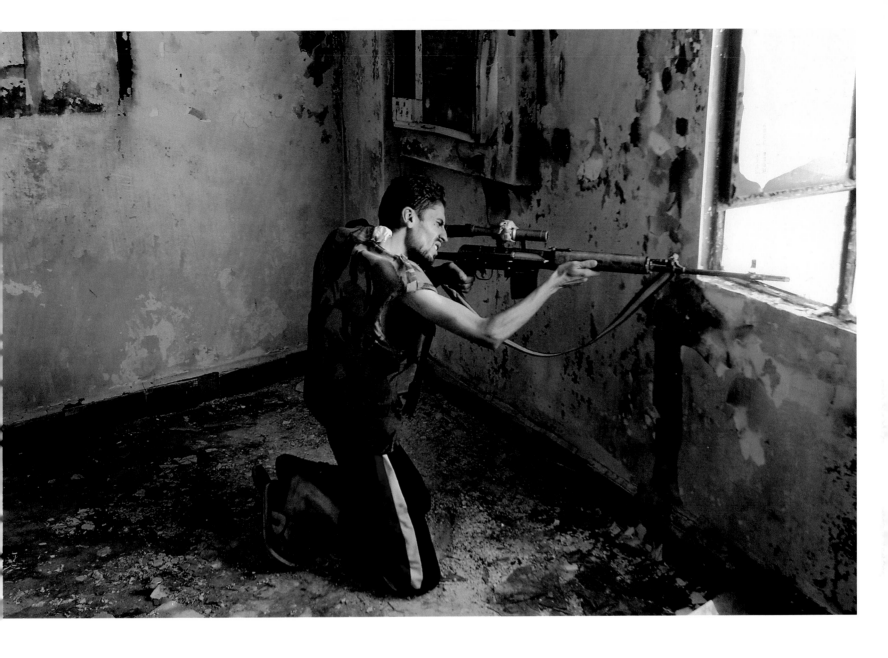

NAJAF, AUGUST 22, 2004
A Shiite sniper loyal to Muqtada al-Sadr fires at U.S. troops from an empty
building on the outskirts of the Najaf cemetery. | GA

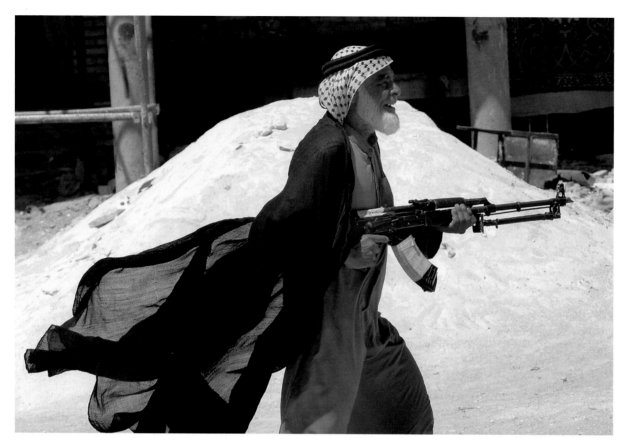

NAJAF, AUGUST 9, 2004
A fighter for the Mahdi Army walks the streets of the old city. | GA

We wait for the fire to subside and run across the street to the other side, the same dark alleys in which the same bored fighters are sitting doing nothing but chewing over the same old conspiracy theories. The walls and the ground are varnished with fresh blood. In the market a couple of shops are on fire from earlier fighting. A man is hiding behind a pile of empty banana boxes with his eight-year-old son.

That is when we catch sight of a small boy with a stunned look on his face. He says his name is Amjad and he is eleven years old.

"How long you have been here?"

"Ten days. Since my brother was killed. There, at the end of that street."

"And why are you here?"

"To become a martyr like my brother."

| Ghaith Abdul-Ahad, Karbala, June 2004

NAJAF, AUGUST 12, 2004
Mahdi Army fighters scan the horizon looking for U.S. tanks during intense morning fighting. | GA

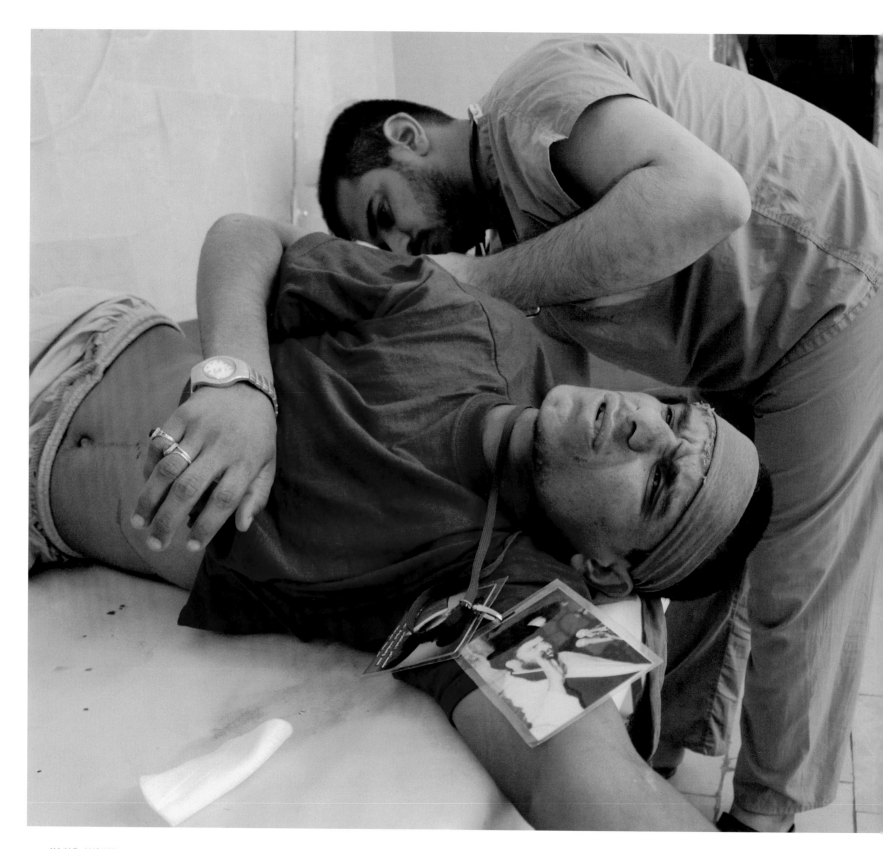

NAJAF, AUGUST 17, 2004
A volunteer doctor treats a sniper wound on the back of a Mahdi Army
fighter in a makeshift trauma center in the Imam Ali shrine. | TA

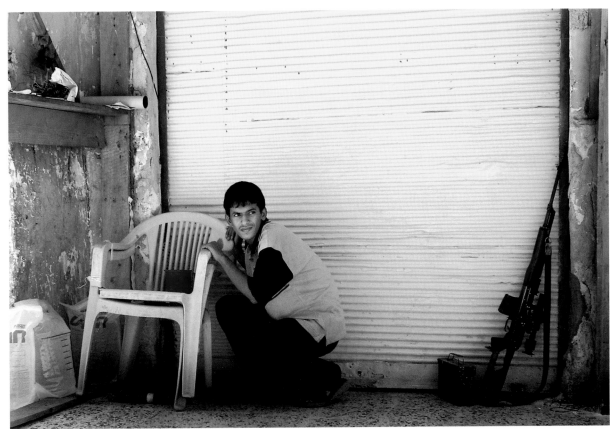

NAJAF, AUGUST 25, 2004
A fighter clutches a chair during heavy U.S. aerial bombardment
on Mahdi Army positions near the shrine of Imam Ali. | GA

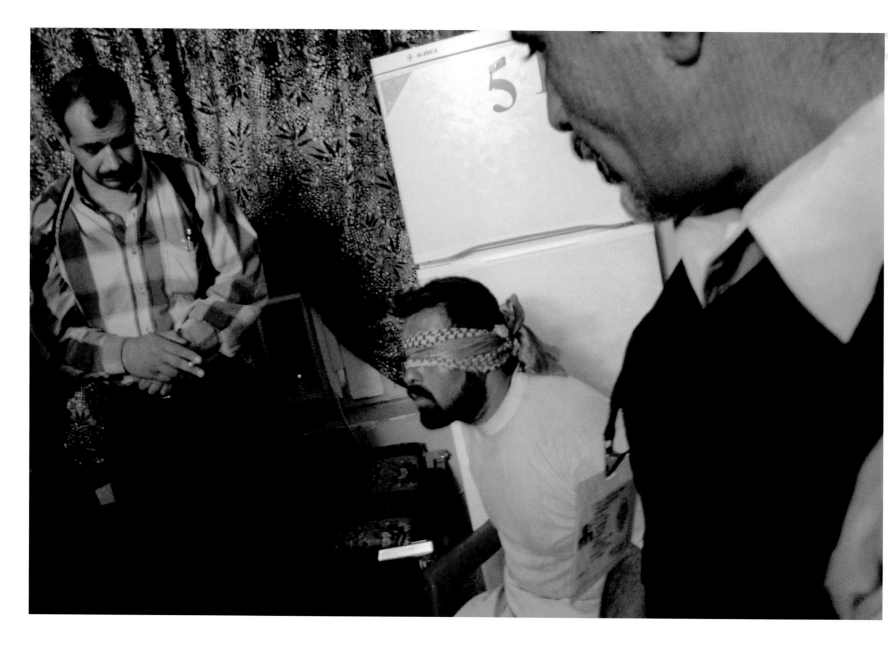

NAJAF, AUGUST 21, 2004
A Mahdi Army fighter from Nasriya is held prisoner by police and interrogated in front of journalists in the Najaf police station. | KA

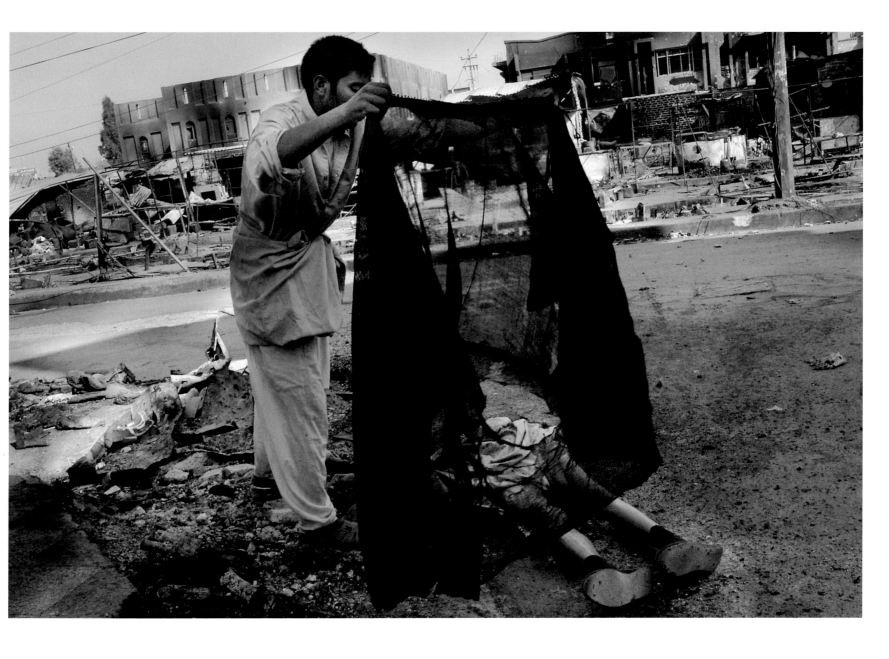

NAJAF, AUGUST 21, 2004

An elderly man, killed in the fighting between U.S. forces and the Mahdi
Army, is covered with his own cloak by a Najaf resident on the wrecked out-
skirts of the old city. | KA

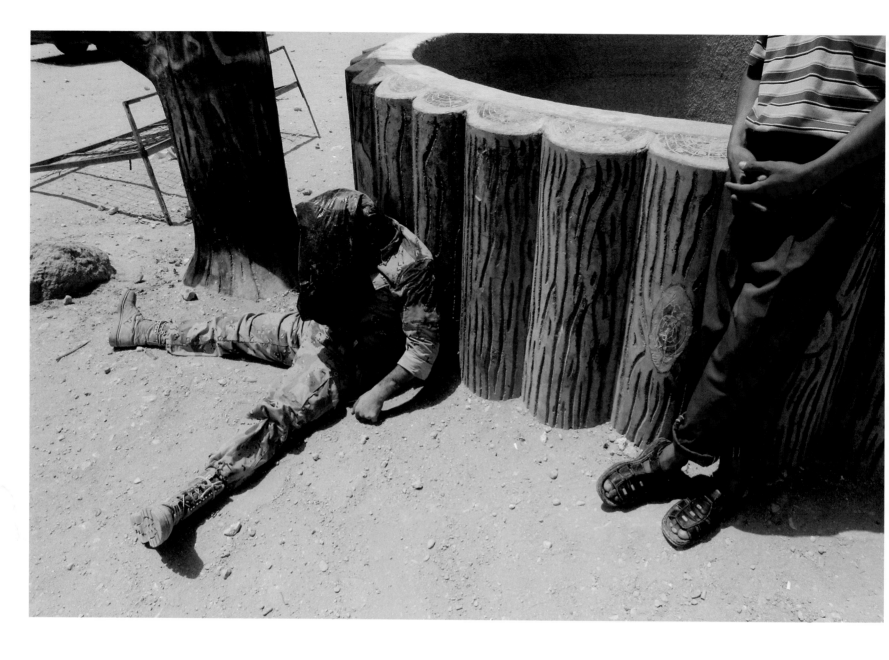

NAJAF, AUGUST 7, 2004
An Iraqi National Guardmen lies dead, killed by Shiite militia. | GA

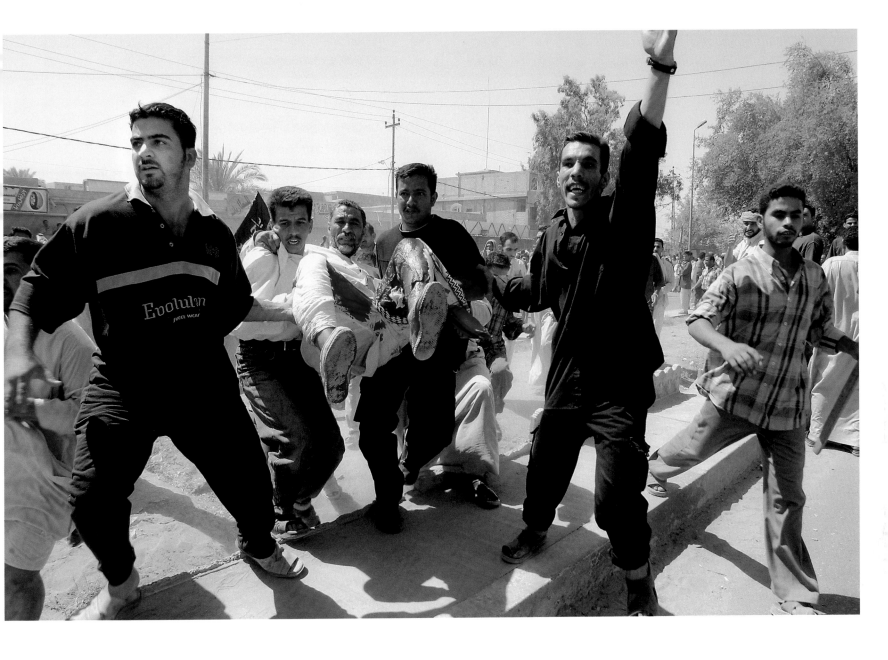

NAJAF, AUGUST 26, 2004
Demonstrators carry an injured man as bullets fly overhead. The gunfire
came from a base occupied by U.S. and Iraqi forces at a Shiite demonstration
trying to reach the shrine of Imam Ali. | GA

try to stay impartial. Keep my mouth shut. Listen as much as possible. That's why I'm here. I'm a journalist. An observer. I'm not a soldier, missionary, contractor, or politician. But when Haider presented me with a gift of sweets and a photograph of himself with his wife in their wedding finery, I could tell he was preparing for martyrdom and I had to say something.

Haider was one of my primary contacts in Muqtada al-Sadr's Mahdi Army, a militant branch of the homegrown Iraqi Shiite movement to resist American occupation. I needed him. By summer 2004 the newly formed Mahdi Army was on a deadly collision course with American forces and their ranks were swelling. Who were they? Would they fight? How and why? The only way to document the Sadr movement was from the inside. But without an authorized escort like Haider, I would rarely last more than ten minutes in a Sadr stronghold before being detained and kicked out by a Mahdi Army patrol. Through Haider I gained extraordinary access to the street-level workings of the Sadr movement. We were divided by a political, cultural, and economic gulf, but he extended his protection to me through angry mobs at demonstrations, guerrilla night patrols in Sadr City, and chaotic street battles with American soldiers.

Of course, he was not entirely benevolent. The Mahdi Army used men like Haider to keep tabs on nosy foreigners like me. He gave me surprising freedom most of the time but occasionally cut off my access in sensitive situations. He had a job to do, and he wasn't working for me. At the same time, I saw Haider gain prestige in the movement as a monitor for foreign journalists.

Though we didn't tell the people we met on the streets, Haider knew I was an American. He put himself on the line, vouching for me. I told him I wasn't a spy, but how could he know for sure? Our unlikely symbiosis depended on a mutual leap of faith.

We were an odd pair, presumed enemies. I'm an American. I love my country. He was a member of a guerrilla movement that battled American soldiers. We were divided by a political, cultural, and economic gulf, but we respected each other and even enjoyed each other's company. He laughed mercilessly when I crumpled myself in an undignified manner on the floor of our car as a Katyusha rocket flew low over our heads and exploded in a nearby empty lot. And I poked fun at his braggadocio when, in spite of his exaggerated claims to be following the movements of Prime Minister Iyad Allawi through the

Mahdi Army intelligence network, he didn't know Allawi was traveling that day in Najaf as I had seen reported on BBC that morning. Haider had his soft side too. He would wave me to silence if Oprah Winfrey appeared on my satellite TV. "A good woman," he would declare. He admired her climb to success against the odds.

Haider's young wife was pregnant with their first child. They lived on meager means together with his mother and brothers in a bullet-pocked house in the impoverished Shiite ghetto in east Baghdad now known as Sadr City. As a young man he had rebelled against Saddam's repression. He was captured by police, beaten severely and repeatedly, and imprisoned for five years in the political wing of Abu Ghraib prison. His fellow prisoners were other poor Shia, loyal to the Sadr clerics, who had defied Saddam's regime. Locked up together in a single, overcrowded room, they studied the Koran and secretly organized to continue their struggle. They assumed they would continue to fight Saddam's forces; they didn't suspect that they would soon be in combat with American soldiers.

Muqtada al-Sadr's grassroots support and front line fighting force comes from people like Haider, the poor and disenfranchised who have glimpsed a more dignified existence in the refuge offered to them: religious *madrassas* and mosques where they are not resented for their daily struggles, as the poor often are, but celebrated for them. They seek dignity and liberation in the midst of a culture of violence. The violence hung heavy over their heads under Saddam, and was reinforced in dramatic fashion by the "shock and awe" foreign invasion and the often heavy-handed and humiliating occupation that followed.

I soon knew their litany of complaints by heart. They were happy to be rid of Saddam, but had paid a terrible price under American-led economic sanctions and bombing. They felt excluded from the "new Iraq" as the interim government, installed under American favor, was stacked with Iraqi exiles who had lived in Britain and the United States over the past two decades. The basic services of government, such as water, electricity, and security, were woeful and deteriorating. They complained bitterly of fraud and corruption in the distribution of money for reconstruction. U.S. forces patrolling their streets were insensitive to local custom and sometimes injured or killed innocent Iraqi citizens in errant bombings or checkpoint shootings. But primarily they simply resented the creeping feeling of being dominated by a foreign force in their own country.

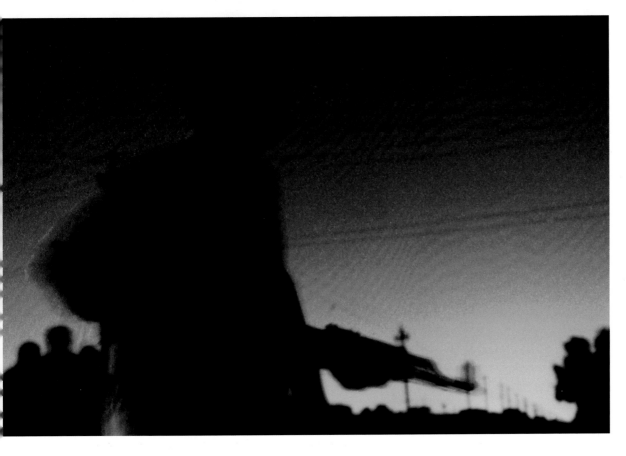

SADR CITY, BAGHDAD, AUGUST 5, 2004
A Mahdi Army night patrol guards
an intersection in anticipation of
an American incursion. | TA

"We don't hate Americans," Haider often told me. "If you come to my house as a friend I will give you food. If you come with a gun I will give you jihad." That word. Often interpreted as "holy war," jihad is more accurately translated as "righteous struggle." It came up repeatedly in my time with Haider and other Mahdi fighters. When jihad entered the conversation and I was pressed for an opinion, I made the point that there are many types of jihad, not all of which involve violence.

Haider argued that his struggle against the invading Americans was righteous, and he was not afraid of martyrdom because he would, on these merits, end up in paradise. His beliefs were pushing him closer and closer to the front lines of fighting. Throughout the summer, as the conflict between the American forces and the Mahdi Army heated up in Sadr City and Najaf, I worried about Haider and his fragile family. Then, on the eve of what would clearly be a major U.S. military incursion into Sadr City, Haider gave me the sweets and the photograph.

There was no obvious occasion for the gifts, and a formality to the presentation aroused my attention. The photograph startled me most.

I had never seen Haider's wife. I had even been to his home several times, but all the young women of the house remained discreetly in the back rooms, carefully separated from the men in the living room. "To remember me," Haider said somberly as he presented the gifts. I understood he was preparing for a possible death in the coming battle.

I didn't know how to reply. This man was no longer an anonymous contact. I tried to cross the cultural barrier, to speak with him in his own terms. I suggested that he need not be impatient; the time and circumstance of his martyrdom and his entry to paradise was in God's hands and would come as God willed. I said I understood that Sadr City, with its chronic violence and poverty, was a very difficult place to raise children into strong healthy adults. I told him I knew he had the strength to overcome these obstacles to give that gift to his son or daughter. That struggle, I suggested, is a jihad as important as any other, and I hoped he would live to see it through. Haider listened, pressed his gifts into my hands, and waited quietly as I gathered my equipment for a day of photography. |

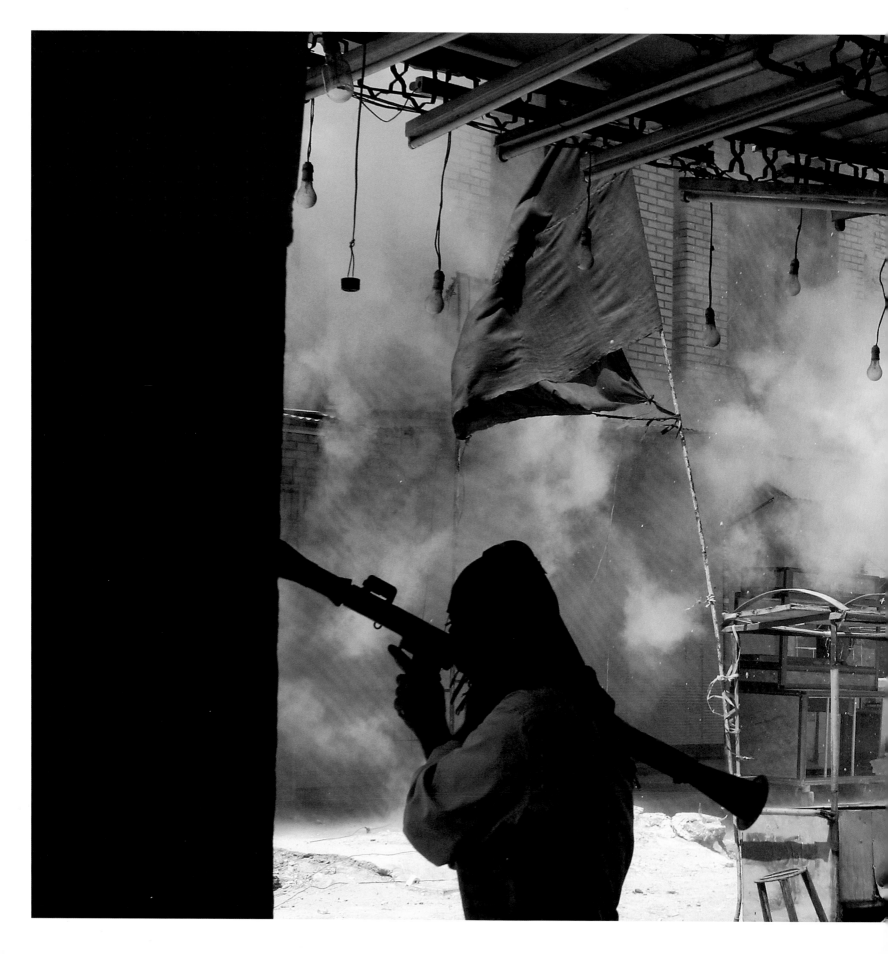

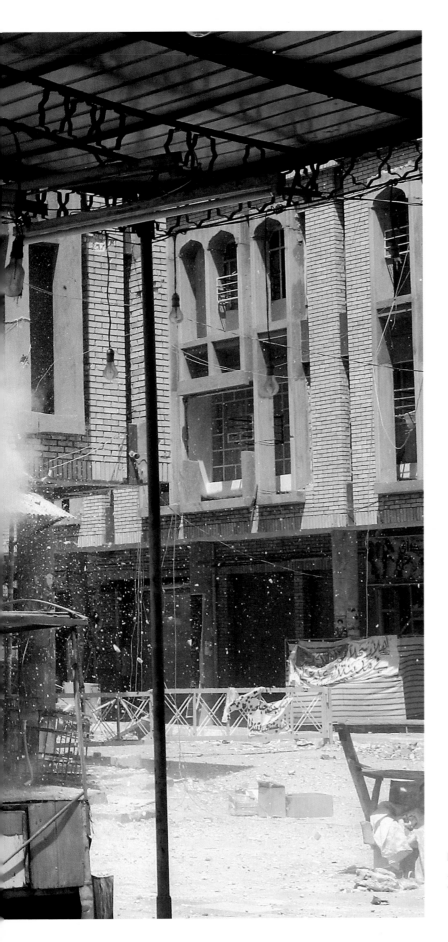

NAJAF, AUGUST 23, 2004
An Iraqi Shiite fighter takes cover as U.S. shells hit a building
from which Mahdi fighters were firing at U.S. forces. | GA

NAJAF, AUGUST 17, 2004
Running for cover from a nearby mortar explosion, men duck into the front gate of the Imam Ali shrine. The shrine was at the center of an American siege of the old city of Najaf, where Mahdi Army fighters staged a three-week rebellion against the Iraqi government and American military occupation. | TA

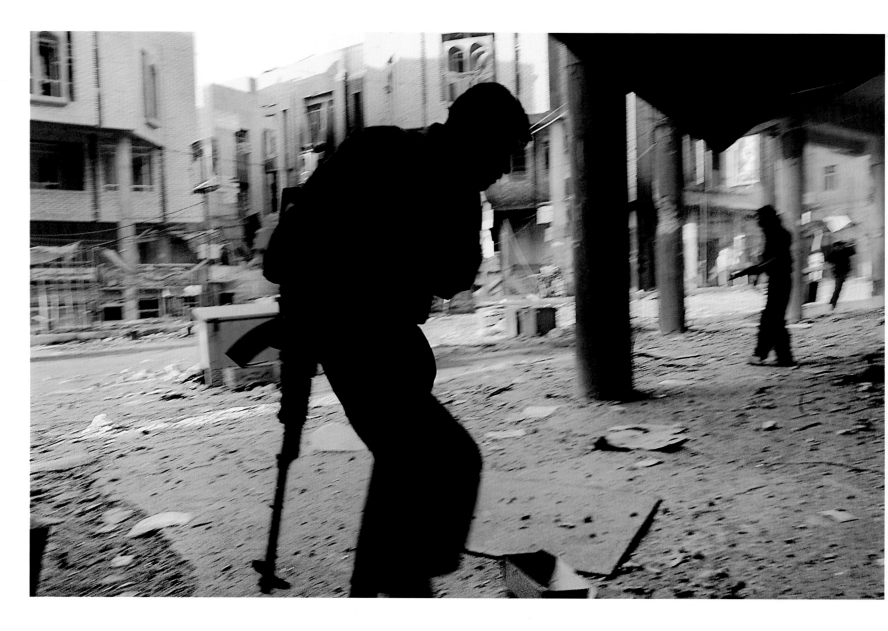

NAJAF, AUGUST 27, 2004
Members of the Mahdi Army run for cover during a gunfight with Iraqi police. | TA

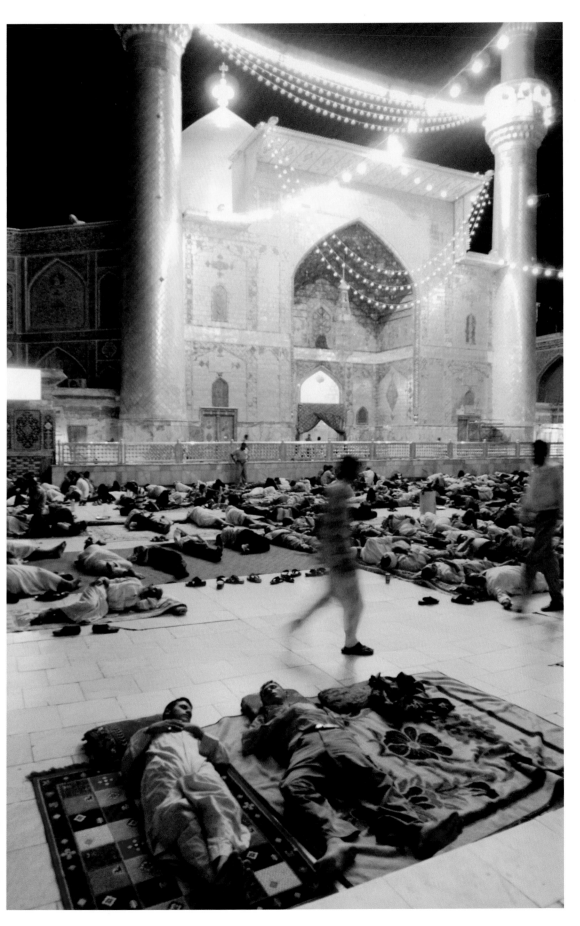

NAJAF, AUGUST 17, 2004
Pilgrims and Mahdi Army fighters sleep in the courtyard of the Imam Ali shrine. Fighters were allowed to enter the shrine courtyard, but the Mahdi Army leadership forbade them to carry weapons inside the shrine's walls. | TA

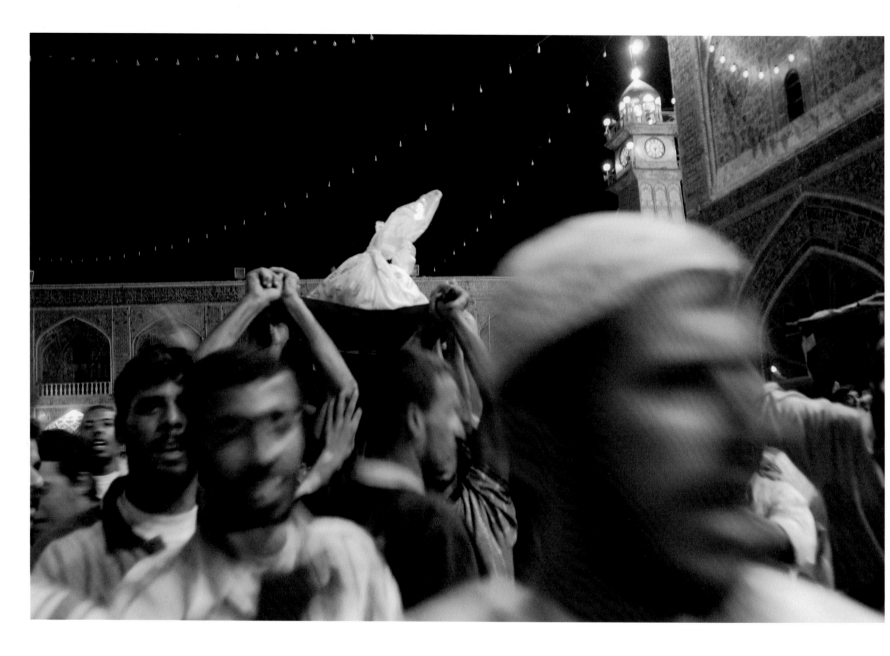

NAJAF, AUGUST 17, 2004
The body of a slain fighter is paraded through the courtyard inside the Imam
Ali shrine during the siege of the old city. Fighters killed in battle with the
Americans were hailed as martyrs by the Mahdi Army and its supporters. | TA

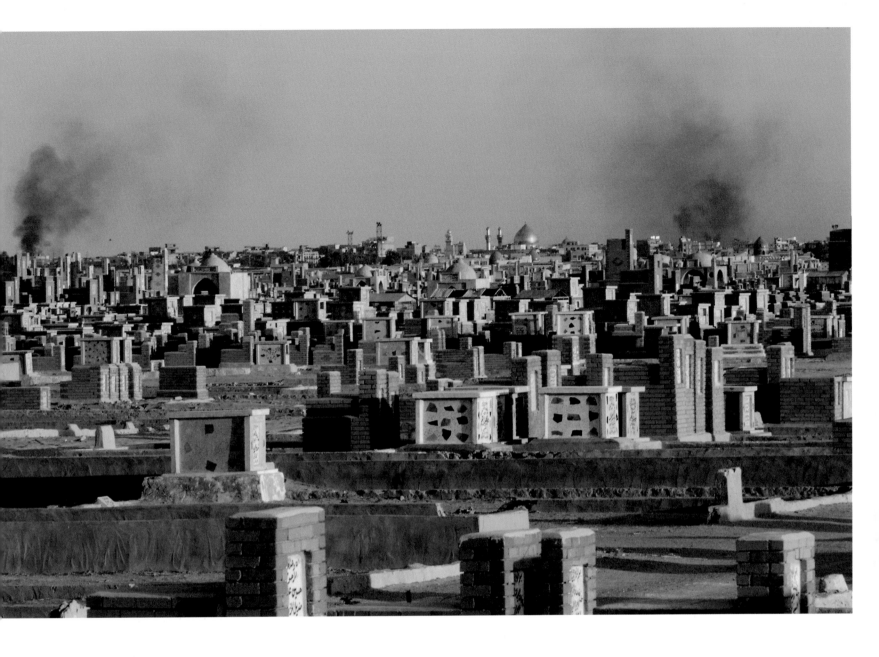

NAJAF, AUGUST 25, 2004
The cemetery of Najaf. Billows of smoke rise in the distance from strike
points of American bombs near the shrine of Imam Ali. | RL

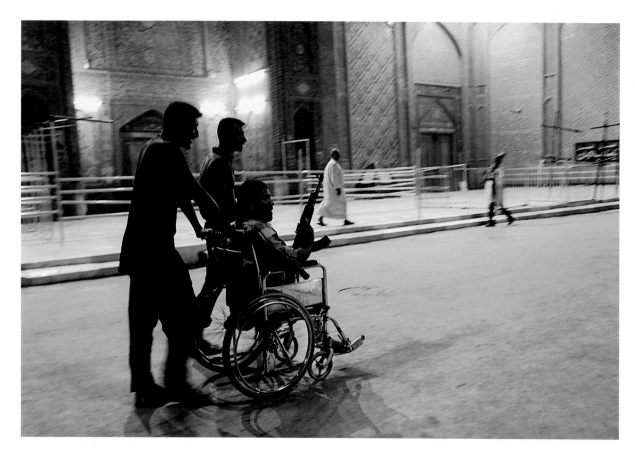

NAJAF, AUGUST 17, 2004
A wheelchair-bound member of the Mahdi Army patrols the outer
walls of the Imam Ali shrine during the siege of the old city. | TA

Once, when the tension was at a peak, the lights died and immedi-
ately came back on. A man screamed and pointed, saying he had
seen the image of the Mahdi (the "lost imam") in an upstairs window.
Others also saw something (some said it was the image of Imam Ali),
and a crowd of about three hundred came running, screaming, and
chanting across the courtyard toward the mysterious window. I photo-
graphed the window and then I tried to photograph the crowd, but
people kept tugging on my arm to see the digital display on my
camera. They wanted to know if I had gotten a picture of the Mahdi.
Finally, my interpreter got fed up and began explaining that the
Mahdi couldn't be photographed by an ordinary camera like mine.

| Thorne Anderson, Najaf, August 2004

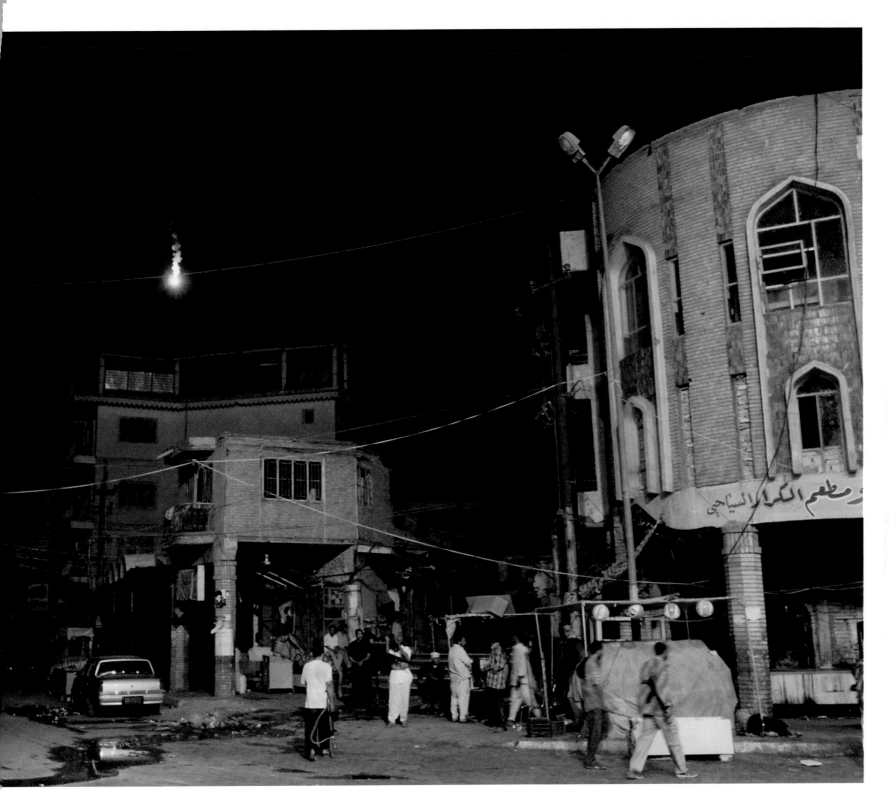

NAJAF, AUGUST 17, 2004
An American flare lights up the night battlefield in the narrow
streets of the old city outside the gates of the shrine. | TA

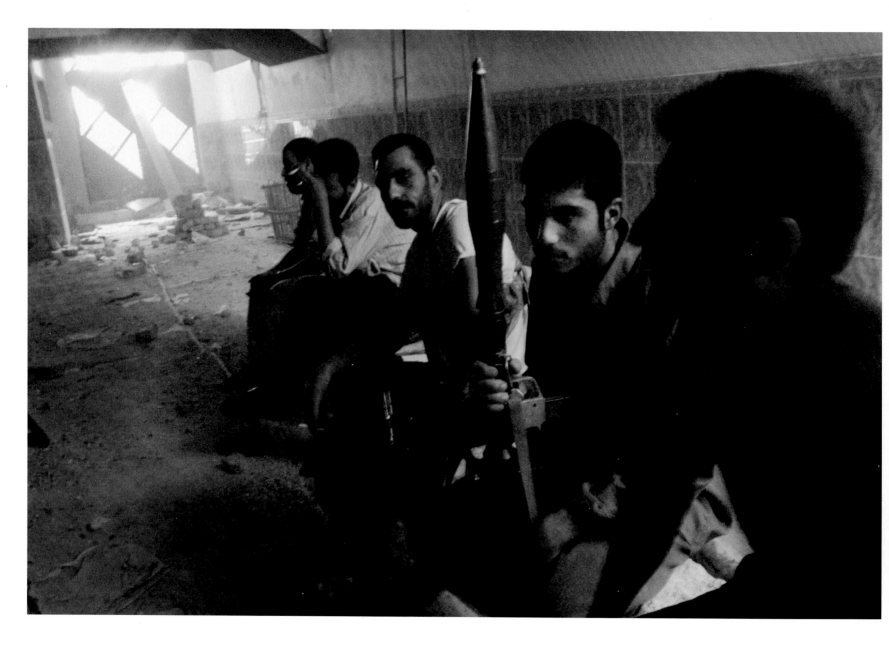

NAJAF, AUGUST 24, 2004
Soldiers of the Mahdi Army wait in the basement for their rotation in front-
line fighting as the building is pummeled by U.S. tank shells. | KA

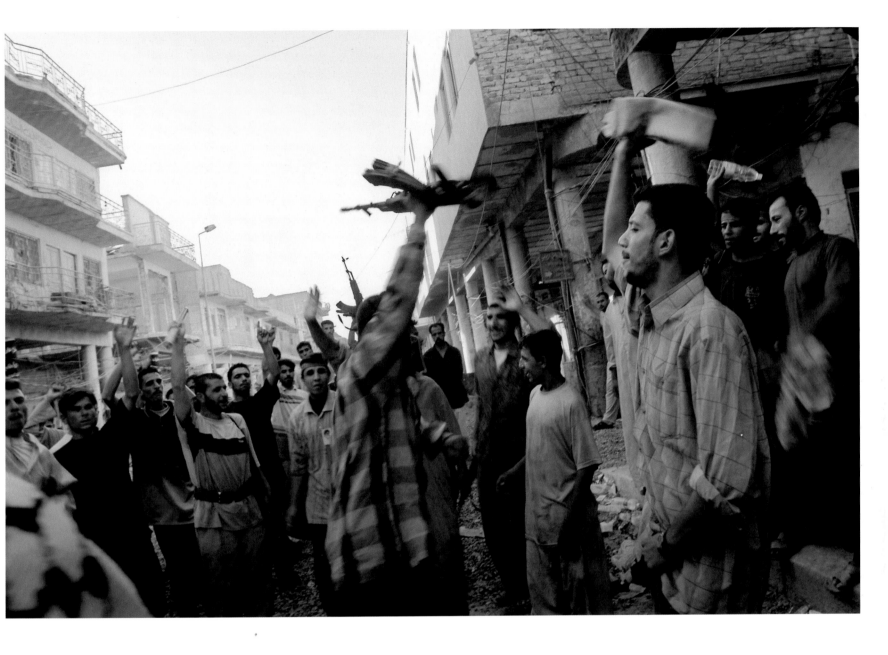

NAJAF, AUGUST 27, 2004
Mahdi Army fighters rally and cheer in support of Muqtada al-Sadr before
handing in their weapons. An announcement from the Imam Ali shrine asked
soldiers to give up their guns and leave the city as part of an agreement bro-
kered by Ayatollah Ali al-Sistani. The Mahdi Army movement won a role in
the political process by agreeing to negotiate and form a political party. | KA

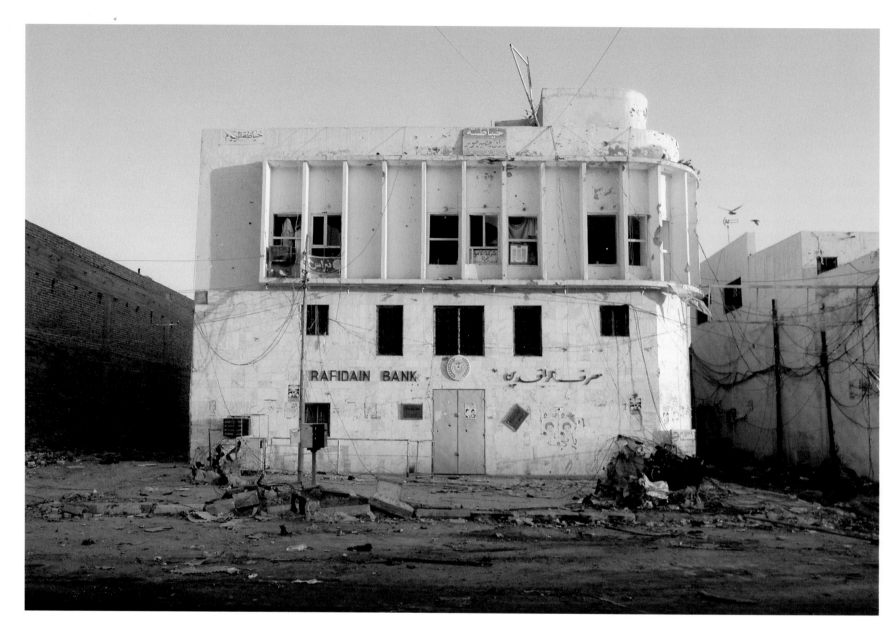

NAJAF, AUGUST 27, 2004
The Rafidain Bank after the siege. American soldiers
were still positioned inside it. | RL

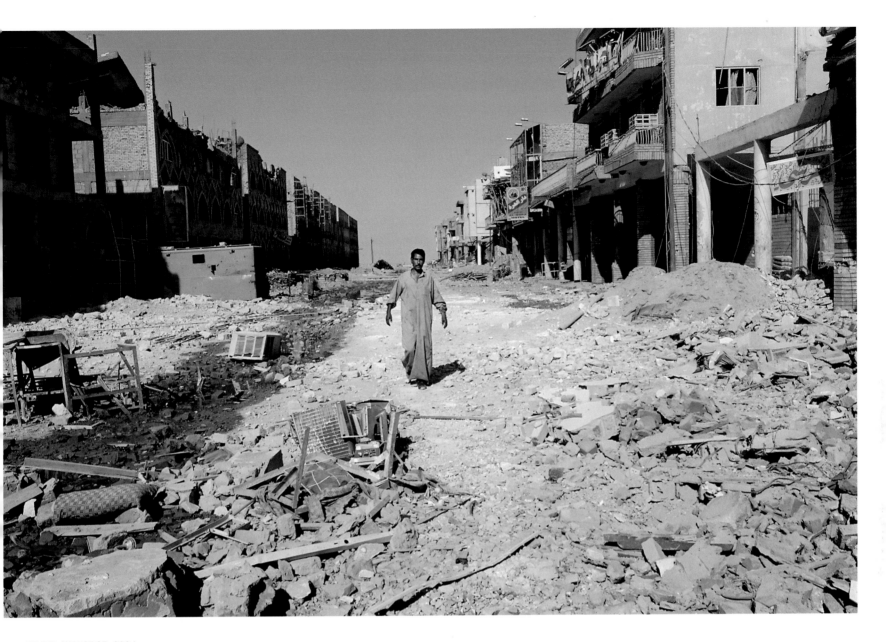

NAJAF, AUGUST 27, 2004
A lone man walks through a devastated business and residential
street west of the Imam Ali shrine. The street was a front line
fighting position for the American Army and Mahdi Army fighters
during a nearly three-week battle that left much of the old city and
surrounding neighborhoods in ruins. A peace deal, brokered by
Ayatollah Ali al-Sistani with the militant cleric Muqtada al-Sadr,
allowed residents to emerge from refuge outside the city or hiding
within it to survey their homes and businesses in the battleground. | TA

OVERLEAF: NAJAF, AUGUST 28, 2004
The temporary graves of Mahdi fighters
killed in battle during the siege of Najaf.
Scraps of paper or cardboard, sometimes
slipped into plastic water bottles, are all
that's available to identify the dead. | RL

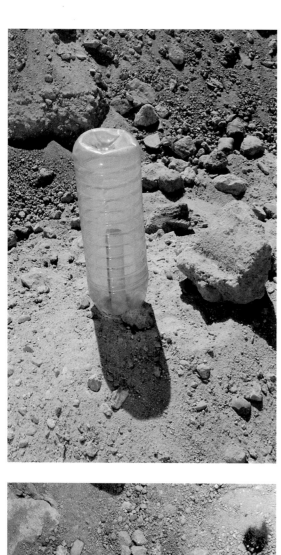
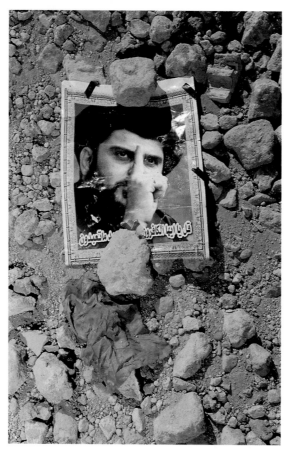
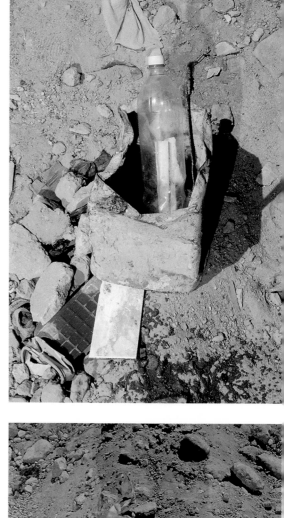

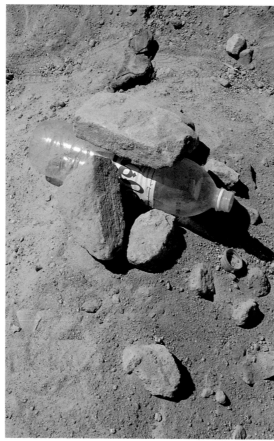
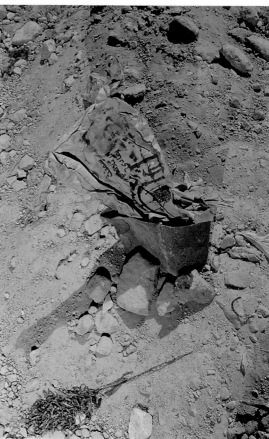

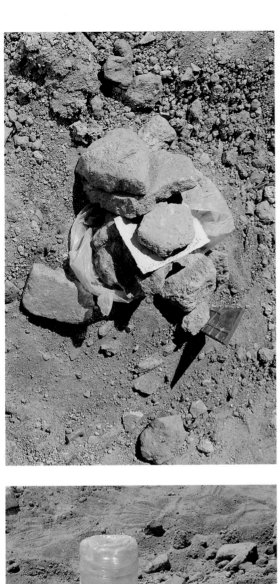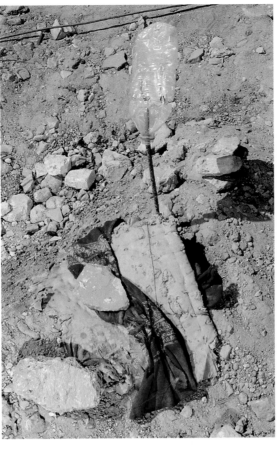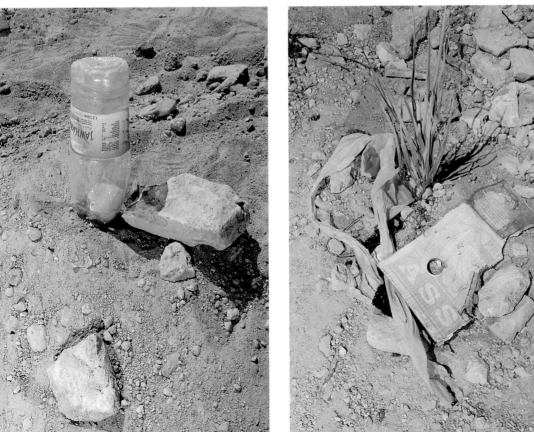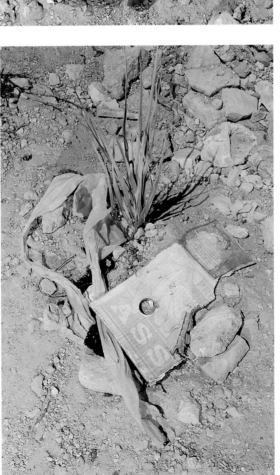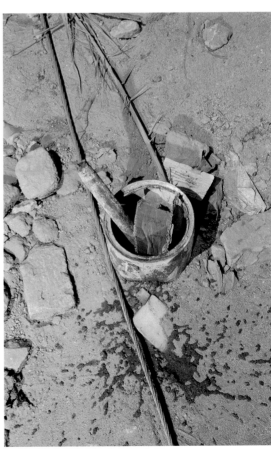

"I am like you,
 scared of these things."

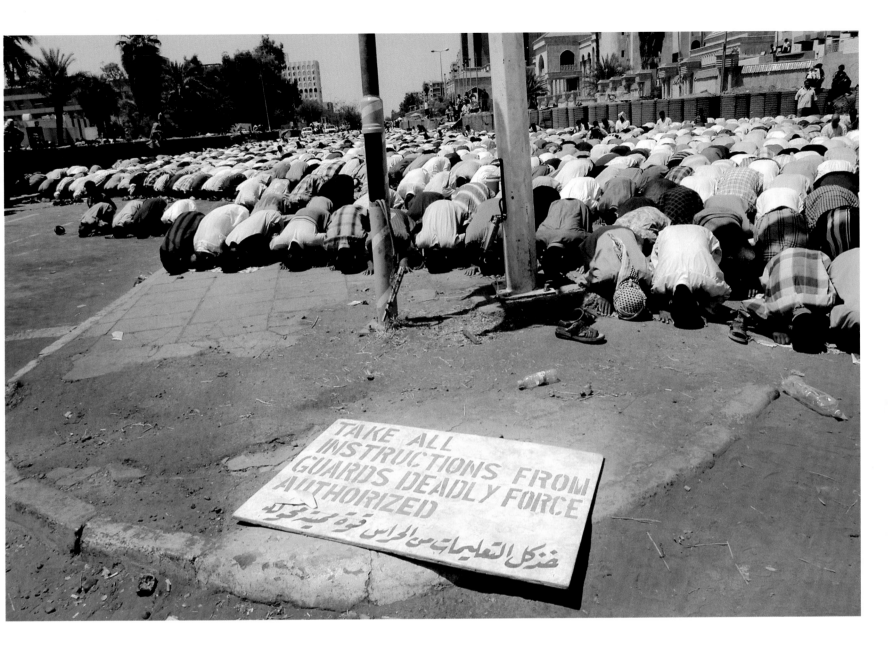

BAGHDAD, AUGUST 13, 2004
Demonstrators supporting Shiite leader Muqtada al-Sadr pray outside the green zone, a heavily fortified compound where the interim Iraqi government and the U.S. embassy are located. The protestors demanded an end to U.S. military actions against al-Sadr's militia, the Mahdi Army, during the buildup to the battle in Najaf. | KA

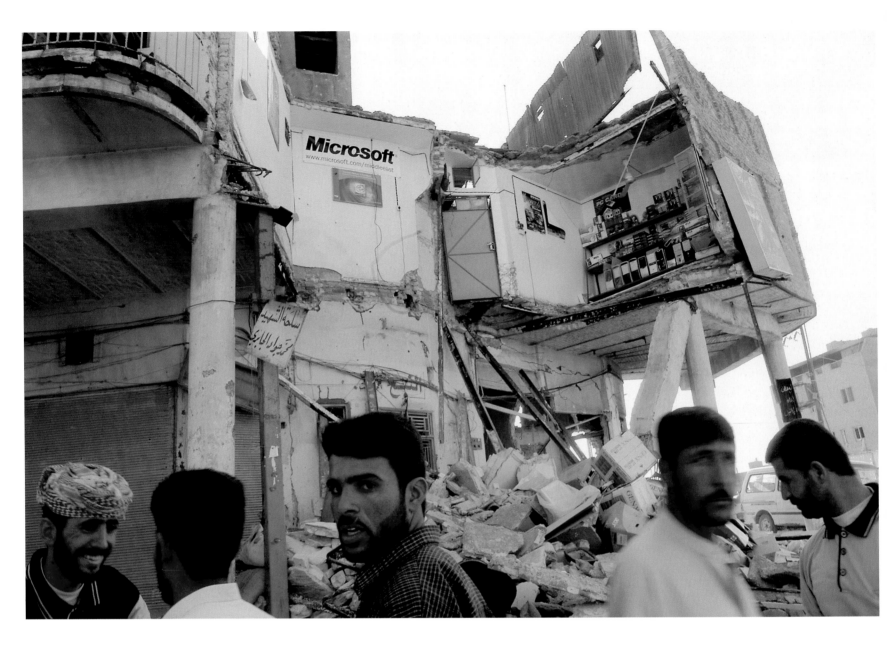

NAJAF, AUGUST 27, 2004
Bombing damage to a computer shop in the old city on the day of the cease-fire between U.S. forces and the Mahdi Army. Fighting has cost the city millions of business dollars and heavy damage to buildings and infrastructure. The holiest city in Shiite Islam, Najaf is a tourist hub that draws vast crowds of pilgrims every year to commemorate the seventh-century martyrdom of Imam Ali. | KA

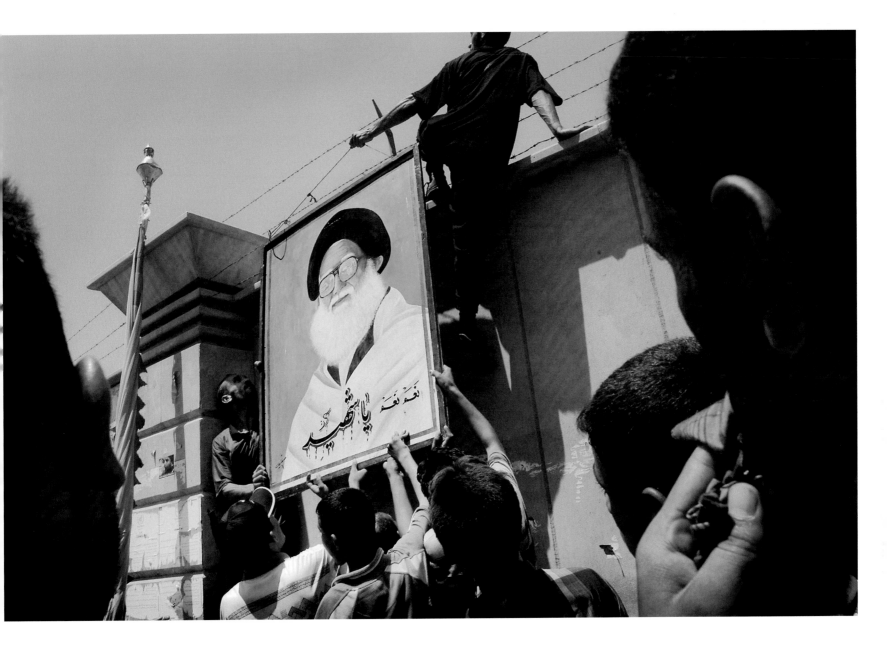

BAGHDAD, AUGUST 13, 2004
Demonstrators hang a picture of Muqtada al-Sadr's uncle, Mohammed Bakr al-Sadr, a Shiite cleric who was assassinated for opposing Saddam Hussein, on a wall outside the green zone. The protest was in response to U.S. military actions against Muqtada al-Sadr and the Mahdi Army. Thousands of al-Sadr's supporters participated, including some Iraqi police. | KA

BAGHDAD, NOVEMBER 17, 2002
A ticket collector awaits customers for the screening of an American film at a movie theater. | TA

SADR CITY, BAGHDAD, JULY 15, 2004
Followers of Muqtada al-Sadr pose with a portrait of their leader. The women assist the Mahdi Army by supplying the fighters with food and other support during battles with U.S. forces. They say they are willing to fight for the militia if the need arises. | KA

BAGHDAD, JULY 17, 2004
A customer walks past a hand-painted sign for a German
sex film into a theater in downtown Baghdad. | TA

From outside Iraq looking in, it may seem that Iraqis imprison their women, and sometimes they virtually do. But inside Iraqi communities, restrictions on women are often passed off as security measures and in some cases are self-imposed.

If an Iraqi woman is kidnapped, her honor may never again be intact. The cultural stigma associated with rape, or the suggestion that rape or other sexual impropriety has occurred, can be a social and sometimes a literal death sentence in Iraq. In very traditional families, honor killings of women by their own family members for infractions of social or sexual codes, in order to preserve the family honor and reputation, are more common now than before the war. With the decrease in law and order since the U.S. invasion, traditional practices are filling the vacuum.

| Kael Alford, Baghdad, September 2004

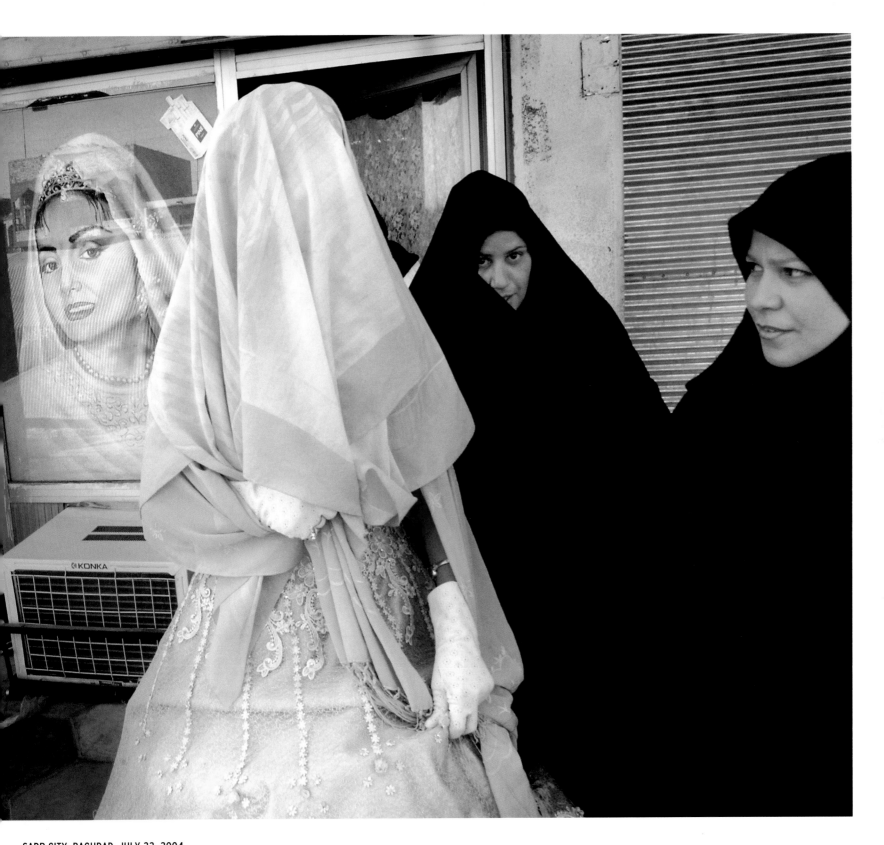

SADR CITY, BAGHDAD, JULY 22, 2004
A bride leaves a beauty salon with her face covered; she will not show herself until she reaches the privacy of a family gathering. The Mahdi Army have threatened beauty salon owners advertising pictures of women without their hair covered. Mahdi fighters police neighborhood streets, enforcing strict moral codes. | KA

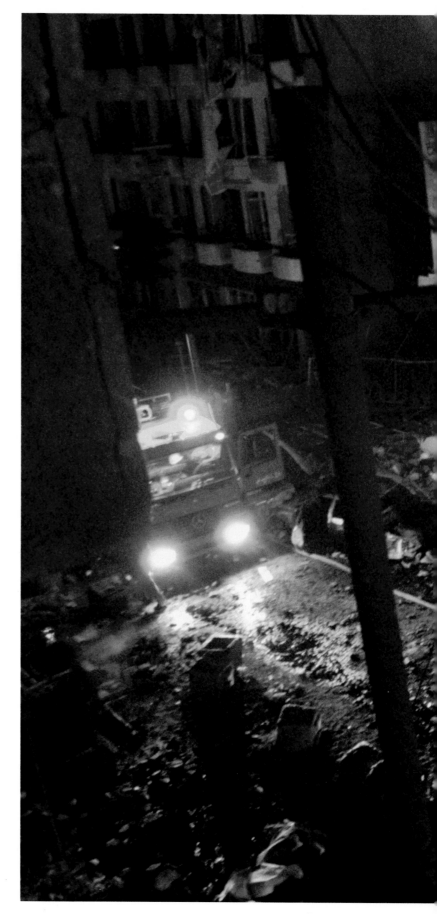

BAGHDAD, APRIL 17, 2004
The Mount Lebanon Hotel and nearby houses lie in ruins after a 450-kilogram car bomb exploded, killing at least seventeen people, mostly Iraqi civilians, and injuring forty-five. Groups alienated from and opposed to the post-war political process have turned to increasingly violent measures. Targets are chosen for sectarian, political, and criminal motivations. | RL

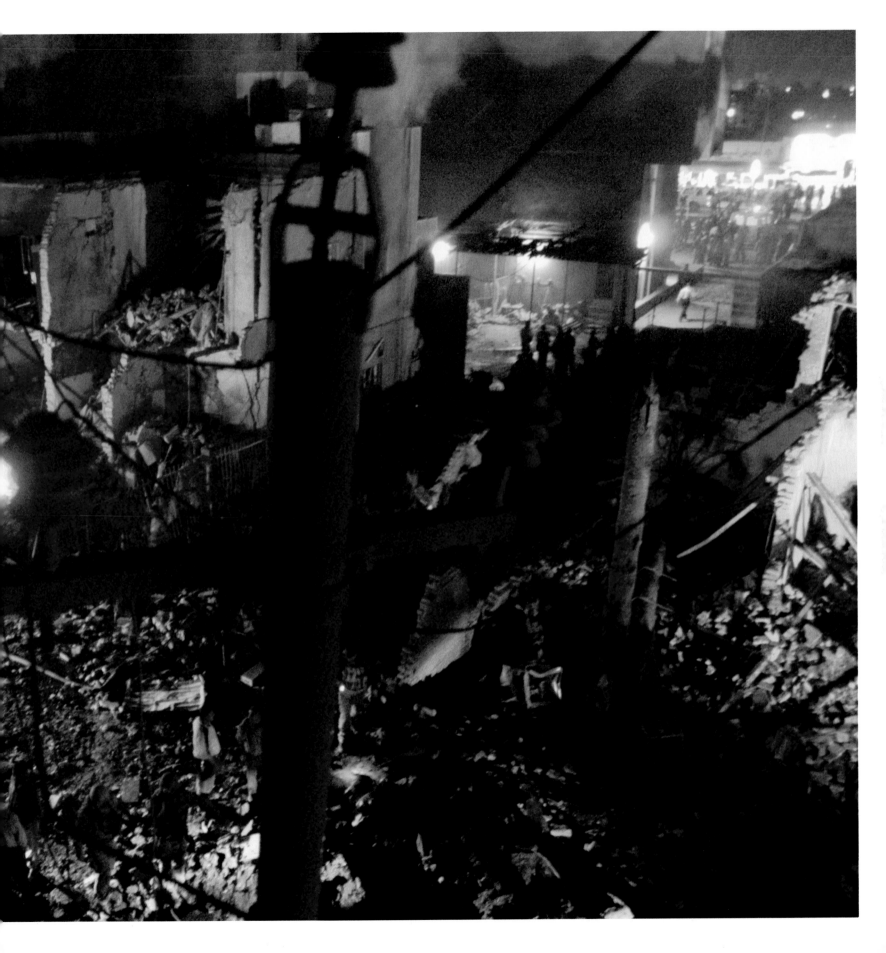

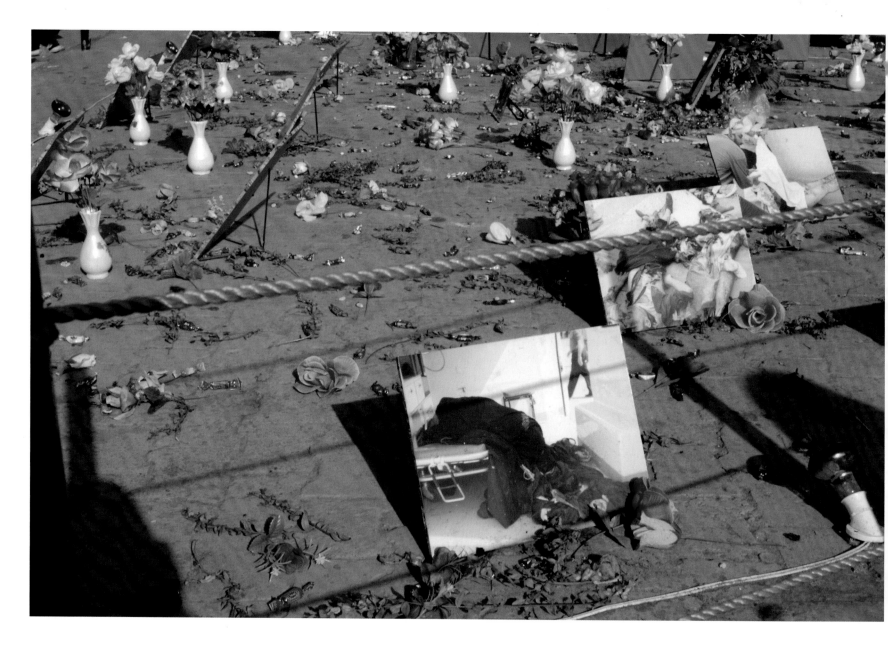

BAGHDAD, MARCH 28, 2004
An improvised shrine at the Kadhimiya mosque honors sixty victims of suicide bombs detonated in and around the mosque in a sectarian attack on Ashura, the holiest day of the Shiite religious calendar. | RL

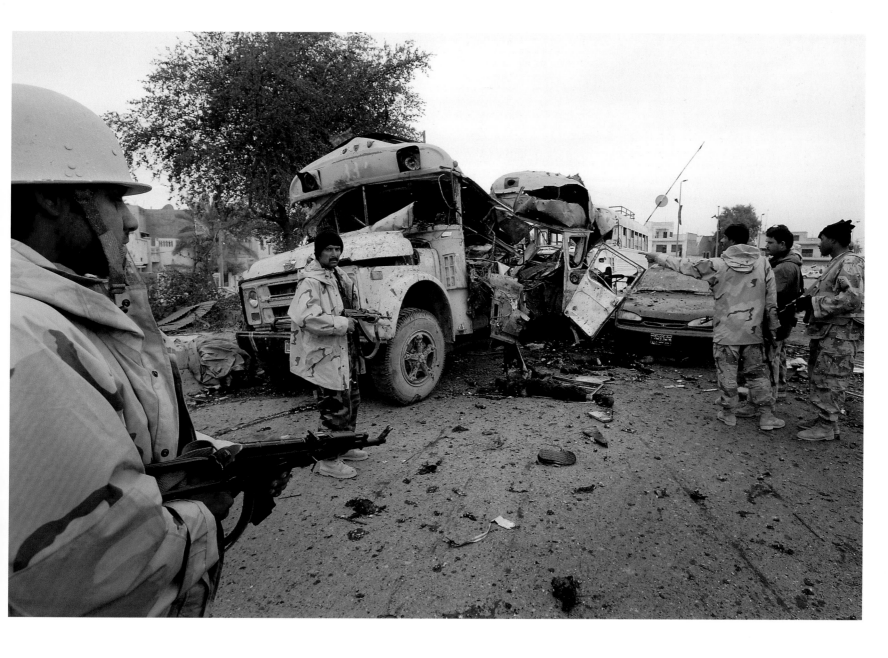

BAGHDAD, FEBRUARY 19, 2005
Iraqi soldiers inspect the wreckage of a destroyed bus in Baghdad's
Kadhimiya district. The bus exploded near a barrier preventing vehicles from
approaching a Shiite mosque, killing five people and wounding forty-six,
police said. Dozens of Shia were killed during the festival of Ashura. | GA

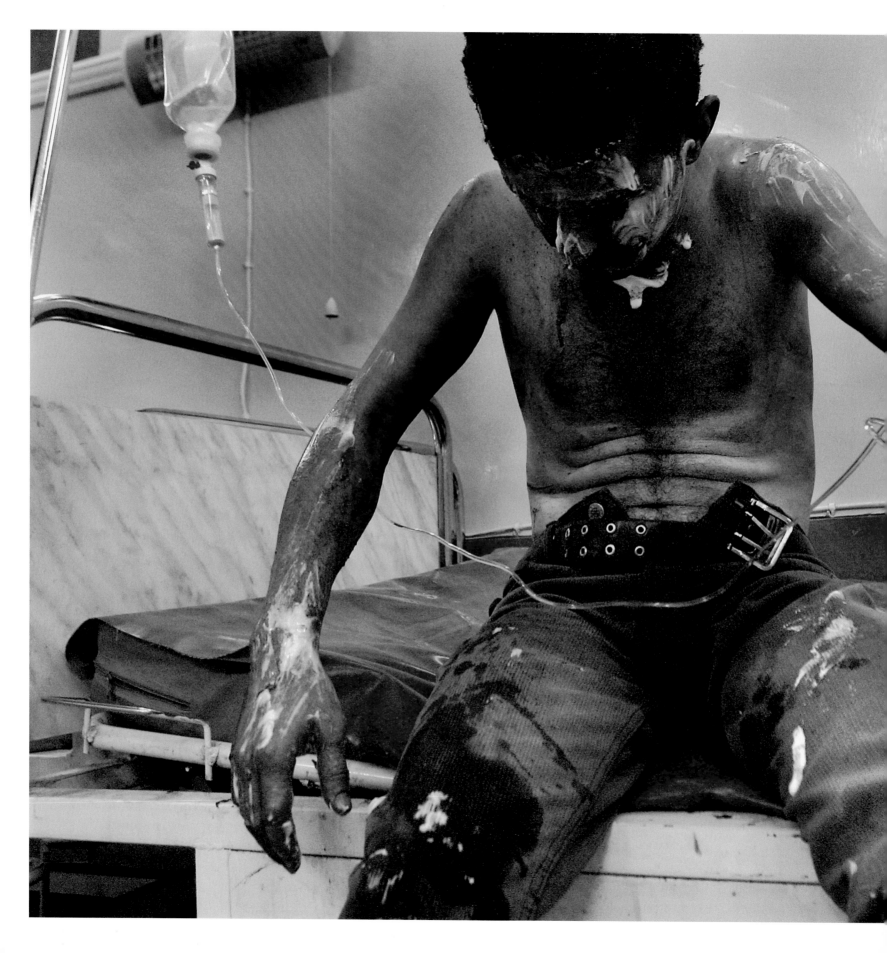

The doctor starts writing something in a white notepad and says, "She is suffering from an acute depression." He looks at Fatima again. "Fatima, my daughter, do you tell yourself that maybe if you die things will get better?"

Still looking at the floor, she speaks for the first time: "Yes, but then I look at my kids and say no."

"Doctor, every time the door is knocked, she starts screaming and fighting," adds her sister.

"Why is that, my dear?" asks the doctor in his soft voice.

"It is all these things around us," says Fatima. "The Americans, the booby traps. No security; I can't let the kids go play outside because of car bombs and fighting." She raises her head for the first time, looks at the doctor and says, "Doctor, you are a learned man. Why can't you stop these car bombs and explosions?"

The doctor giggles and looks at the ceiling, raising his palms. "But how can I? I am like you, scared of these things."

| Ghaith Abdul-Ahad, Baghdad, March 2005

BAGHDAD, AUGUST 1, 2004
A man receives treatment at Kindi Hospital after suffering injuries when two apparent car bombs exploded just minutes apart outside Christian churches. Car bombs exploded outside at least six churches in Iraq on Sunday in an attack apparently coordinated to coincide with evening prayers. | GA

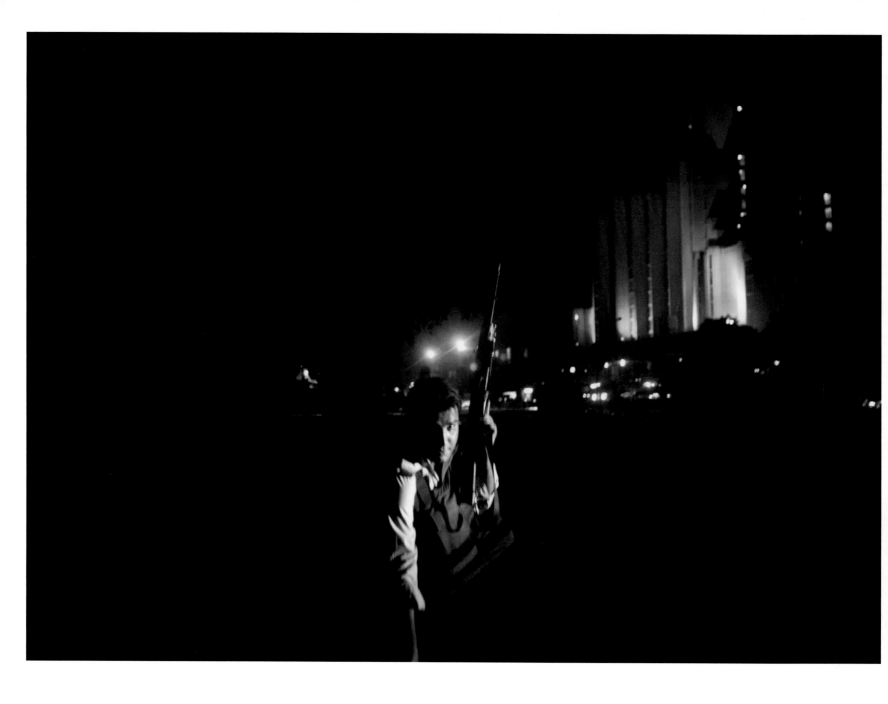

BAGHDAD, JUNE 28, 2005
Police secure the site of a car bomb in the car park of the Babylon
Hotel. Police said only one man was injured in the blast. | GA

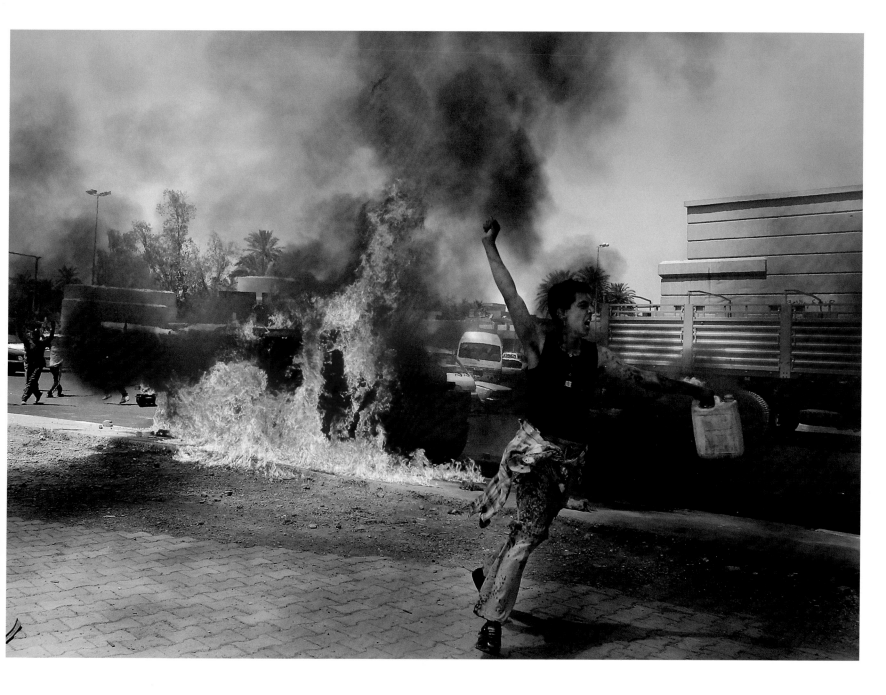

BAGHDAD, APRIL 4, 2004
An Iraqi boy celebrates after setting fire to a damaged U.S. vehicle
that was attacked earlier by insurgents. | GA

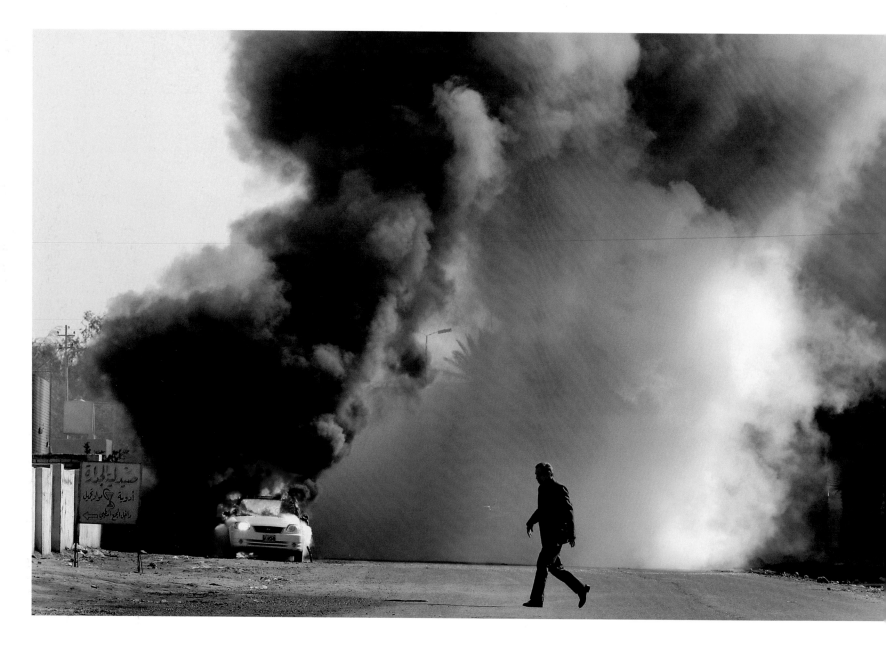

BAGHDAD, JANUARY 28, 2005
A car bomb burns next to a school in south Baghdad an hour after a
suicide bomber targeted a police station in the same area. The city wit-
nessed a surge of violence as the country prepared for elections. | GA

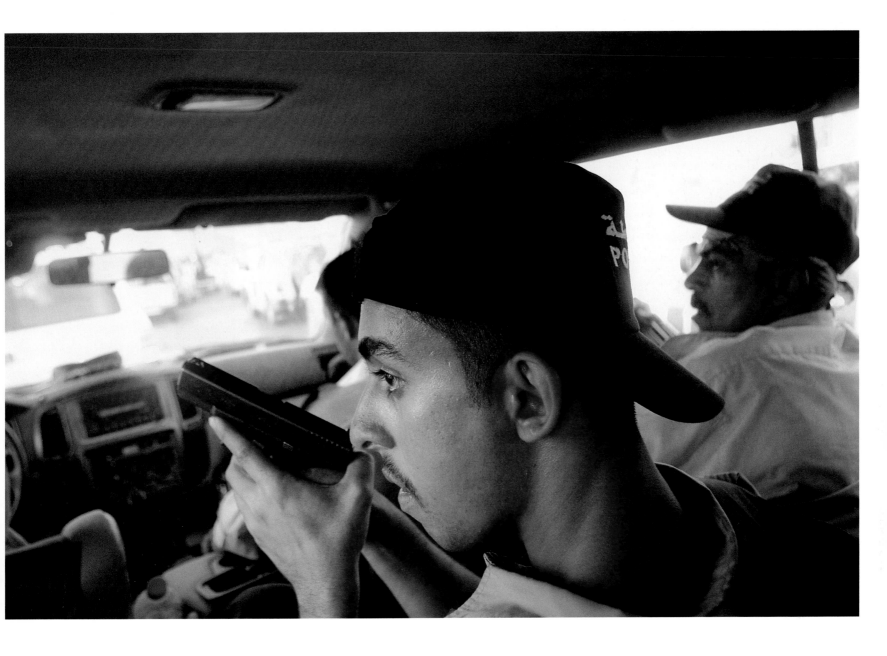

BAGHDAD, SEPTEMBER 4, 2004

Iraqi police take firing positions as they drive to Baghdad after a joint U.S.-Iraqi offensive on Latifiyah, a haven for Sunni Muslim insurgents. The towns of Latifiyah and Mahmudiya, twenty-five kilometers south of Baghdad, have long been under the de facto control of insurgents. Rebels have regularly assassinated police officers, raided stations, and ambushed cars on the deadly stretch of road. | GA

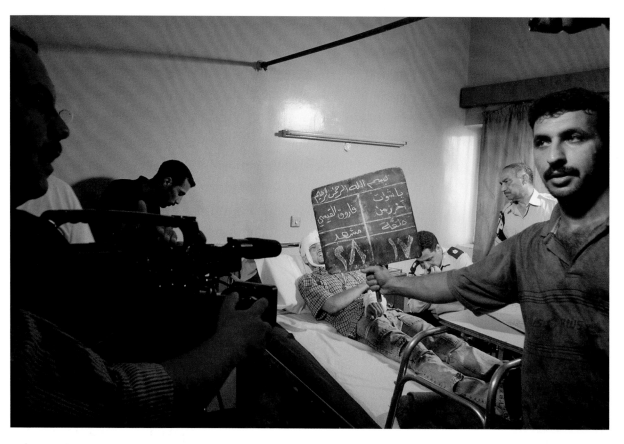

BAGHDAD, SEPTEMBER 8, 2004
Iraqi artists work on a scene for a soap opera describing life
under the occupation. Baghdad's new art movement is heavily
influenced by the war and daily violence. | GA

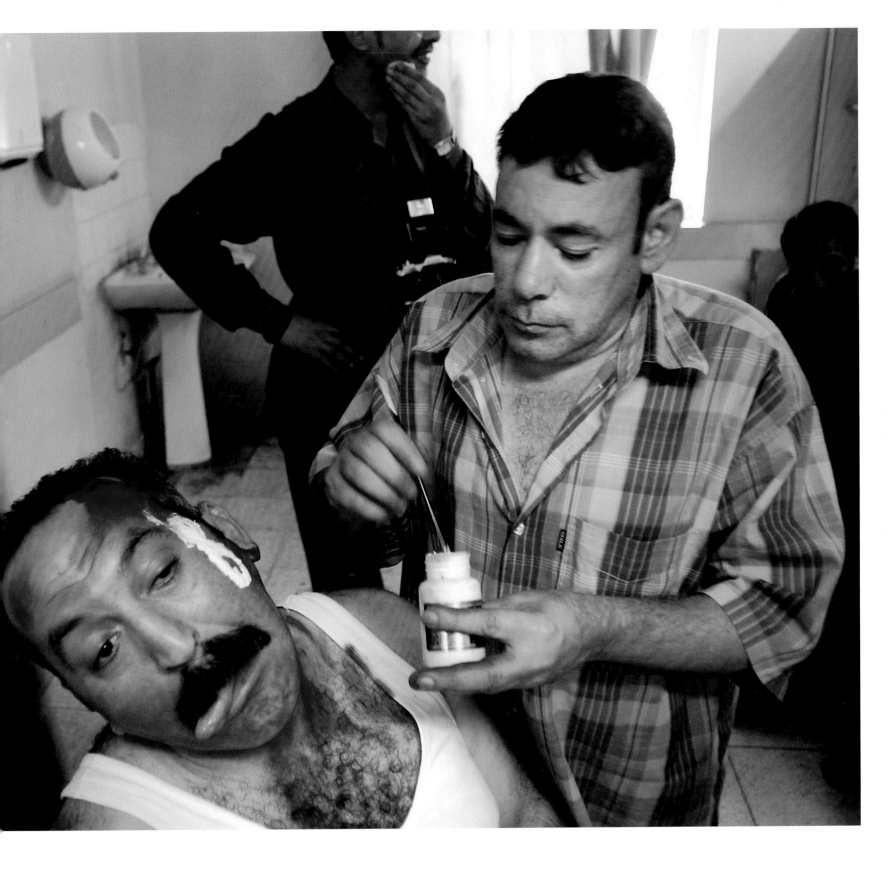

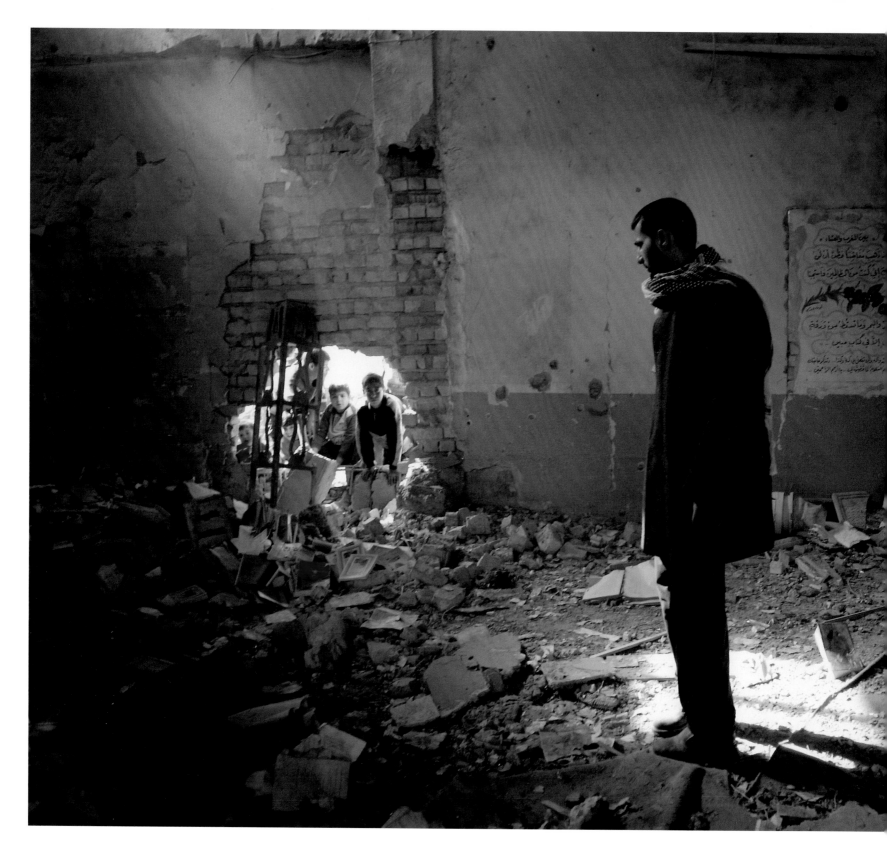

BAGHDAD, FEBRUARY 5, 2005
An Iraqi man stands in the debris of a bomb blast that destroyed the Shiite al-Tawheed mosque. Witnesses said masked men planted explosives around the building early in the morning and then blew it up. | GA

"War wounds are
 always multiple wounds."

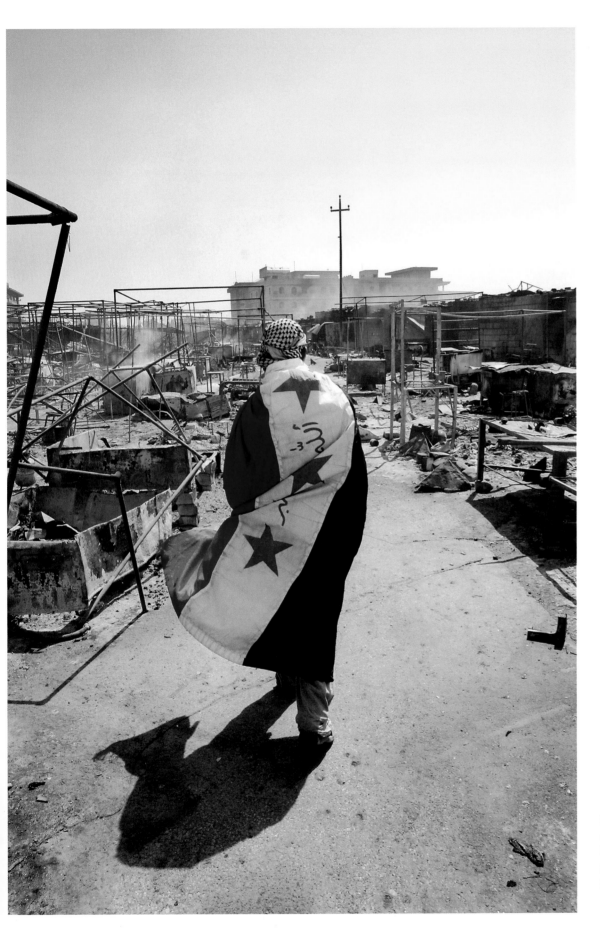

NAJAF, AUGUST 7, 2004
An Iraqi Shiite fighter drapes himself in an Iraqi flag as he walks through a market-place destroyed during clashes with U.S. Marines. | GA

FALLUJA, SEPTEMBER 5, 2003
Graffiti marks the wall of an Iraqi police station in the center of Falluja before the two U.S. offensives against insurgents left the city in ruins. A broken city water pipe has flooded the street. | KA

RASHAD PSYCHIATRIC HOSPITAL, BAGHDAD, APRIL 15, 2004
Siham, a patient, smokes in the Ibn Omran Women's Ward | RL

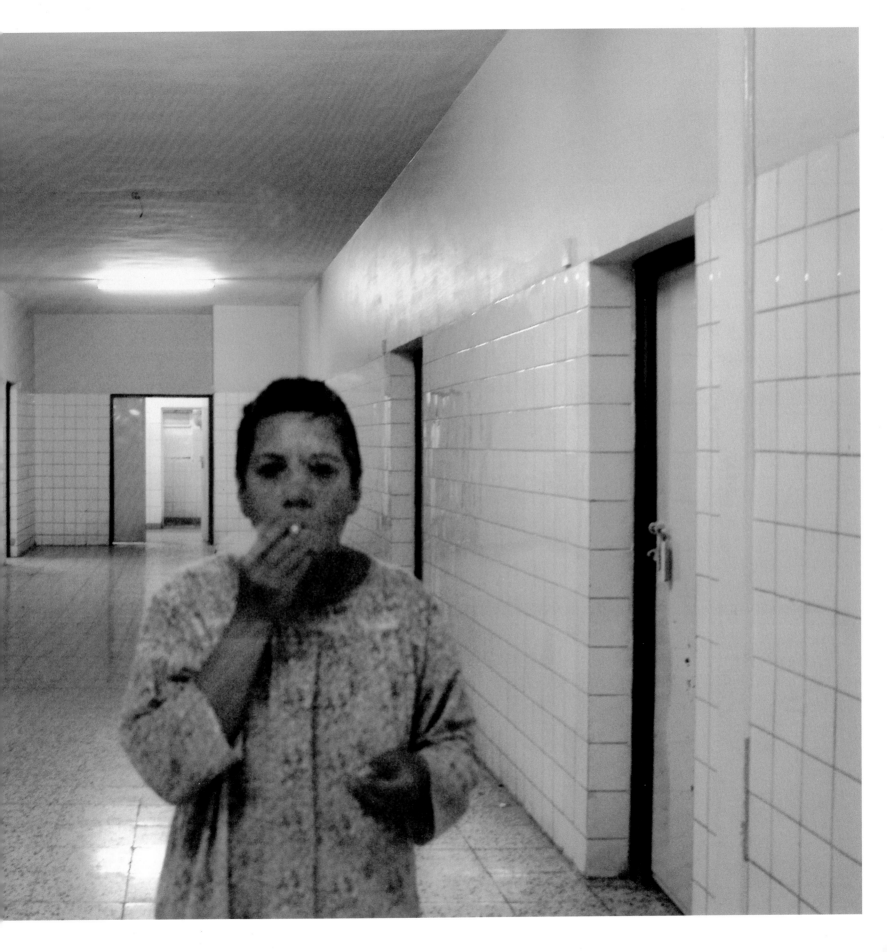

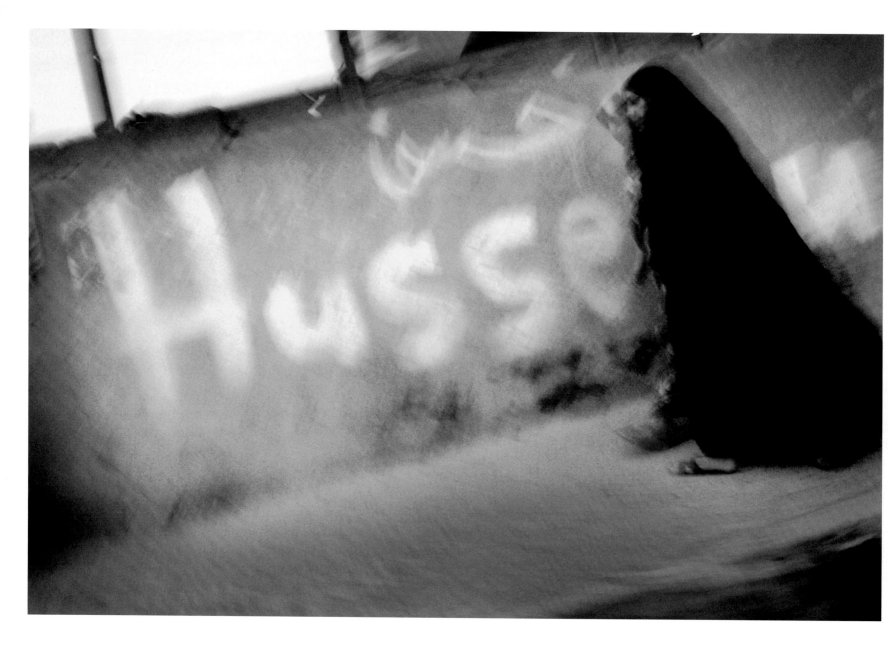

SADR CITY, BAGHDAD, SEPTEMBER 7, 2004
Women walk past the name of Imam Hussein, the son of Imam Ali, founder of Shia Islam, scrawled on a wall. Under Saddam Hussein, such a statement of Shiite faith and solidarity would have beeen viewed as a threat to the unity of the state. Since the U.S. invasion, Sadr City has become an open book of religious and political graffiti. | KA

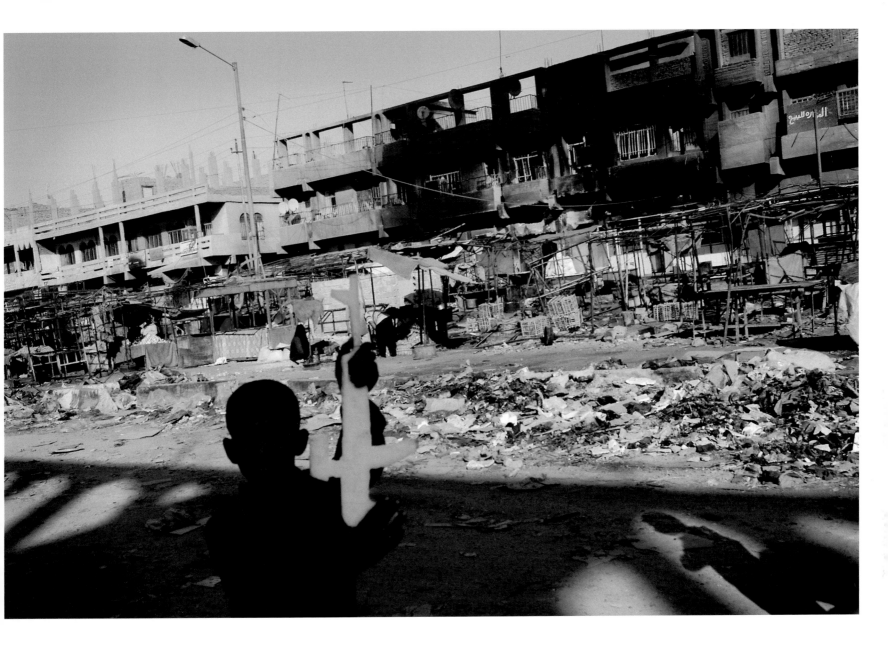

SADR CITY, BAGHDAD, OCTOBER 5, 2004
A boy brandishes a toy Kalashnikov in a main thoroughfare and abandoned
food market the day after the area was heavily damaged in fighting between
U.S. forces and the Mahdi Army. U.S. forces blasted the apartment buildings
with helicopter gunships. | KA

I have spent nearly ten months in Iraq—almost all of that time "embedded" with the Iraqi people themselves. I traveled with American soldiers for a few days, and it was like being in a plastic bubble. From the American humvees I could see the Iraq that I know, but there was no interaction with it. The Americans have almost no cultural contact with Iraqi people. They may have an occasional chat with some random Iraqis who pass by, but the American soldiers don't make Iraqi friends over time, they don't eat in their homes, visit their mosques, play with their children, go to weddings, play dominoes, or take afternoon naps with them.

| Thorne Anderson, Baghdad, September 2004

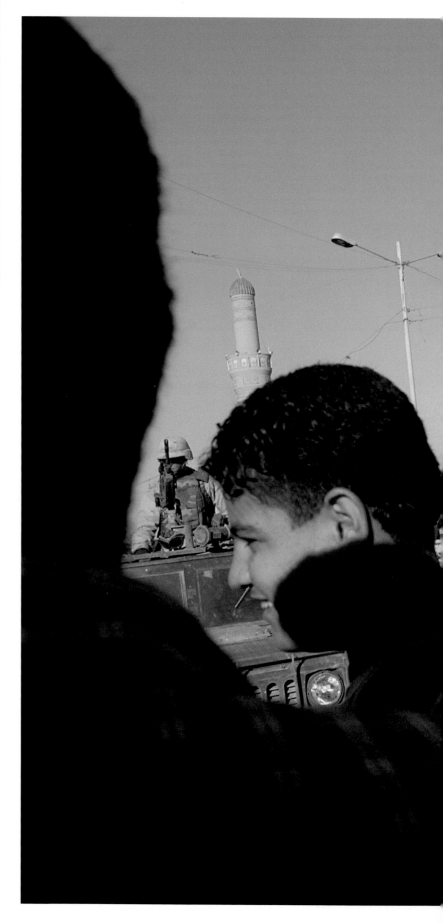

SADR CITY, BAGHDAD, MAY 1, 2003
American soldiers get bogged down in human traffic after investigating a shooting incident in the Sadr City neighborhood, formerly known as Saddam City. | TA

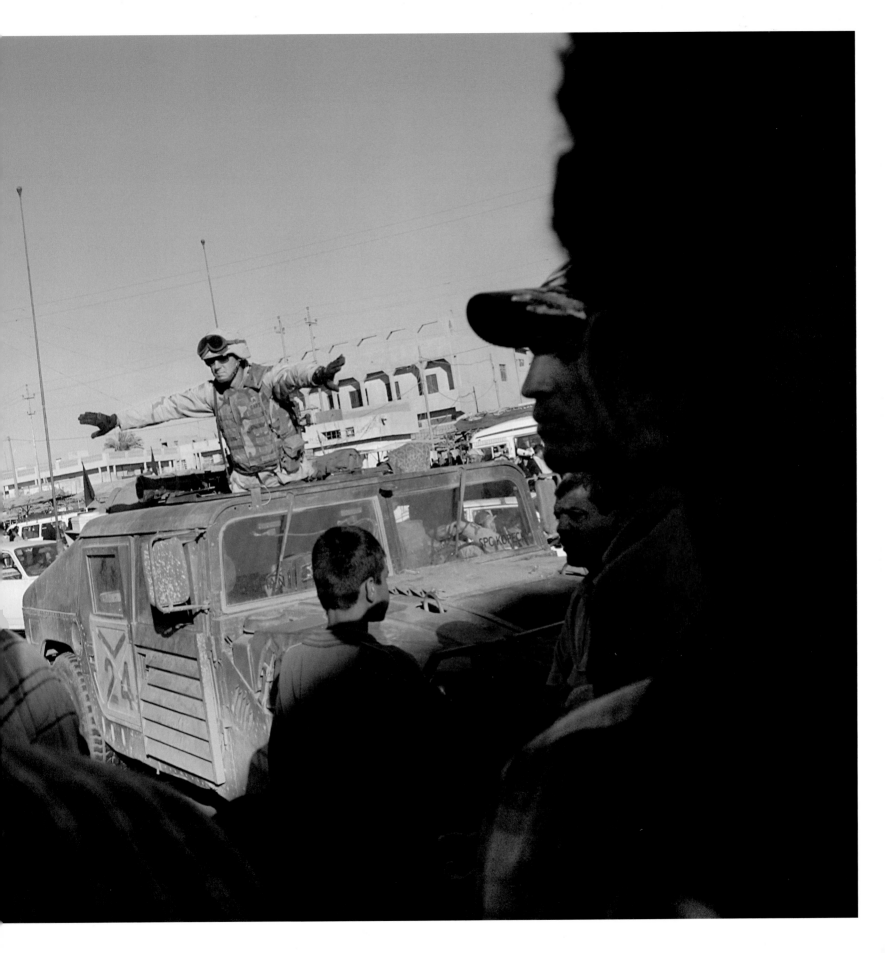

BAGHDAD, APRIL 26, 2003
An Iraqi police officer stands in the looted armory of his police station in the Adhamiya neighborhood shortly after Baghdad fell to American Marines. He was wounded in the chaos at war's end, and American soldiers confiscated his weapon, but he returned to keep watch on what was left of his station. | TA

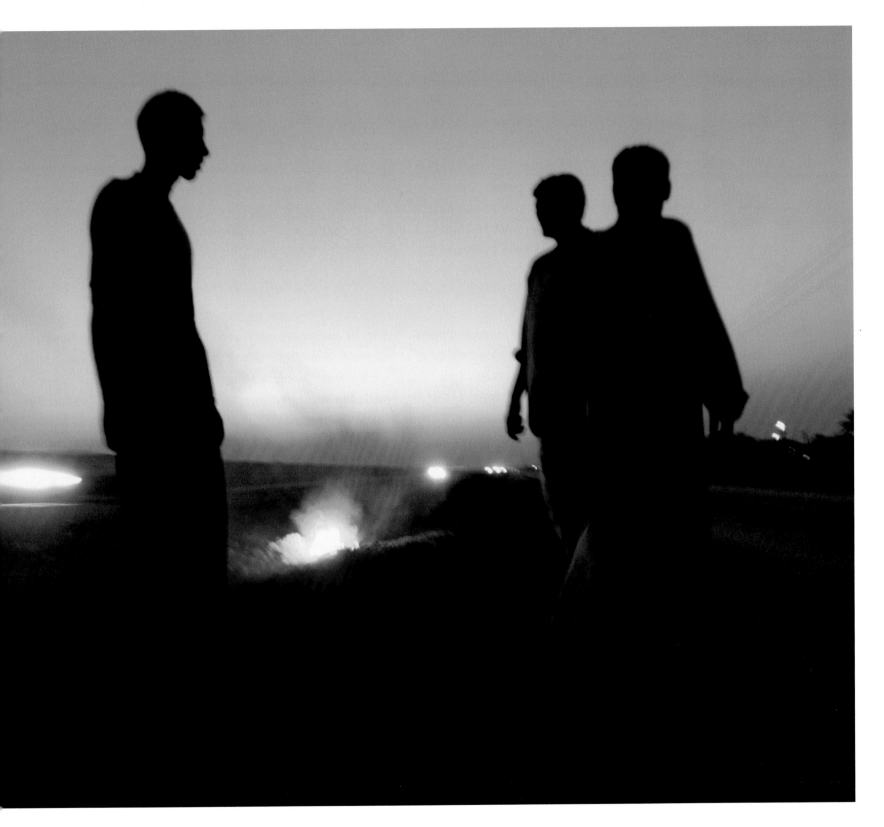

ROAD BETWEEN FALLUJA AND RAMADI, SEPTEMBER 18, 2003
Curious men join a resistance fighter to survey the remains
of a burning U.S. humvee attacked in an ambush. | KA

GHAITH ABDUL-AHAD

Born in Baghdad, Iraq, Ghaith studied architecture at Baghdad University and had never traveled outside Iraq until after the recent war began. A deserter from Saddam Hussein's Iraqi army, he lived underground in Baghdad for six years, changing his residence every few months to avoid detection and arrest. Ghaith began making street photography in 2001. Soon after U.S. Marines took control of Baghdad in April 2003, he began writing for the *Guardian* and *Washington Post*. His photographs have been published in the *New York Times*, *Washington Post*, *Los Angeles Times*, the *Guardian*, *The Times* (London), and other media outlets. He was one of the last journalists to work in insurgent-held Falluja before the all-out American assault on that city in April 2004. He also worked behind Mahdi Army front lines during the American assault on Najaf in August of the same year. He continues to cover the front lines of both the Sunni and Shiite insurgency movements.

KAEL ALFORD

Born in Middletown, New York, Kael earned a bachelor's degree in literature from Boston University and a master's degree from the University of Missouri-Columbia School of Journalism and taught photojournalism at the American University of Bulgaria. Since 1999 she has been an independent photojournalist covering culture, politics, and conflict in southeastern Europe and the Middle East for U.S. and European magazines and newspapers. Her work has appeared in *Time*, *Newsweek*, *U.S. News & World Report*, *Vanity Fair*, the *New York Times*, *San Francisco Chronicle*, *The Christian Science Monitor*, *The Times* (London), and *NRC Handelsblad* (The Netherlands), among other publications. She was based in Baghdad during the U.S. invasion of Iraq in 2003, and she has spent more than eight months there on three separate trips. She is based in New York and is represented by Panos Pictures in London.

THORNE ANDERSON

Born in Montgomery, Alabama, Thorne earned a master's degree from the University of Missouri-Columbia School of Journalism and taught Journalism and Mass Communication at the American University in Bulgaria. He has been covering international news with Corbis/Sygma since 1999. Thorne's photographs are regularly published in magazines and newspapers including *Time*, *Newsweek*, *U.S. News & World Report*, *Stern*, the *New York Times*, *Boston Globe*, *Chicago Tribune*, *Los Angeles Times*, *San Francisco Chronicle*, *The Times* (London), the *Guardian*, and other publications. Thorne spent ten months on multiple journeys in Iraq. He is among the few active journalists who worked in Iraq during the sanctions period before the most recent war.

RITA LEISTNER

Born in Toronto, Canada, Rita obtained a master's degree in comparative literature in 1990 and worked as a photographer and as a lighting technician in the film industry before moving to Cambodia in 1998 as an independent photojournalist. After studying at the International Center for Photography in New York in 2000, Rita went on to cover the war in Iraq, spending ten months there between April 2003 and September 2004. Her photographs have been published in *The Walrus*, *Time*, *Newsweek*, *Rolling Stone*, *Colors*, *Alphabet City*, and *Maclean's*, among other publications. Her award-winning writing often accompanies her in-depth photo feature stories. She joined Redux Pictures in 2005.

ACKNOWLEDGMENTS

We would like to recognize the brave and ingenious Iraqi women and men who worked with us as interpreters, drivers, and guides during the gathering of this material. The risks they took assisting us are innumerable. Without them our work would not be possible. We are grateful to have them as colleagues and friends.

We would also like to thank those editors and colleagues who shared their time in reviewing and advising this project: Leo Divendal, Dick Doughty, Kareem Fahim, Paul Fusco, Alice Gabriner, Ron Haviv, Ken Horowitz, Yunghi Kim, Dietmar Liz-Lepiorz, Minka Nijhuis, Paolo Pellegrin, Dionne Searcey, Jack Van Antwerp, and Jamie Wellford.

Photo Mechanic editing and prepress software by Camera Bits was very helpful in the creation of this book.

Special thanks to my editors at the *Guardian*: Ian Katz, Leslie Plommer, Esther Addley, and Paul Macinnes; my editors at Getty Images: Hugh Pinney, April Jenkins, Muhanad Falah, and Alaa Sadoon. And to my friends and family: Wendell Steavenson, Salam Pax, Laurent Marion, Joao Silva, Rory McCarthy, Rory Carroll, James Meek, Suzan Sachs, Patrick Tyler, Brent Stirton, Molly Bingham, Steve Connors, Scott Nelson, Steve Farrell, Karl Vick, Anthony Shadid, Neil MacFarquhar, and Zain Selim.

GHAITH ABDUL-AHAD

Special thanks to Thomas and Lynn Alford, Michael Regnier and Panos Pictures, Kathy Kelly of Voices in the Wilderness, Rob Collier and Mark Abel of the *San Francisco Chronicle*, Scott Baldauf and *The Christian Science Monitor*, Steve Farrell of *The Times* (London), Patrick Graham, Dionne Searcey, and Todd Stevens. Also thanks to Alaa, Abdul Amir, Adnan and Waleed, Luay, Abu Abbas, Qais, and Zahraa in Baghdad.

KAEL ALFORD

Special thanks to Bruce, Rebekah, Eade, and Jane Anderson and the rest of my family; my editors at Corbis: David Laidler, Stokes Young, Jodie Factor, April Jenkins, and Sarah Hughes; Anna Badkhen of the *San Francisco Chronicle* and David Filipov of the *Boston Globe*; Kathy Kelly of Voices in the Wilderness; Jeremy Scahill of *Democracy Now!*; Justin Jin; Michele Ernsting; and Aaron Bolgatz.

THORNE ANDERSON

Special thanks to my family and *The Walrus*; Jasmine Jopling and Marcel Saba at my agency, Redux Pictures; Eric Bageot and Jonathan Wells at Sipa; Lazar Antonic, Berivan (Estelle Vigoureux), Thanassis Cambanis, Barbara Davidson, Christopher Decherd, Marco DiLauro, Scott Eels, Arthur Gottschalk, Katja Heinemann, Jon Higgins, Adnan Khan, Henry Knight, M.L. Knight, Guntar Kravis, Diana Kuprel at *Ideas*, Doris and Mort Levin and family, Dale McMurchy, Kendall Messick, Stephen Morrison, Robert Palmer, Richard Pendlebury, Betsy Pisik, Janet Reitman, Leslie Sparks, John Trotter, Geert van Kesteren, Steve Wiley, Paul and Patricia Wilson, Dr. Imad and the staff and patients of the Rashad Hospital; the Turkish Press Corp, especially Burak Kara and Jeroen Kramer; the soldiers of C Troop, 3/7 Cavalry, 3rd ID; Thanaa, Bashar, Ali M., Ammar, Mohammed and Asma S., Yerevan, Abu Tamara, and Alaa in Iraq.

RITA LEISTNER

Editor: Mary Bahr
Managing Editor: Marcy Brant
Designer: Peter Holm, Sterling Hill Productions
Design Assistant: Daria Hoak, Sterling Hill Productions

Printed in Canada
First printing, October 2005
10 9 8 7 6 5 4 3 2 1

Chelsea Green sees publishing as a tool for cultural change and ecological stewardship. We strive to align our book manufacturing practices with our editorial mission, and to reduce the impact of our business enterprise on the environment. We print our books and catalogs on chlorine-free recycled paper, using soy-based inks, whenever possible. Chelsea Green is a member of the Green Press Initiative (www.greenpressinitiative.org), a nonprofit coalition of publishers, manufacturers, and authors working to protect the world's endangered forests and conserve natural resources.

Unembedded was printed on Jensen, a 10 percent post-consumer waste recycled, old growth forest-free paper supplied by Friesens.

Library of Congress Cataloging-in-Publication Data
Unembedded : four independent photojournalists on the war in Iraq / Ghaith Abdul-Ahad, Kael Alford, Thorne Anderson, Rita Leistner ; foreword by Philip Jones Griffiths ; introduction by Phillip Robertson.
 p. cm.
 ISBN 1-931498-95-4 (hardcover) – ISBN 1-931498-98-9 (pbk.)
 1. Iraq War, 2003–Pictorial works. 2. News photographers–Iraq. 3. News photographers–United States. I. Abdul-Ahad, Ghaith.
 DS79.762.U54 2005
 956.7044'3'0222--dc22

 2005022385

Chelsea Green Publishing Company
Post Office Box 428
White River Junction, VT 05001
(800) 639-4099
www.chelseagreen.com